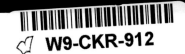

THE SARTORIALIST

X

SCOTT SCHUMAN

PENGUIN BOOKS

PENGUIN BOOKS

An imprint of Penguin Random House LLC
375 Hudson Street, New York, New York 10014

penguin.com

First published 2015

ISBN 978-0-14-312805-2

Designed by Studio Fury
Printed and bound in Italy by Graphicom srl
Colour reproduction by Altaimage Ltd

1 3 5 7 9 10 8 6 4 2

TO MY DAUGHTERS, ISABEL AND CLAUDIA.

I'VE NEVER LEARNED SO MUCH ABOUT THE WORLD AS WHEN I WAS TEACHING MY LITTLE GIRLS HOW TO SEE IT.

X MARKS TEN YEARS SINCE I STARTED MY BLOG THE SARTORIALIST.

Though this book is not a retrospective, it does denote an evolution in my work from fashion found in cities like New York, Paris, London and Milan, to global style in locations as diverse as Marrakesh, Cusco, Bangkok, Bari, Johannesburg, Jodhpur, Bali, Lima, Mumbai, Dubai, Rome, Kiev, Varanasi and Bhutan.

I am proud to think that as you flip through the book you're never sure where the next page will take you.

On the blog, some people have found this jarring and don't understand how such a disparate assortment of ages, races and income levels can be presented in the same space. This may be because people are looking for specific answers to their fashion questions. But I believe this collection of images offers something much more important: inspiration and fuel for daydreams.

Like costumes in a movie, the clothing in these images better helps you imagine a possible context and personality for each individual. When reviewing the photographs, I constantly wondered, 'What is that person's life like?' And so I created my own stories. These stories may be about an elegant, older man in Milan sitting in his apartment amid his carefully collected treasures and memories; or about two kids on their way to school in Varanasi, India, dressed in school uniform, looking wonderfully mischievous in a way that makes me jealous of their imminent adventures. Some of the stories are happy and some are sad, but that's life. Even when it's imagined.

Scott Schuman, The Sartorialist

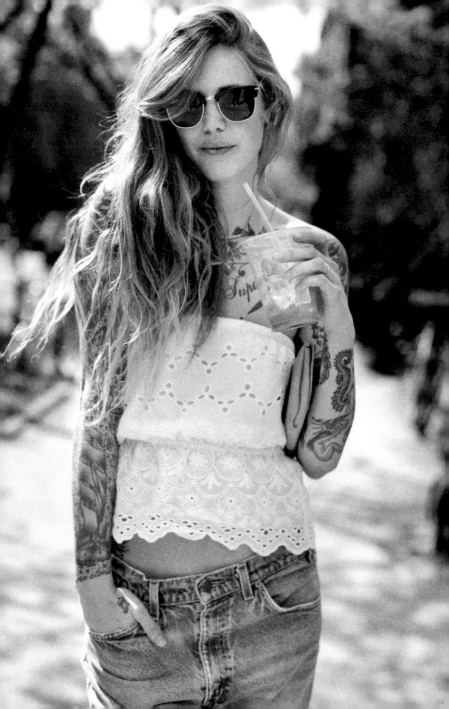

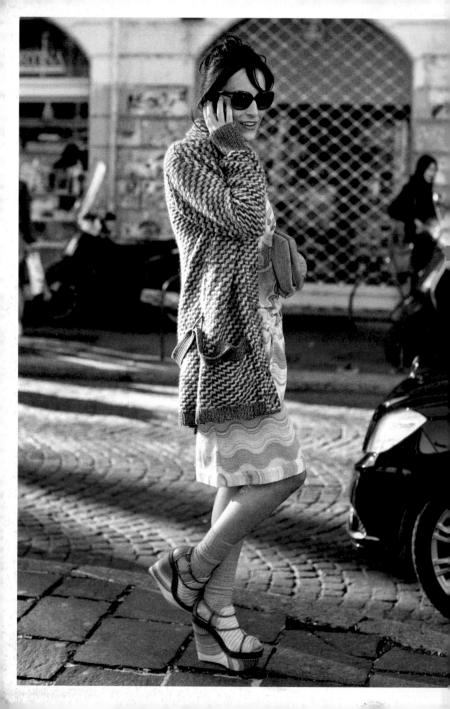

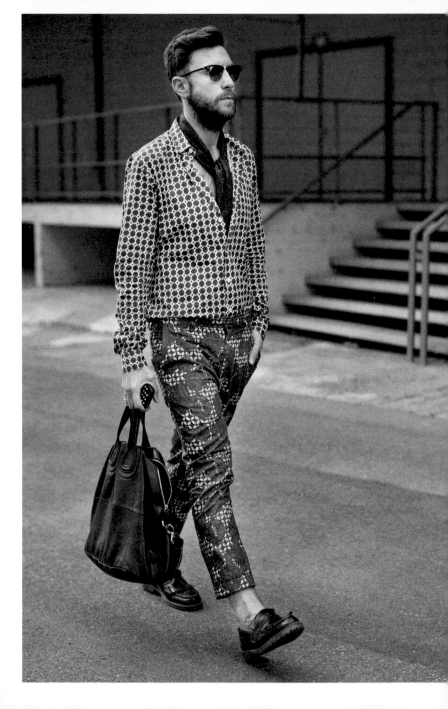

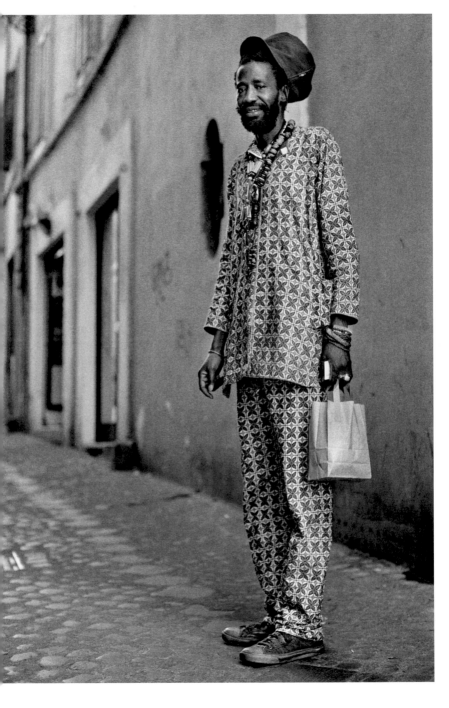

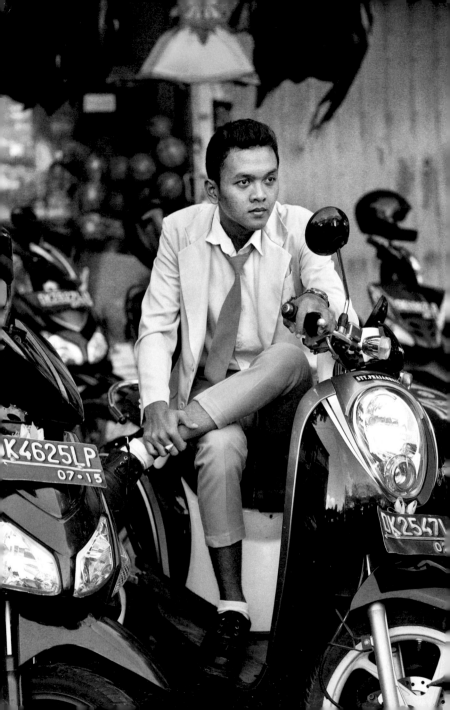

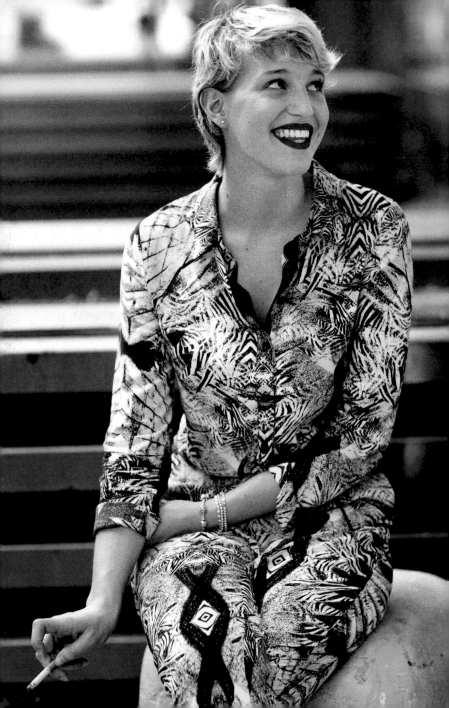

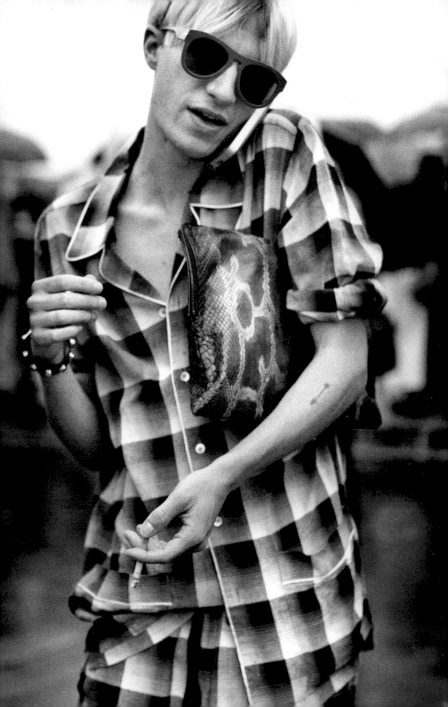

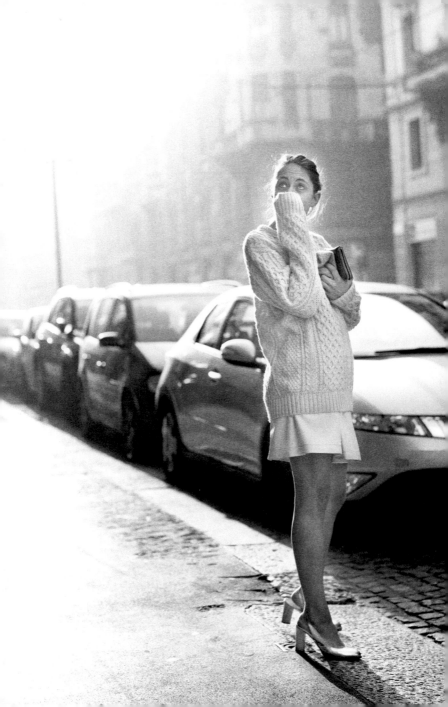

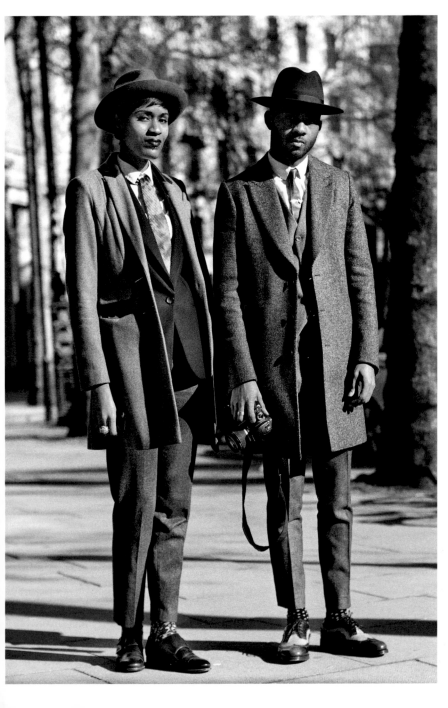

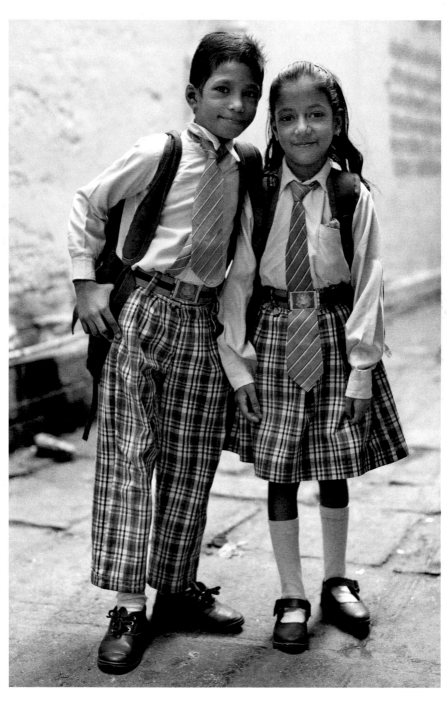

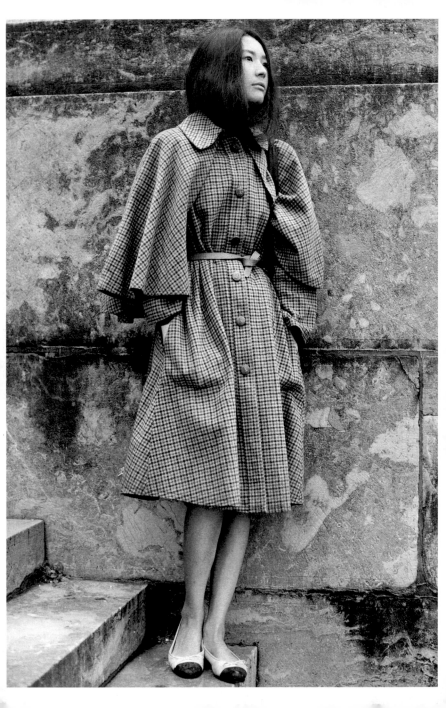

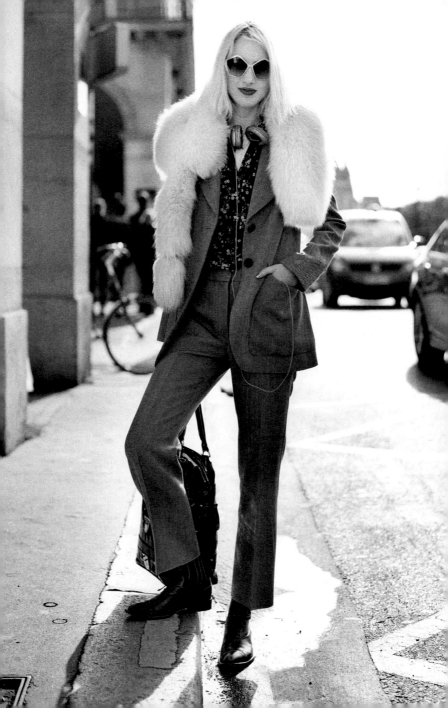

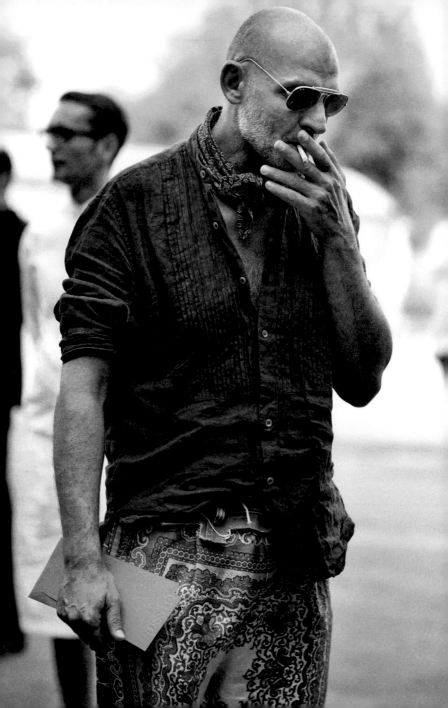

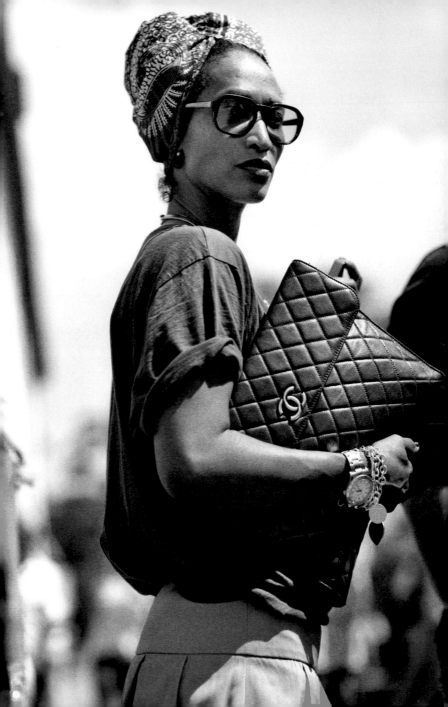

—

ON THE STREET...
THE BUS DRIVER,
MUMBAI

—

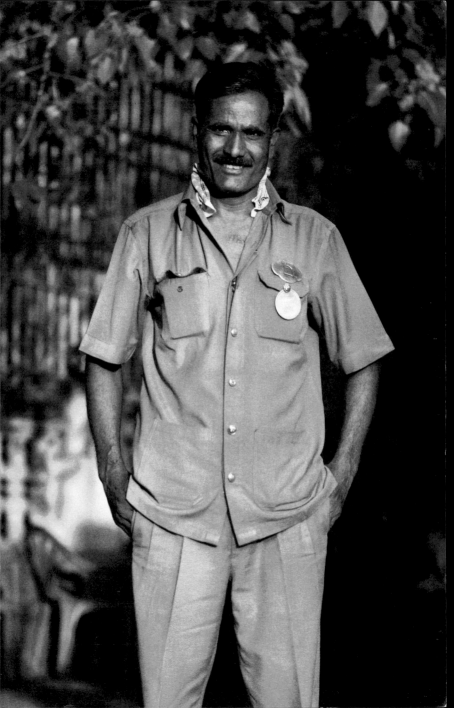

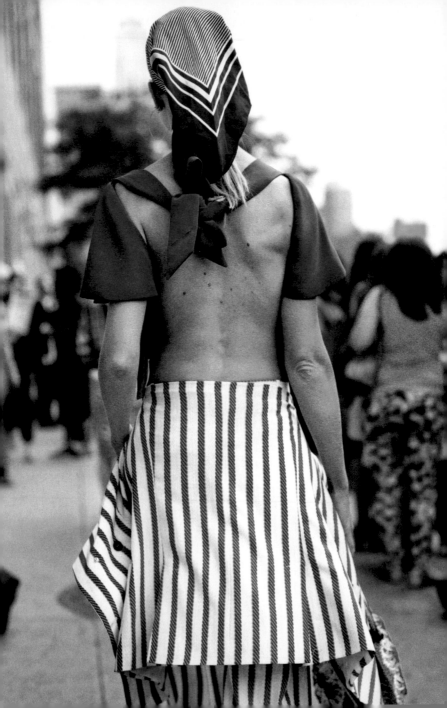

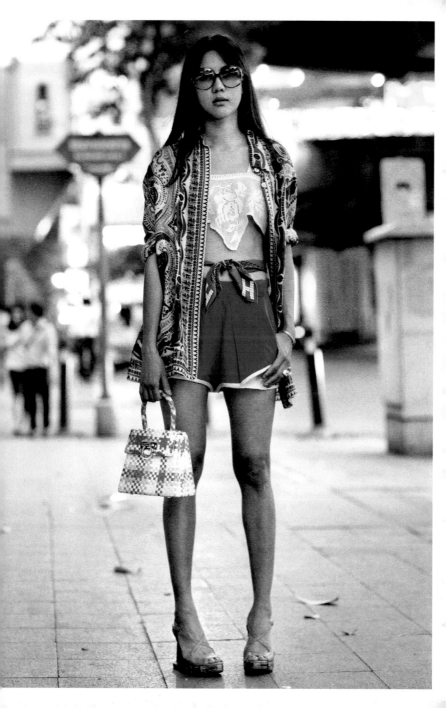

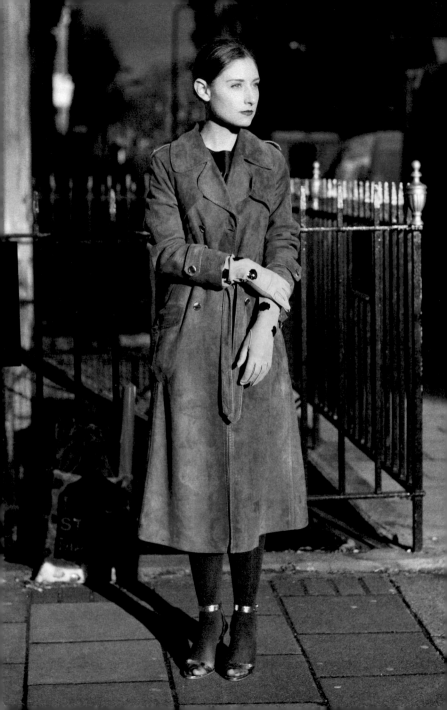

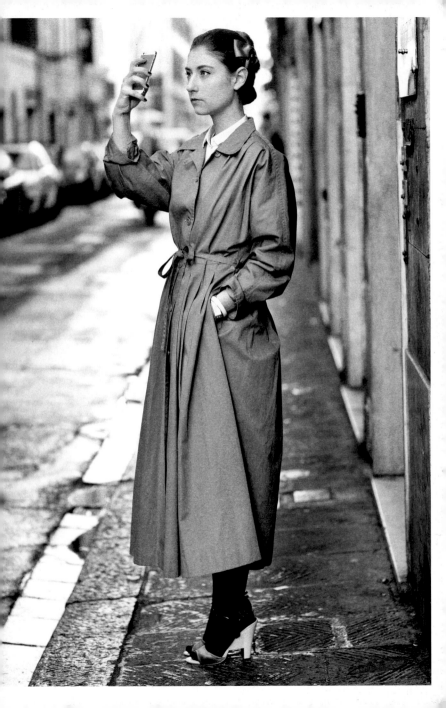

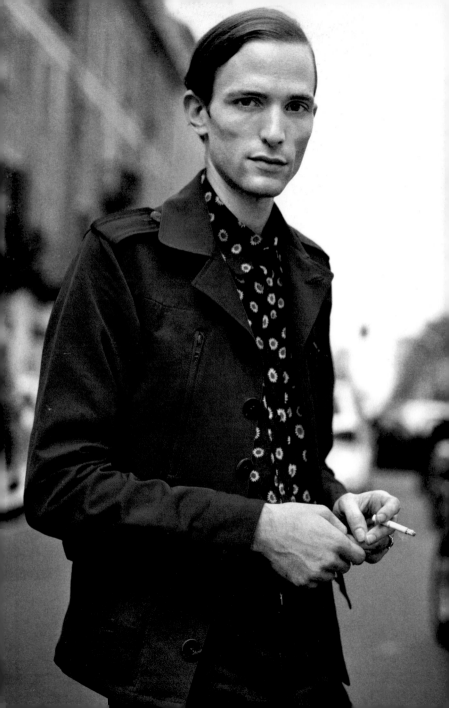

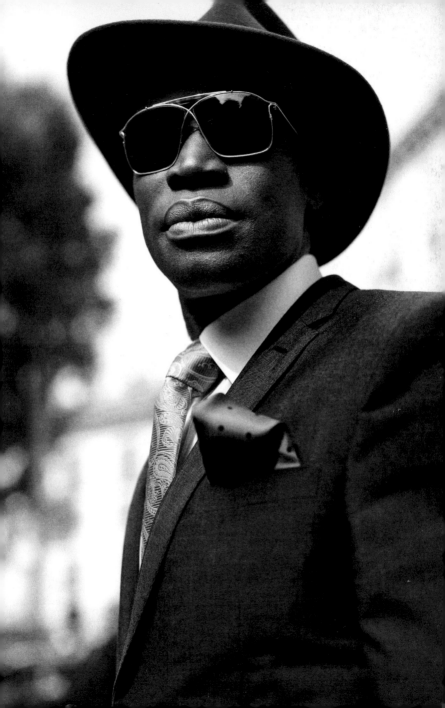

ADA

———

Ada Kokosar is exactly the type of woman I wanted to shoot when I first started attending fashion week as The Sartorialist ten years ago. She's a freelance stylist with great personal style. When I ask her about a particular look she's wearing she tells me about the concept, the artistic inspiration, or the touch of a fabric rather than just rattling off a list of designer brands. I hate to say that she's the kind of woman that has fun with fashion for the 'right reasons', but there you have it.

———

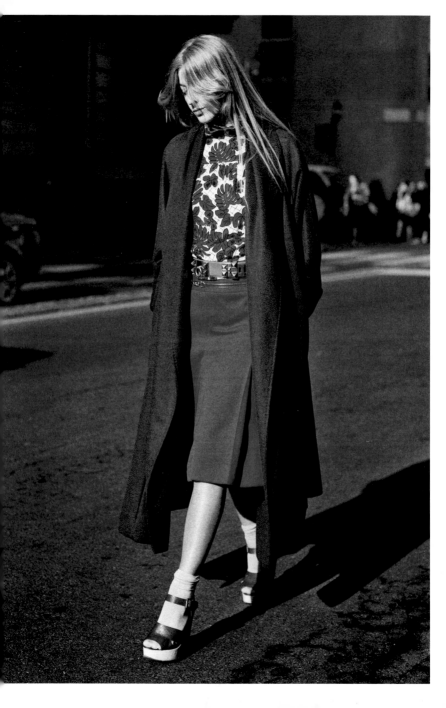

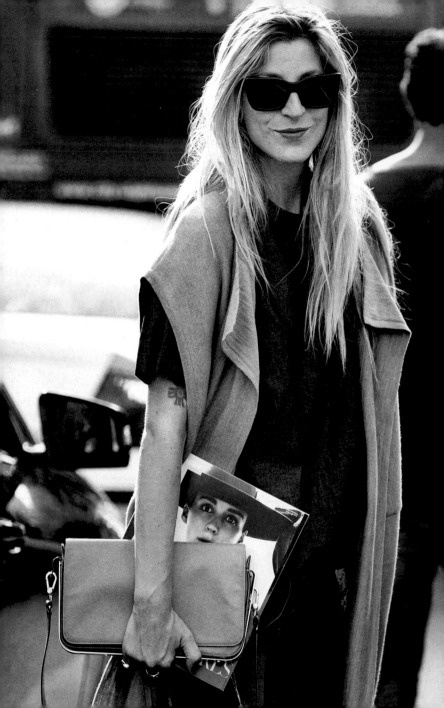

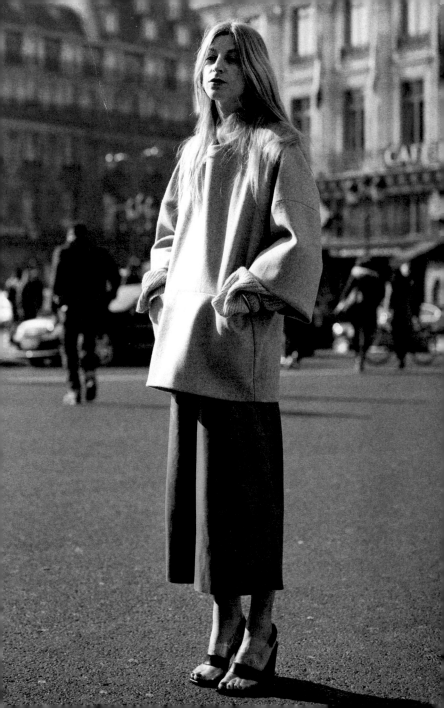

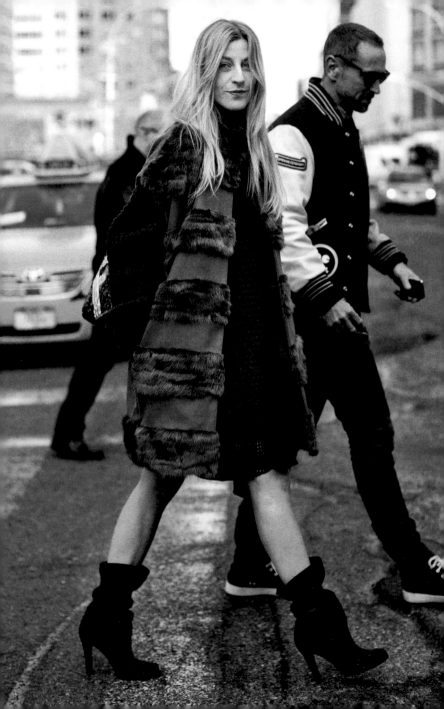

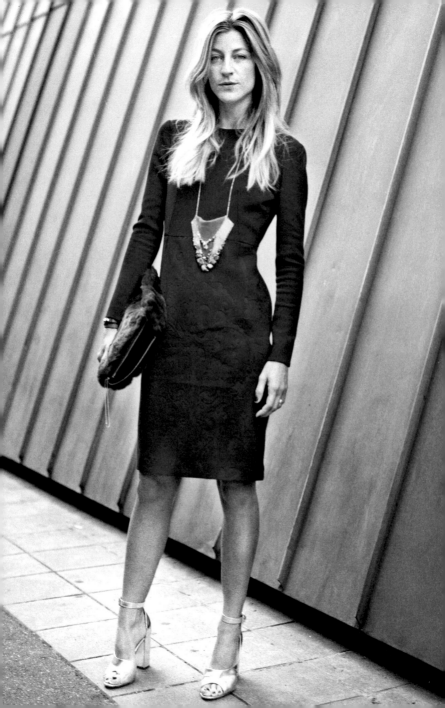

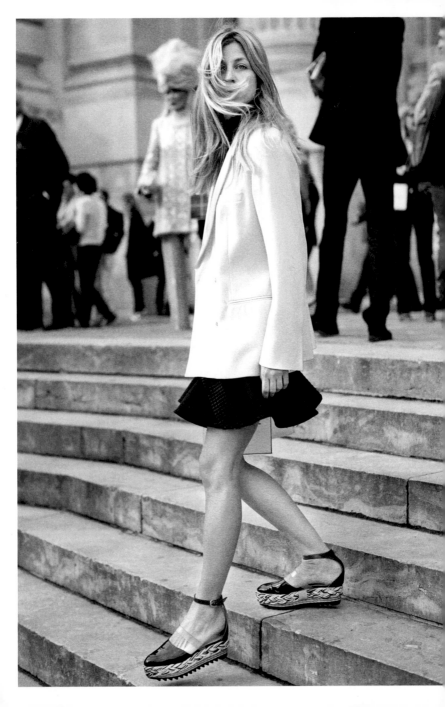

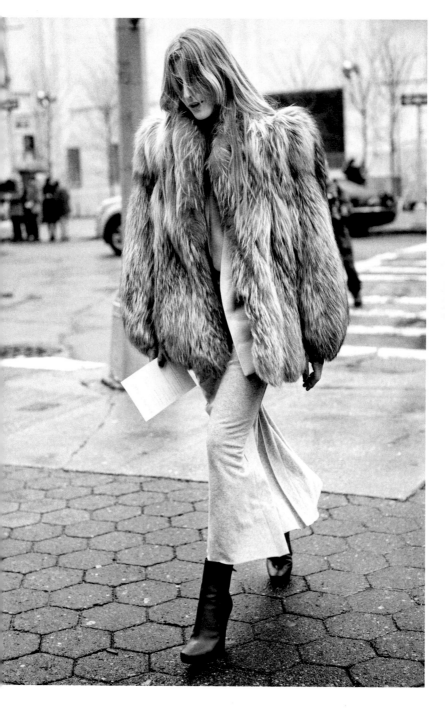

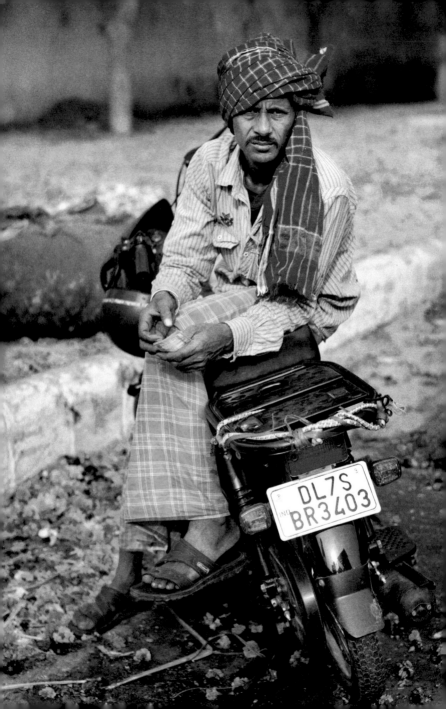

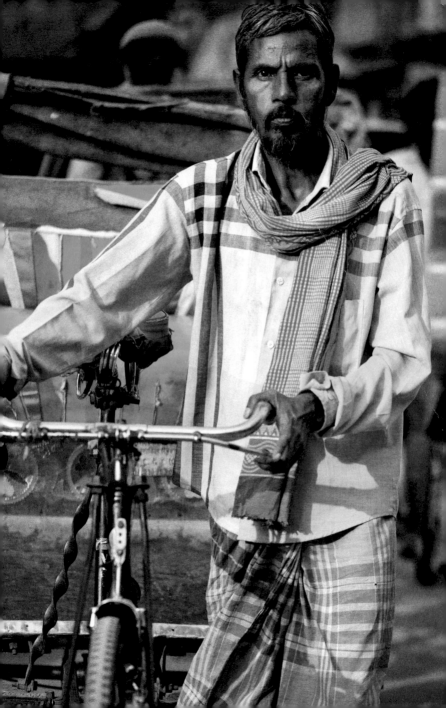

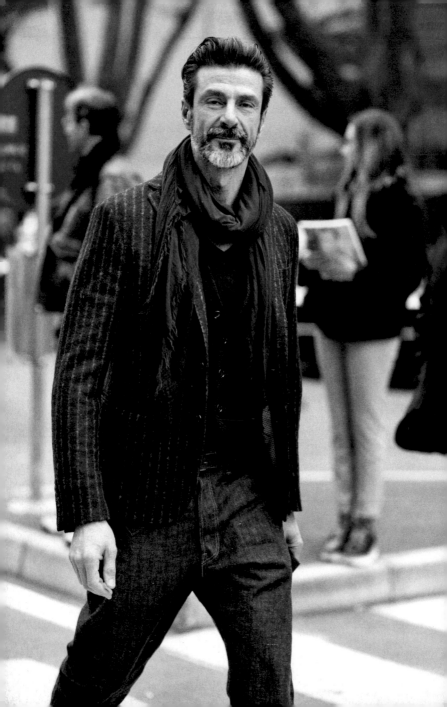

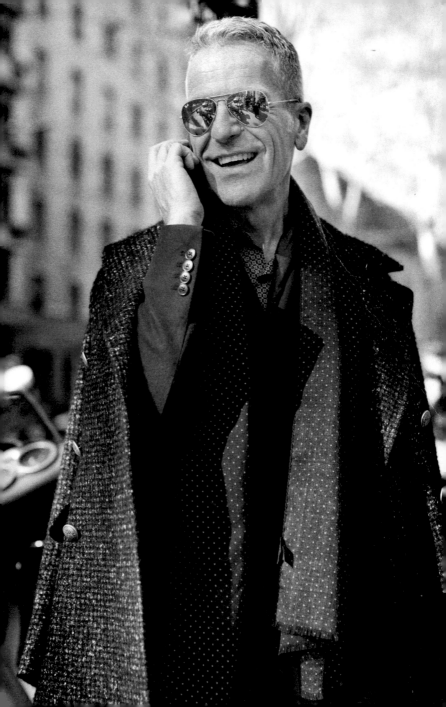

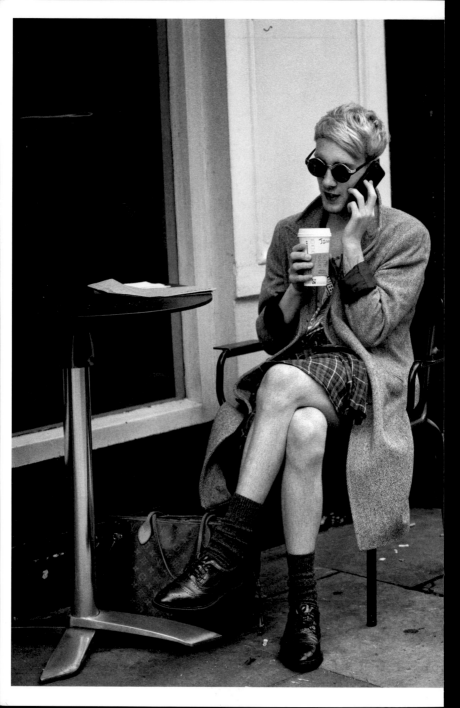

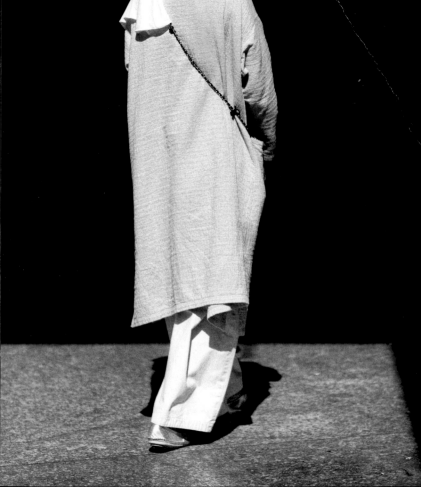

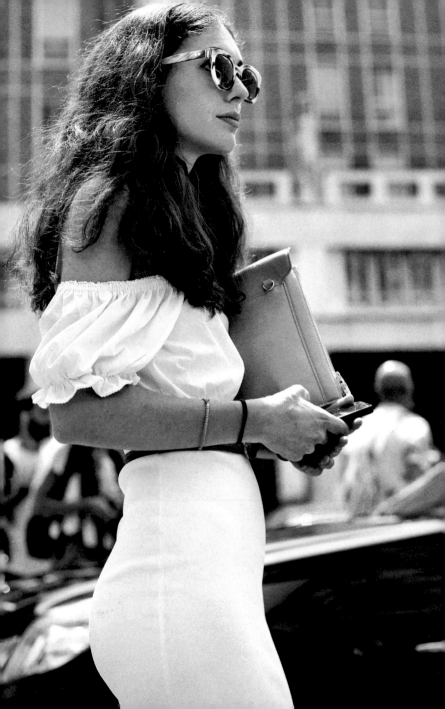

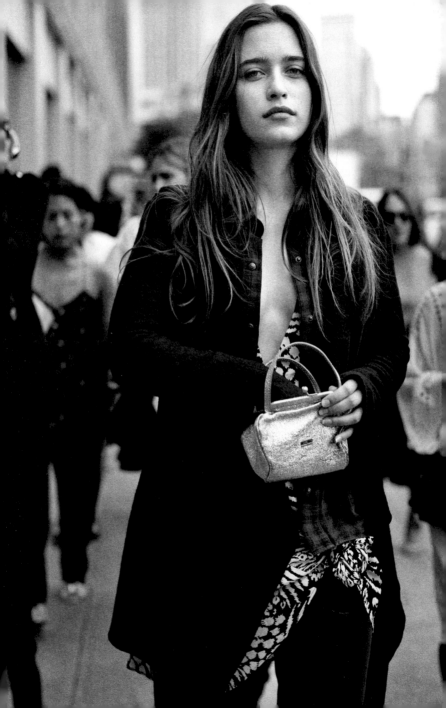

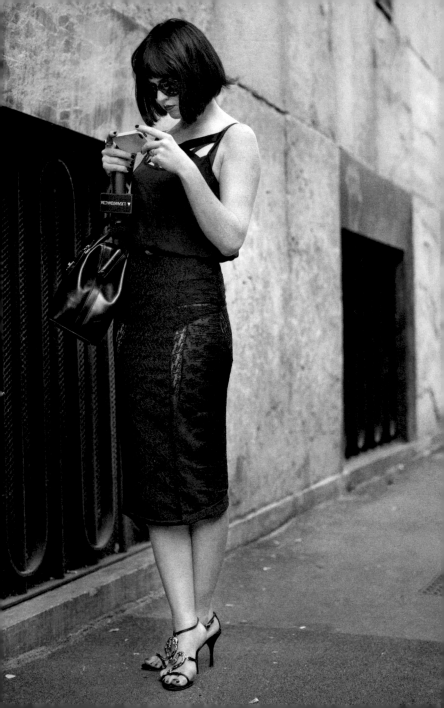

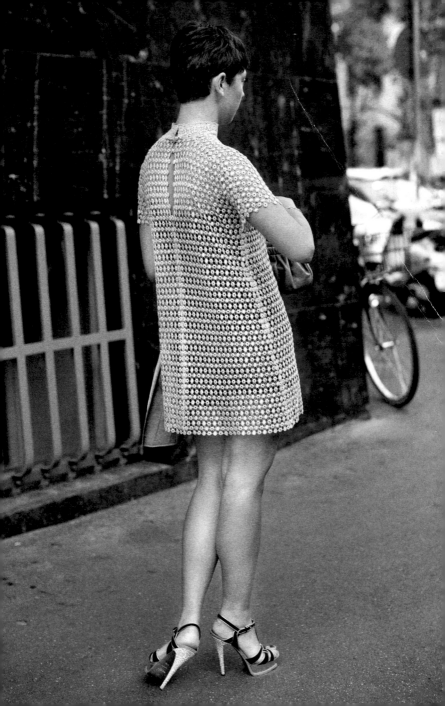

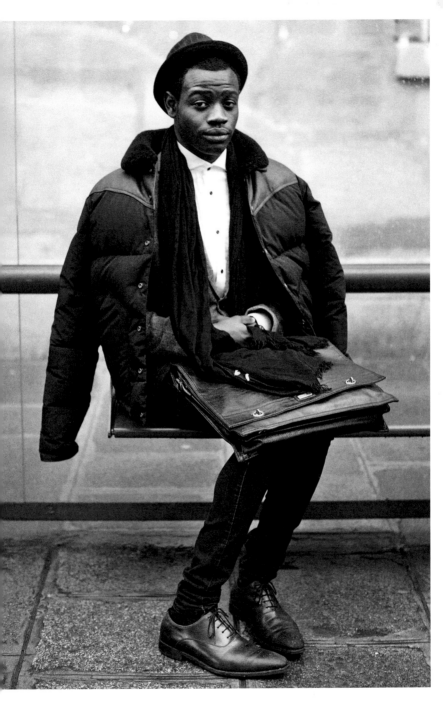

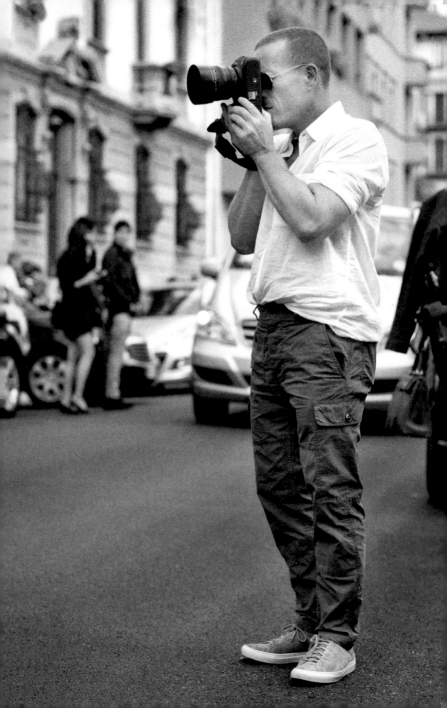

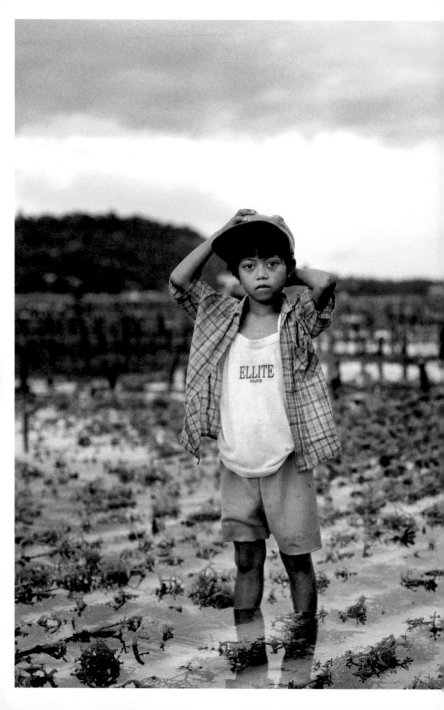

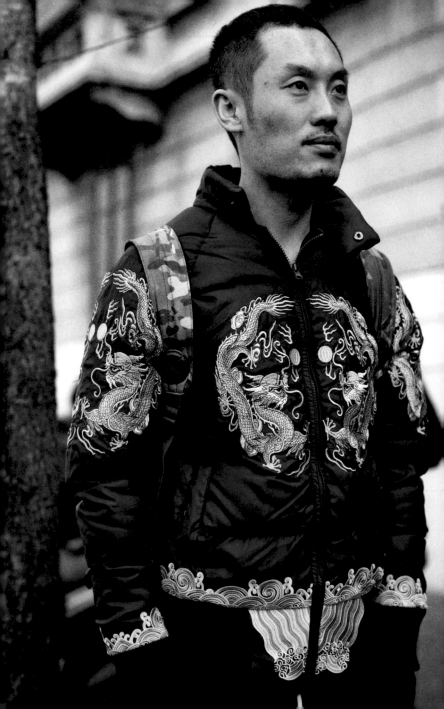

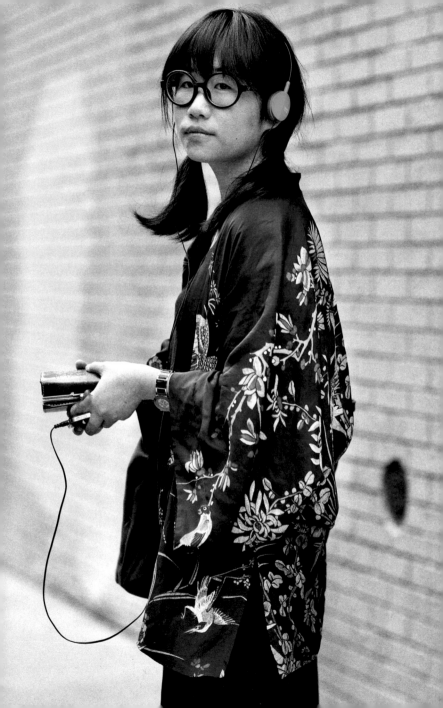

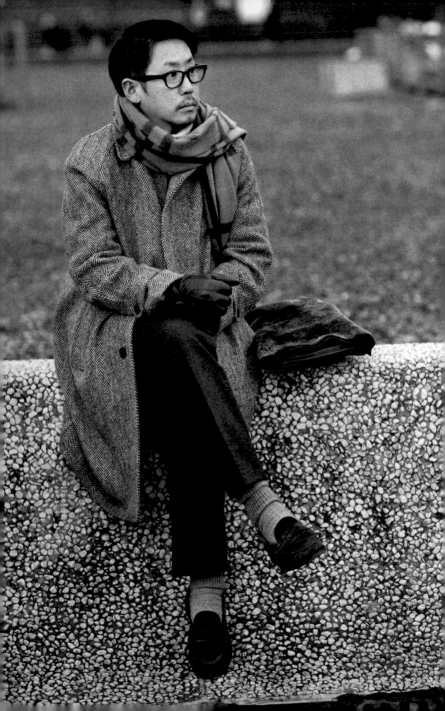

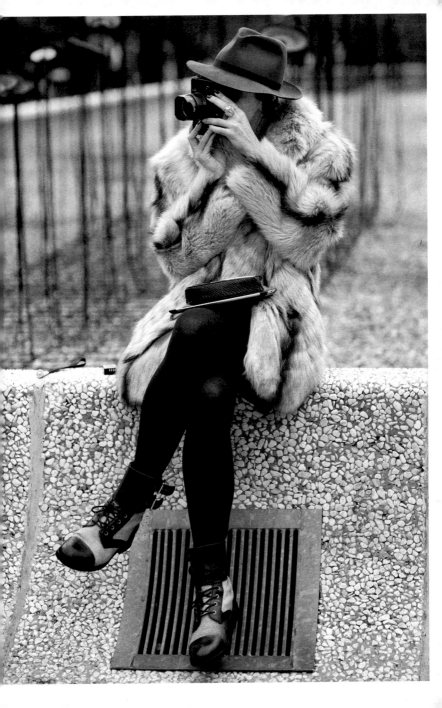

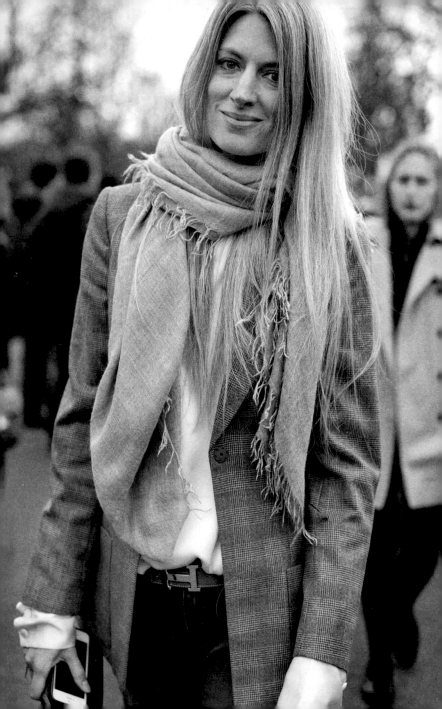

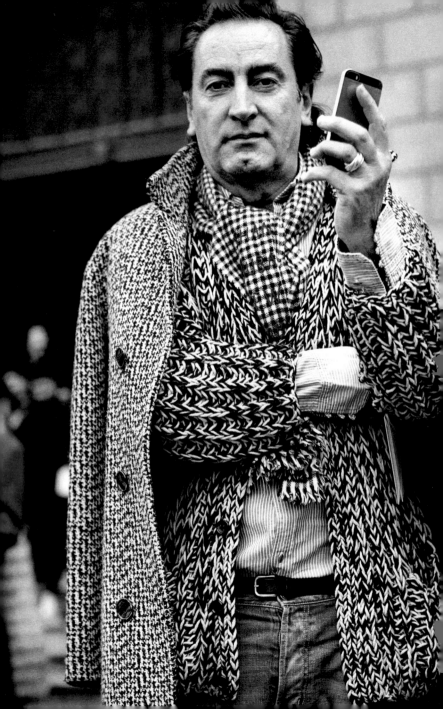

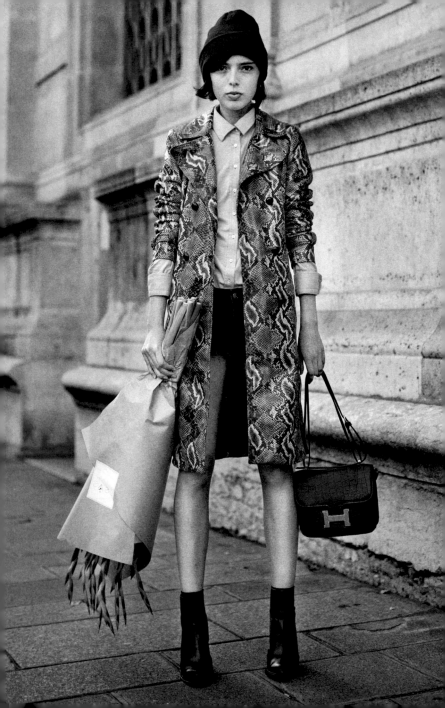

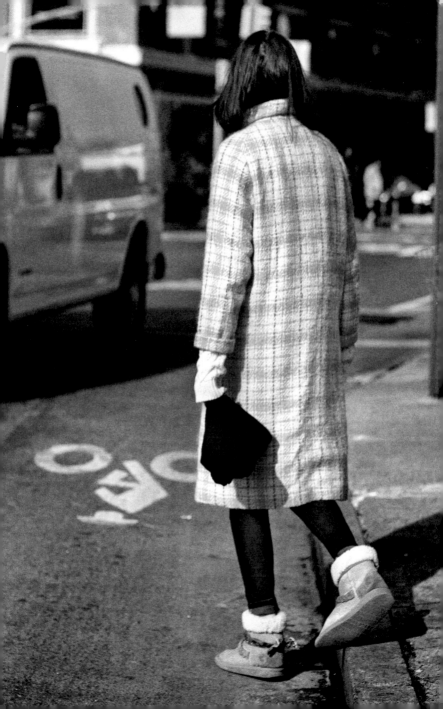

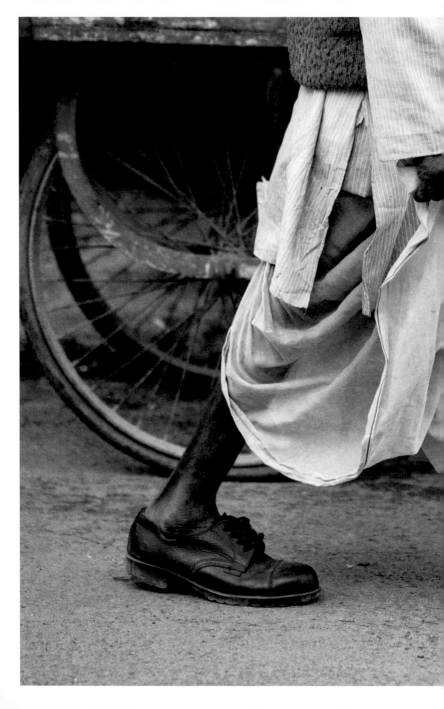

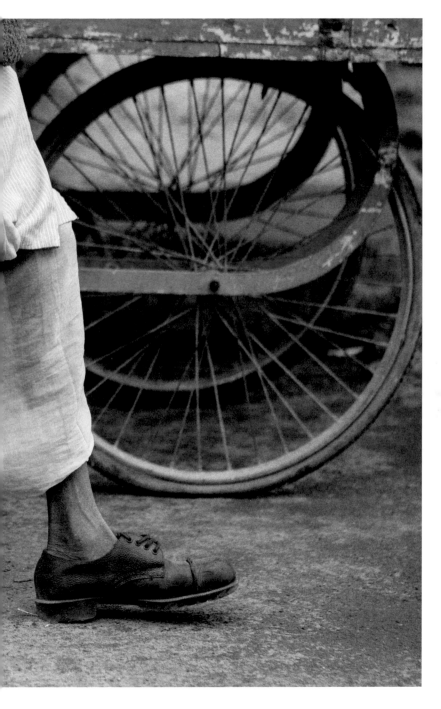

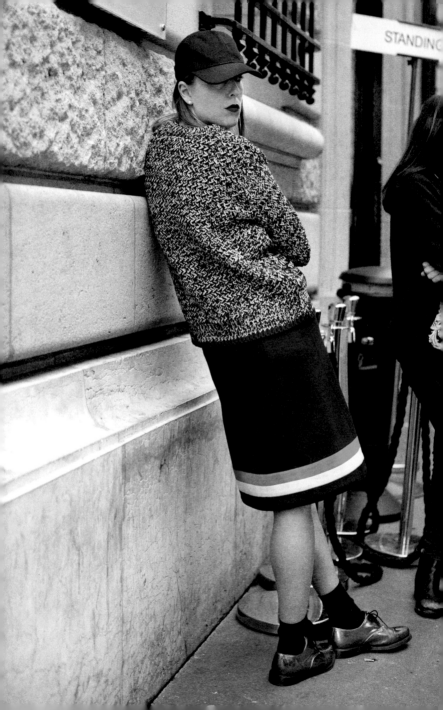

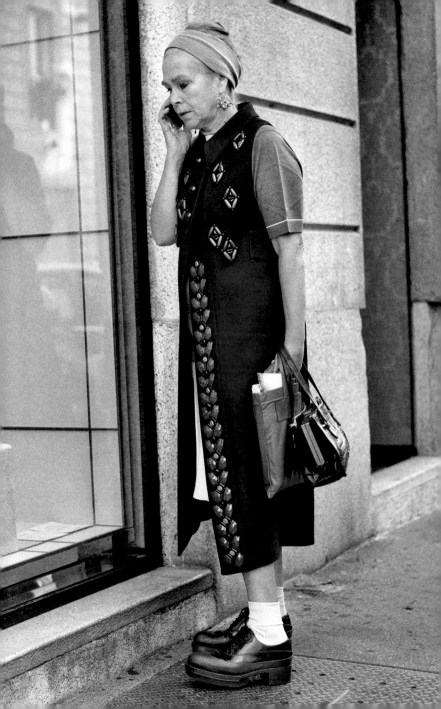

LAFAYETTE STREET

———

It was early spring 2012. I was sitting on my bike looking down at my phone on Prince Street when a fluttering blur of orange fabric and an expanse of bare skin flew past me, heading uptown on Lafayette Street. It took a full split-second to decide whether I wanted to pursue but after a very cold, long winter, any exposed skin is worth closer inspection. Now let me be clear, this young lady was flying up Lafayette and I was in hot pursuit trying to make up about 200 yards before I could even get in range of a shot.

She had long flowing red hair, her back barely concealed under a silk top tucked into a rich sunburnt orange skirt. At first I stayed on her right shoulder, shooting into the sidewalk, but that background proved to be too dark and too busy. I drifted over to her left shoulder and shot into the street but the taxis and cars were equally distracting. By this time we had both arrived at the traffic light on Houston and Lafayette. I decided that if I couldn't get the shot by 8th Street, the next intersection, I'd give up.

The light turned green and we were off. It was late afternoon and the sun was casting strong reflected pools of light along this stretch of pavement. As I took aim, I started to pick up the occasional, repetitive glint of light. I took my eye off of her back for a moment and, glancing down for the first time, realized she had a gold-hued metal prosthetic leg. This changed the whole idea of the shot instantly. I held a shallow breath and managed three shots in that 25 yard field of light and shadow before giving up.

Of the three shots, one frame, this frame, was perfect. I love how it captures something about psychical strength, sensual beauty and the freedom that only a springtime bike ride can offer.

———

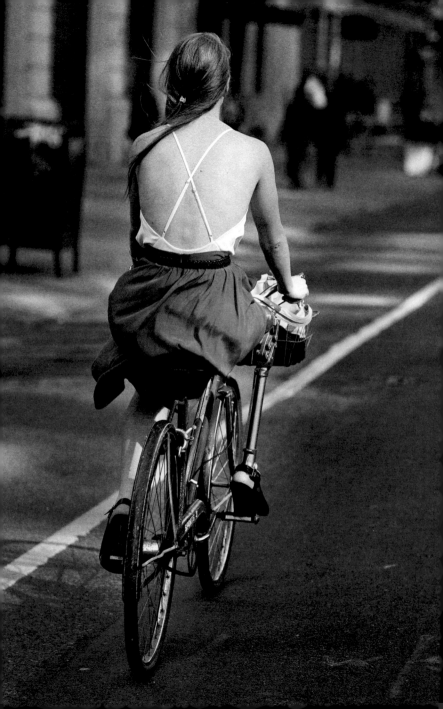

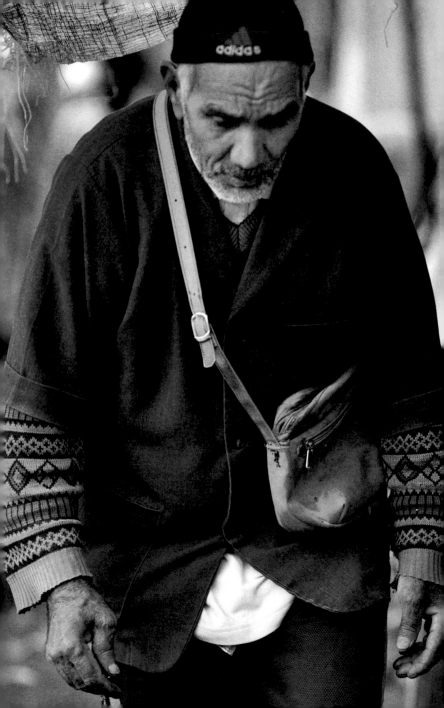

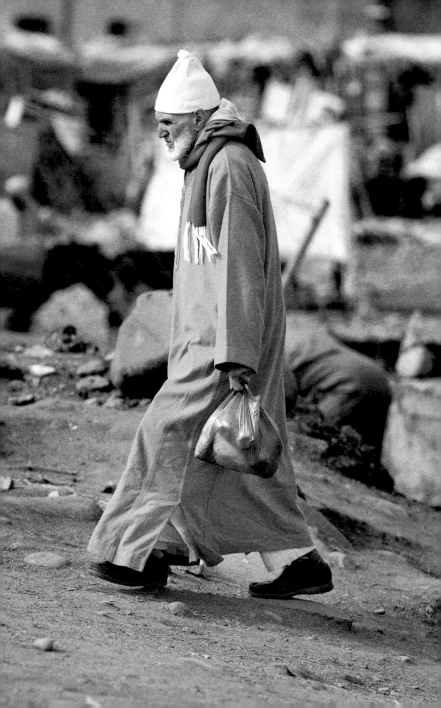

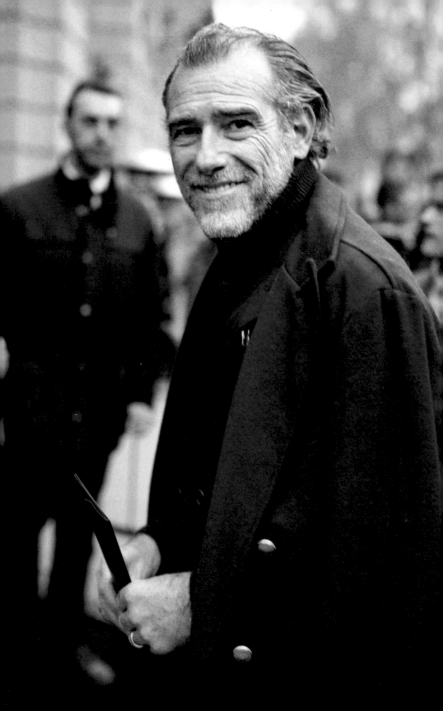

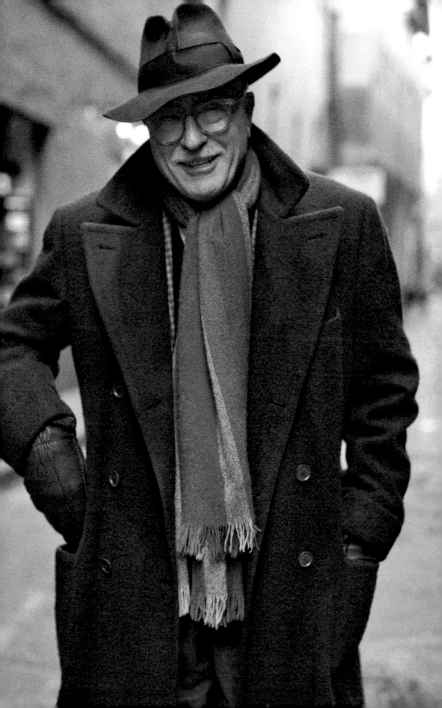

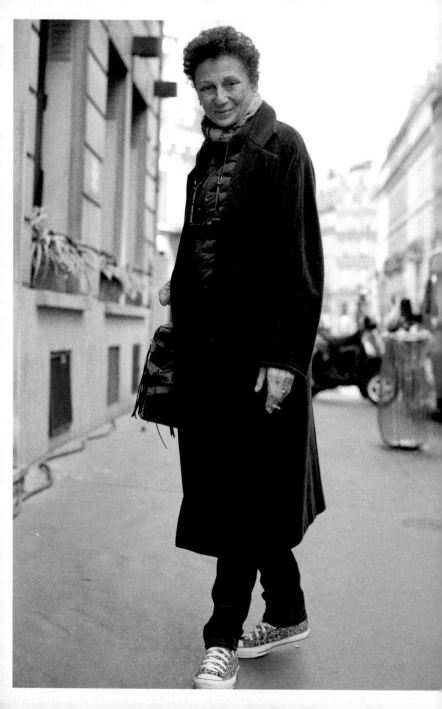

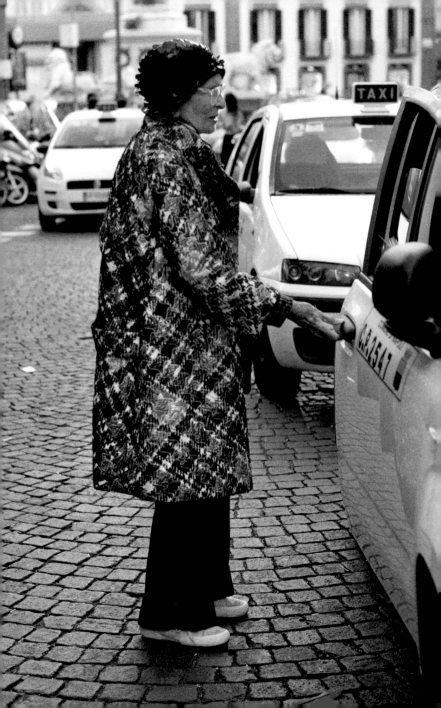

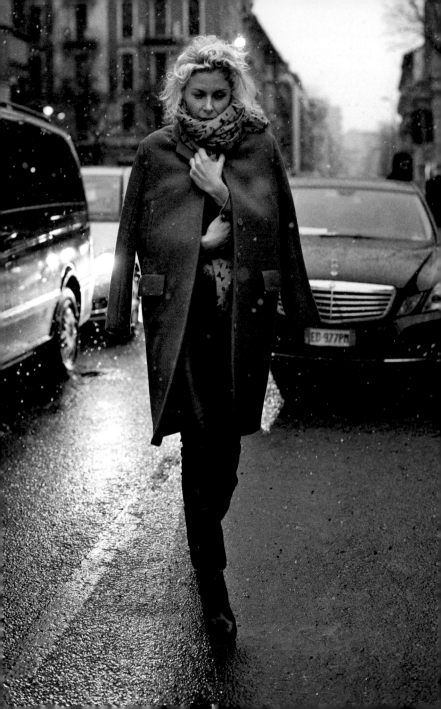

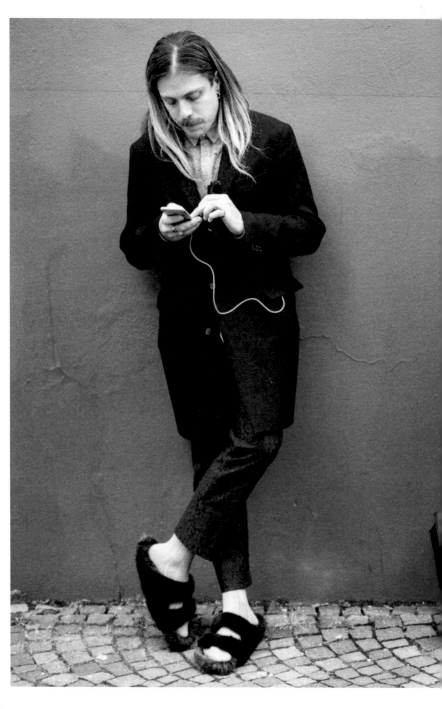

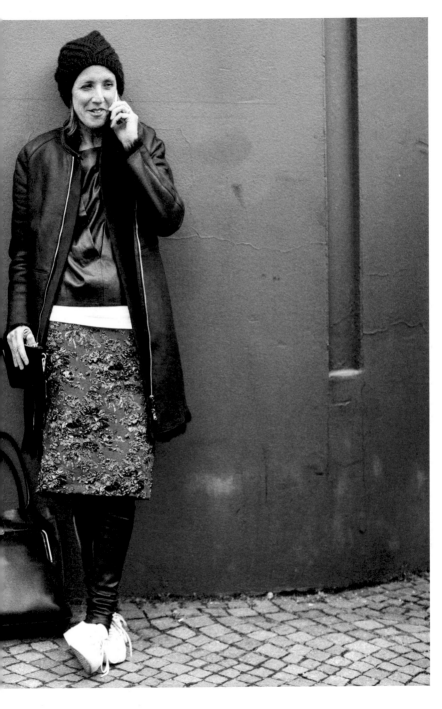

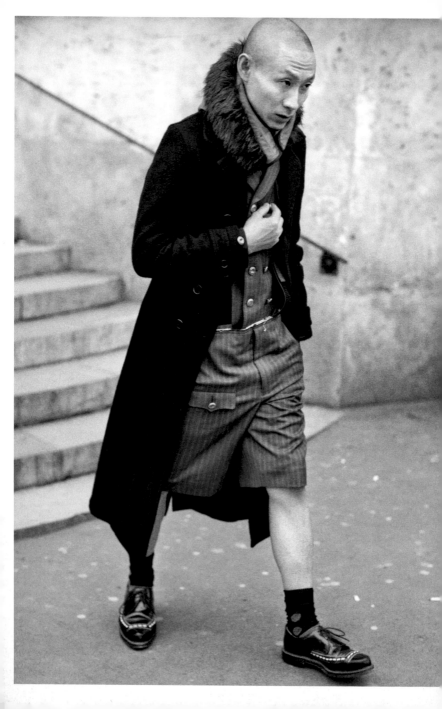

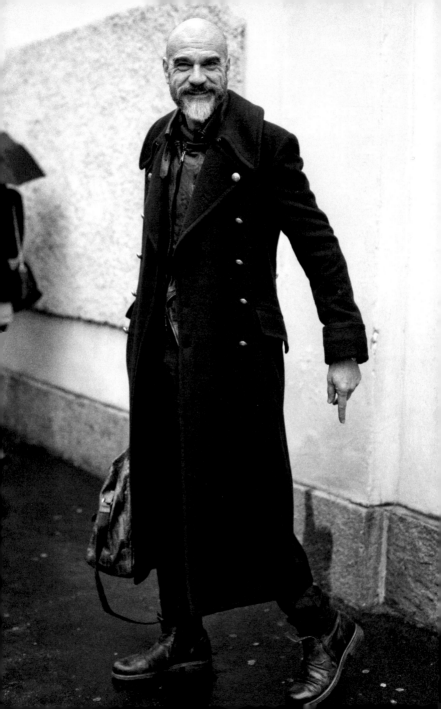

PENCILS AND PAINTBRUSHES

I love shooting with my iPhone.

If the camera is my paintbrush, the iPhone is like a pencil. I can instantly share on Instagram photos that I would have felt were too whimsical for my blog.

It's also made me a better photographer by forcing me to keep my eyes open to any stimulation. I find that it's easier for me to start exploring new subjects like architecture or landscapes, or even selfies, when shooting from my phone because it doesn't demand the commitment of carrying around the big Canon camera when I'm not sure what I'm looking for anyway.

To my surprise I've received quite a bit of work solely based on iPhone shots that clients have seen on Instagram.

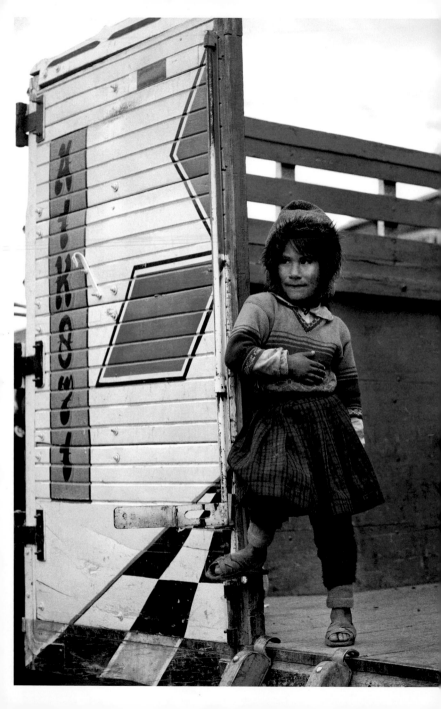

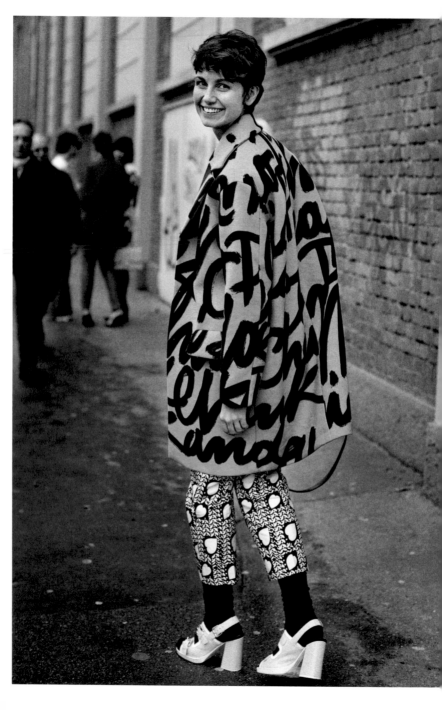

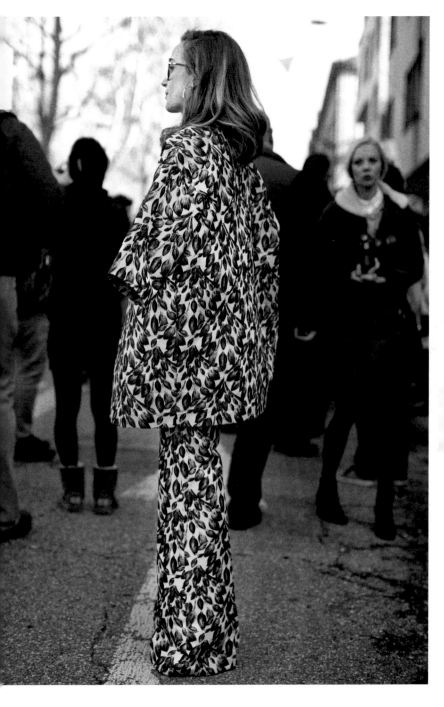

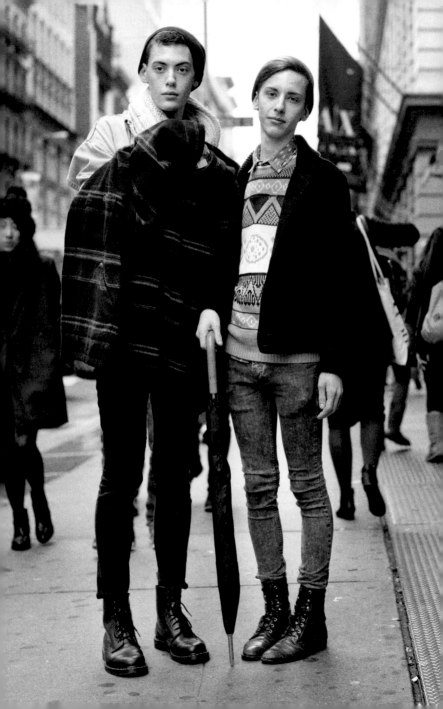

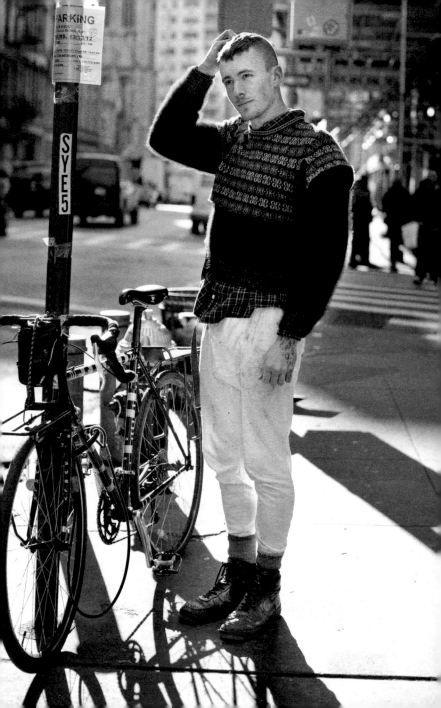

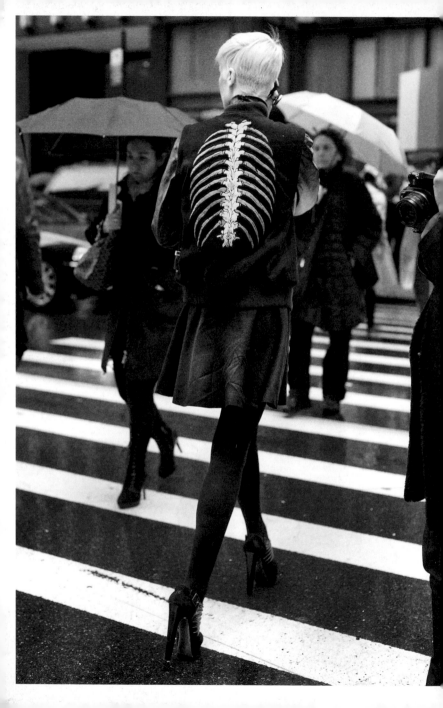

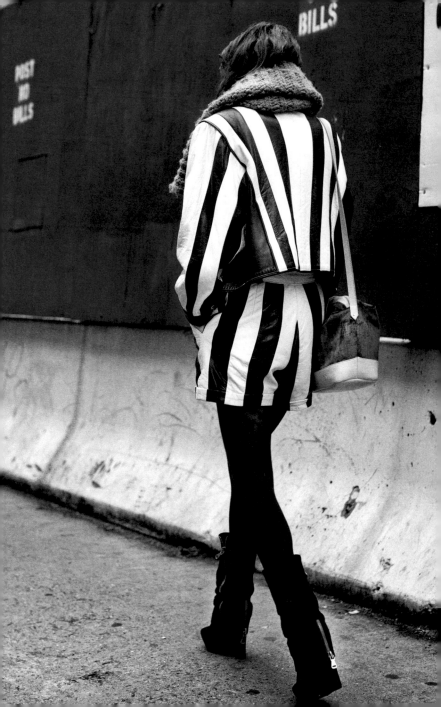

RUNWAY CHALLENGE

———

'Who would wear these clothes?', 'Where would you wear these clothes?', 'I can't afford these clothes!'

YOU'RE RIGHT!

For most people, what appears on the runways of New York, Paris or Milan will always be out of reach and too fashion-forward. But it doesn't mean the suggestions offered at fashion shows can't have a potentially dramatic impact on your everyday style.

Let's remember one thing, the best international designers are very, very good at: colour combinations, pattern mixing, layering textures and mashing up unusual cultural references (think eskimo firefighter).

Take a collection like Prada. I challenge you to flip the looks upside down and appreciate the abstract suggestions Miuccia offers on colours, texture and pattern. The chartreuse green, dark peppermint and electric teal in the far right figure… not everyone can mix colour like that! Or the royal blue, grass green, powder pink and plastic yellow on the near right model – again, that's a very sophisticated colour story you simply don't see every day on the street.

Here's another challenge: spend some time looking at runway photos of the opposite sex. Even though I've never worn women's clothes, I always come away from the women's collections filled with fresh inspiration.

The final challenge. I rarely wear colour. I love it but just not on my body. You know where most of that runway inspiration influences me? In my home decor. I would love my home to look like a Dries Van Noten runway show.

———

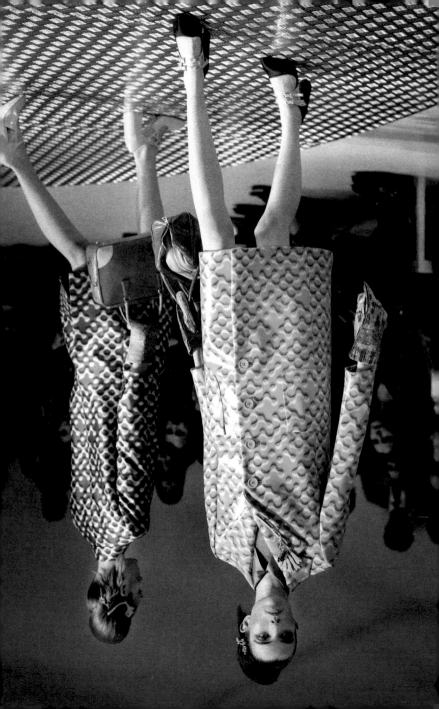

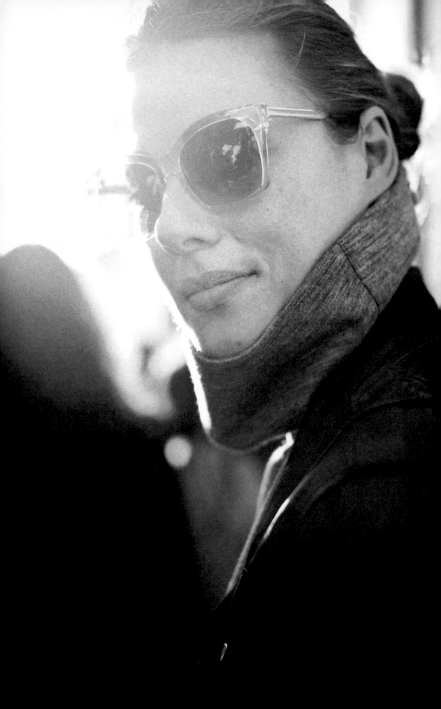

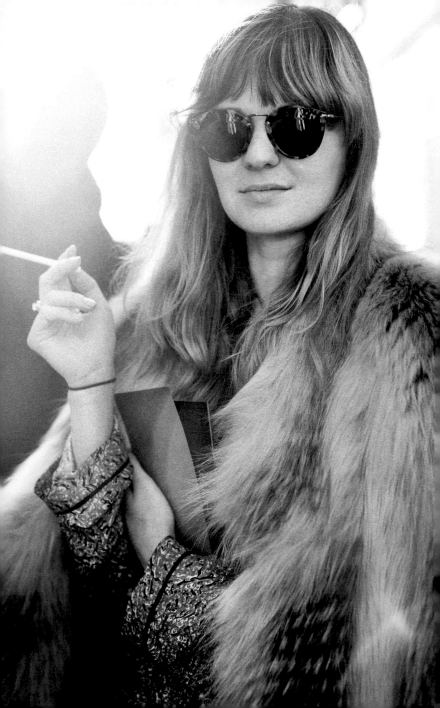

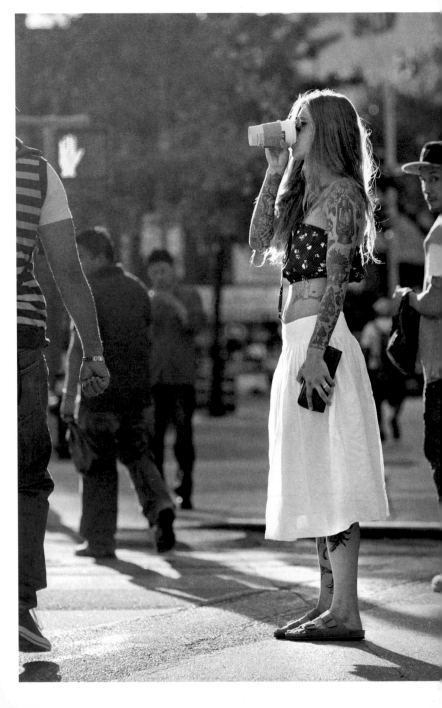

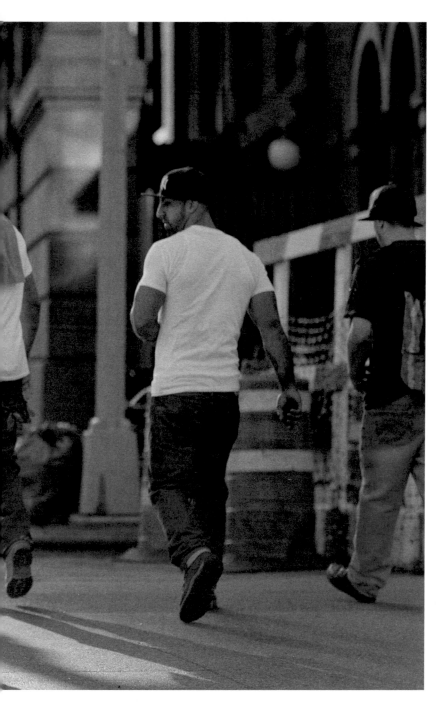

—

ON THE STREET...
FIFTEENTH ST.,
NEW YORK

—

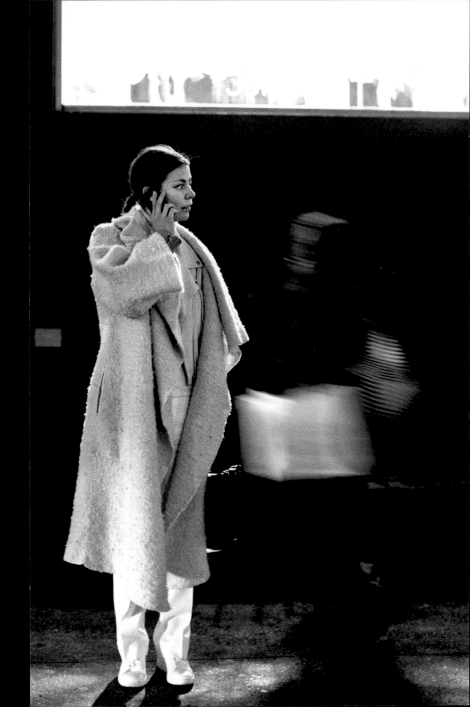

STREETS OF THE WORLD

—

I'm always surprised by the reaction when I post a photo on the blog of someone from a humble background, dressed in a way I find inspiring. People say 'this person is worried about their next meal, not what colour shoes to wear', but what I think they seem to miss is that there is a difference between having less and having nothing. Much of the world is poor, but this does not prohibit people from enjoying life, music, food, art and, yes, even fashion.

Look at the gentleman on the facing page that I met in Peru. I didn't get the sense he had a lot, but wearing a hat jauntily tilted to the side clearly says to anyone of any culture 'I've got style!'

Or the two gentlemen I saw working in the spice markets of Mumbai. They worked as porters but they stood out for very similar reasons. The man on page 108 wears such a beautiful colour combination of green and blue but it wasn't until later, when working on the image, that I noticed that the selvage along the bottom of his *lungi* was the exact same green as his shirt. Was this on purpose? I guess we'll never know, but I'd like to think so. And look at the man on page 109 even in the heat he was meticulously dressed. His shirt was perfectly ironed and the *lungi* carefully wrapped. He really stood out from the other porters, not for the price of his clothing or artistic flair specifically, but for how carefully he put himself together. He took pride in the way he dressed and that's true elegance.

—

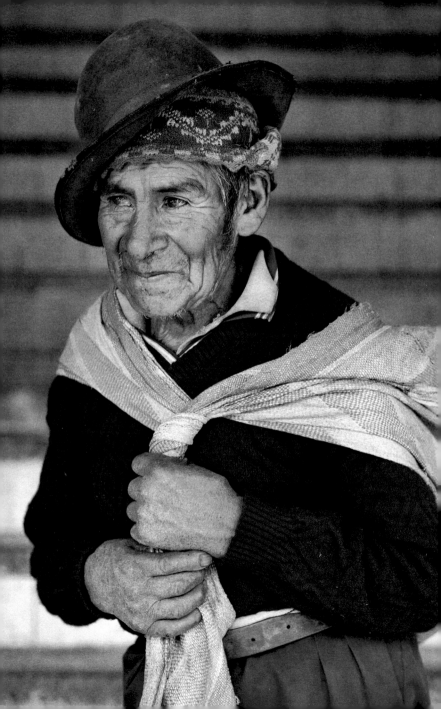

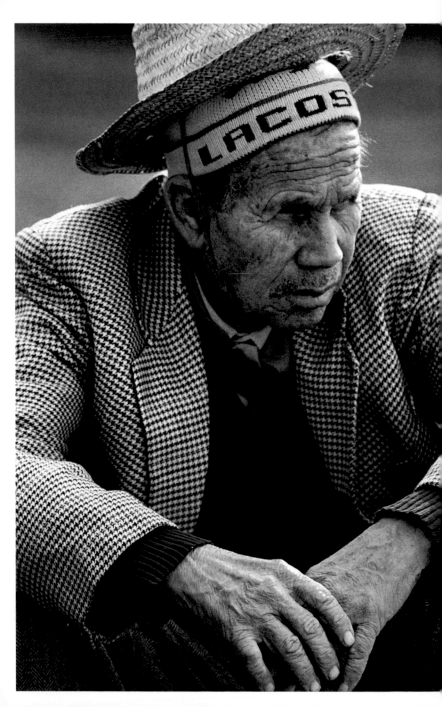

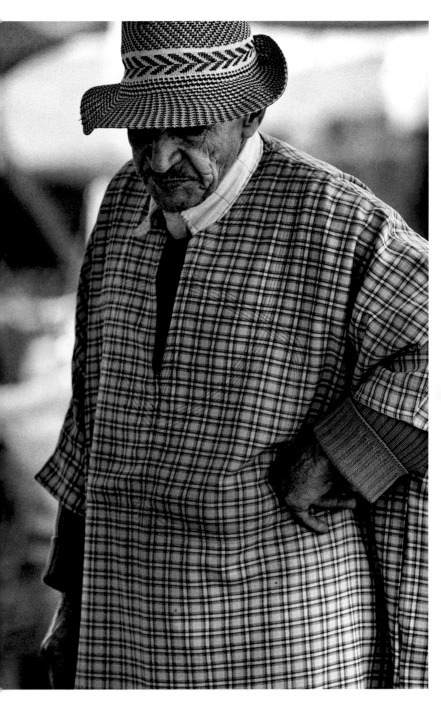

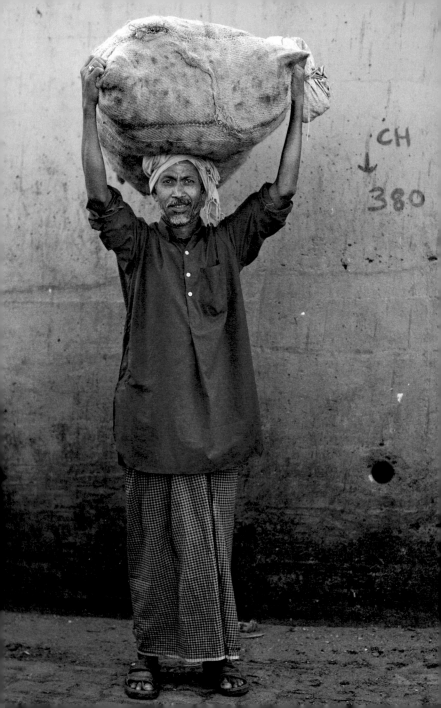

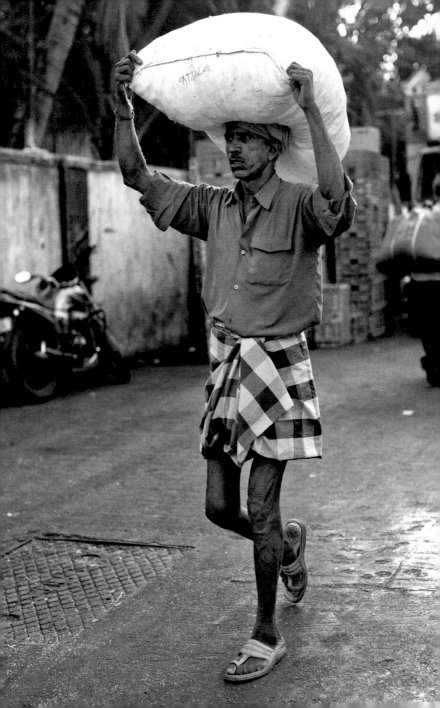

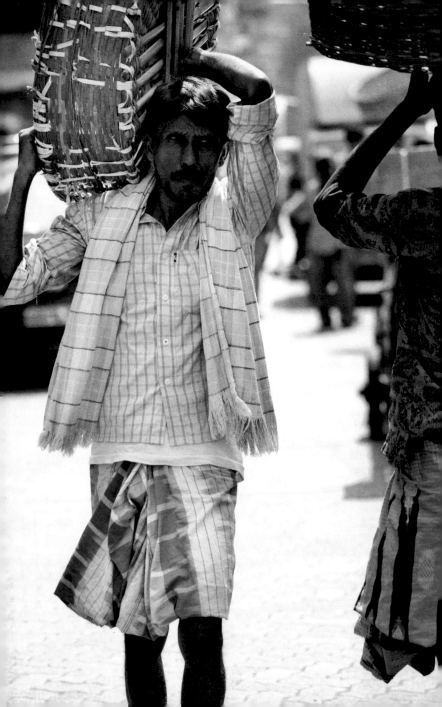

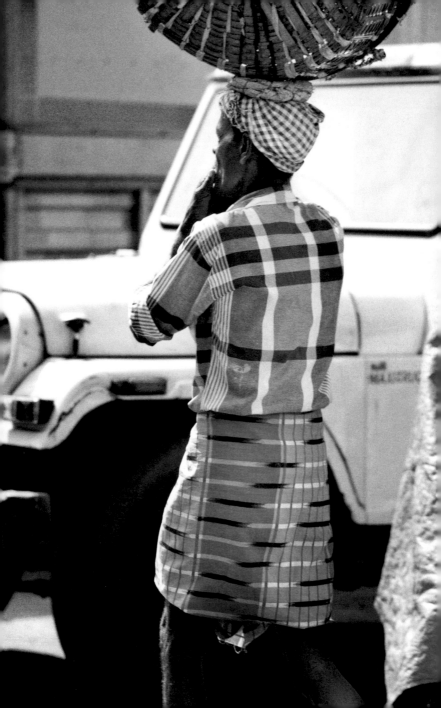

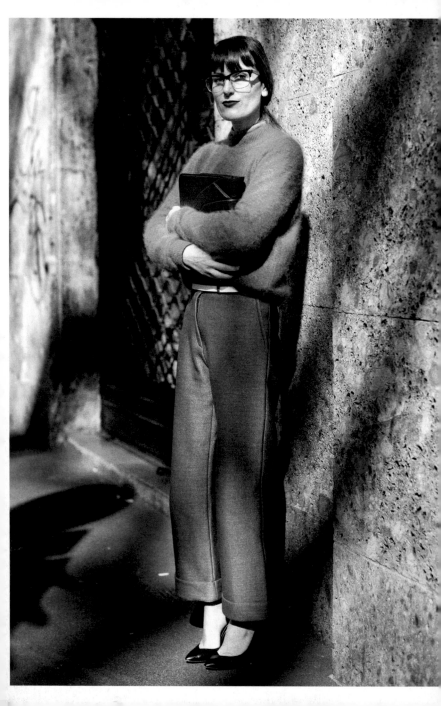

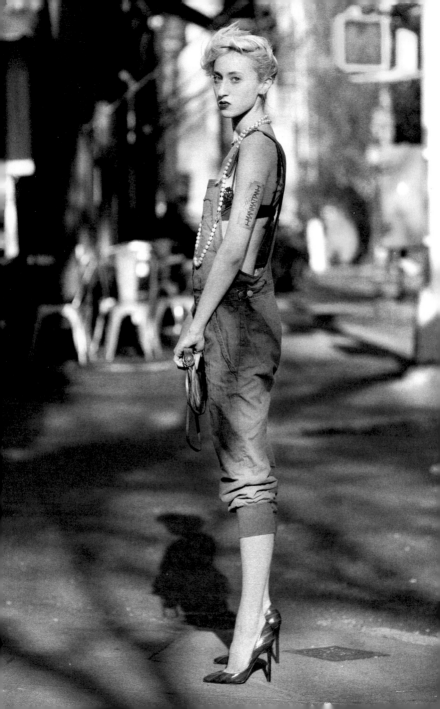

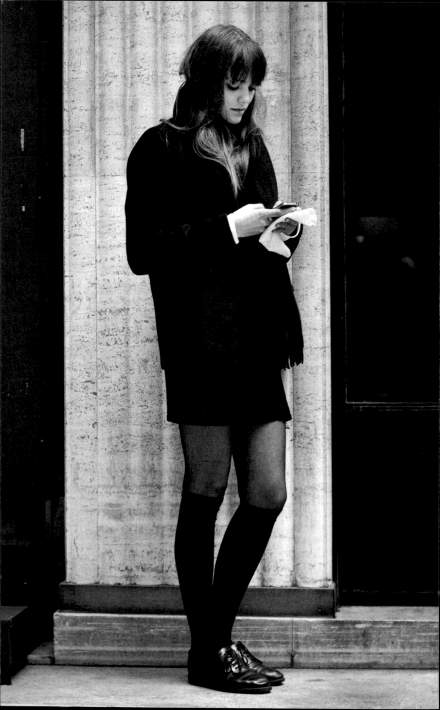

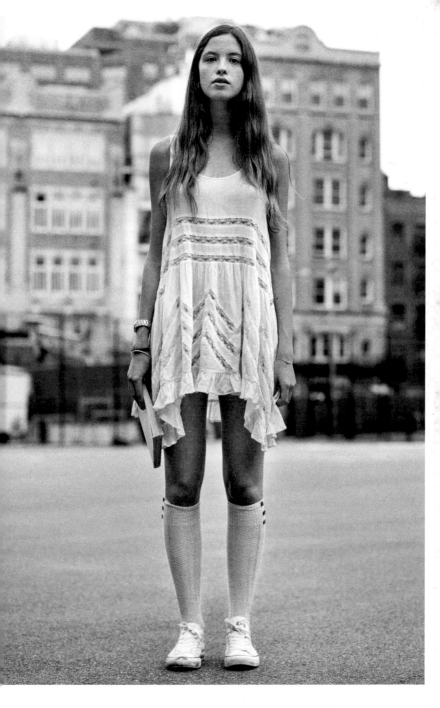

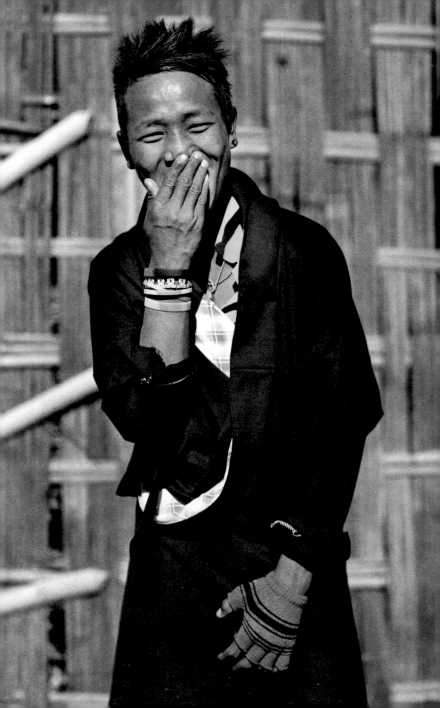

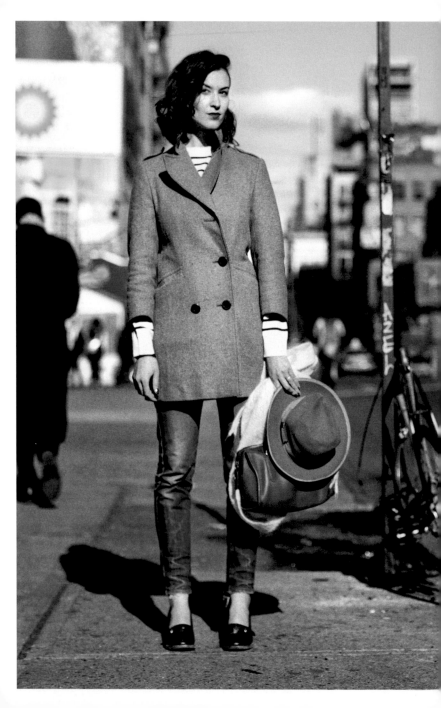

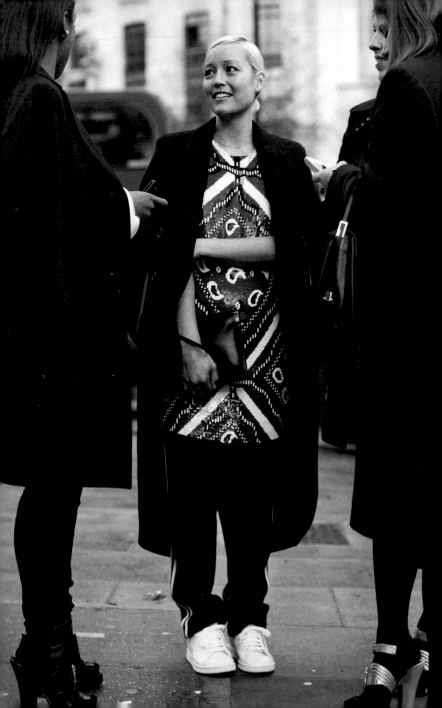

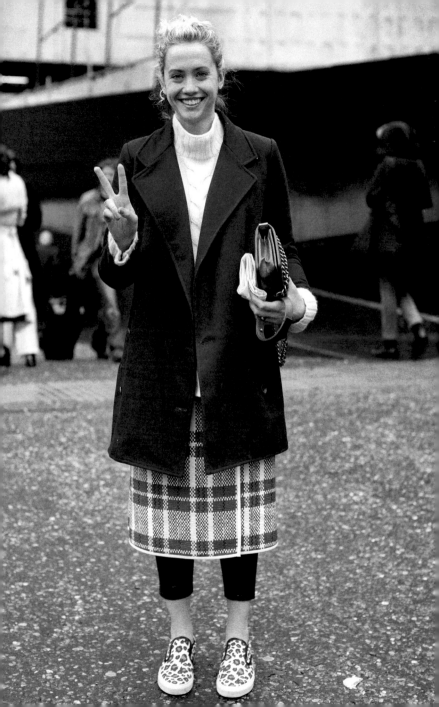

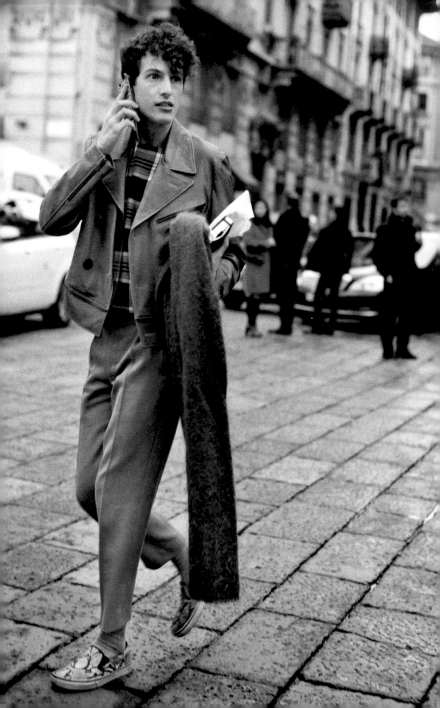

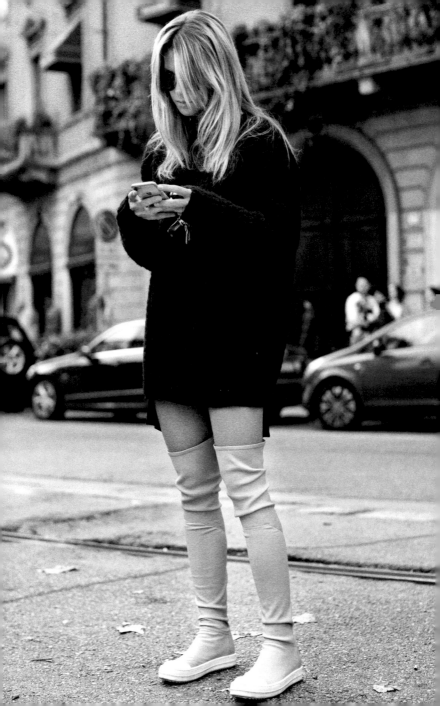

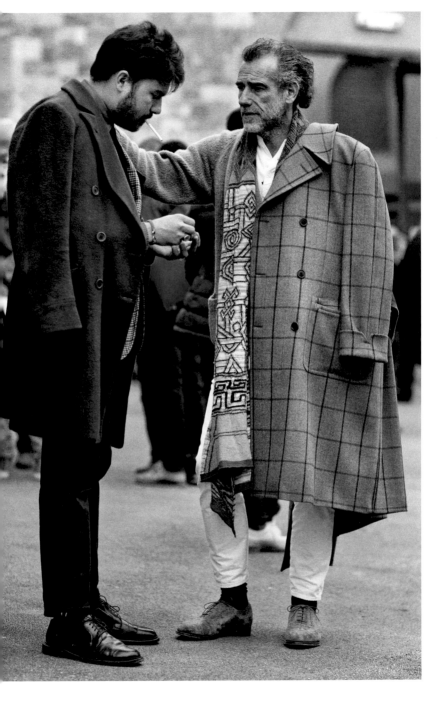

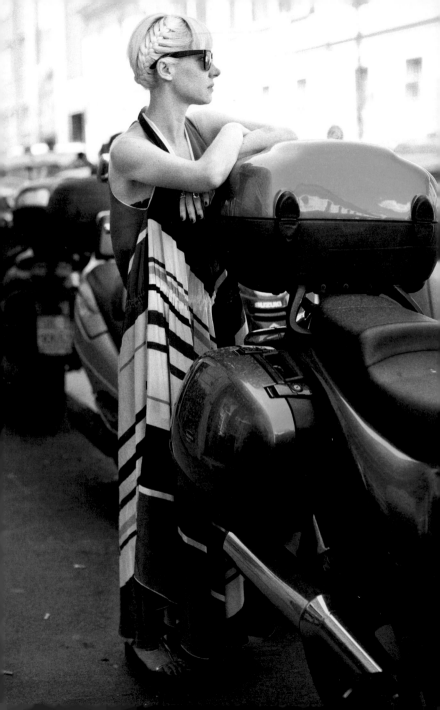

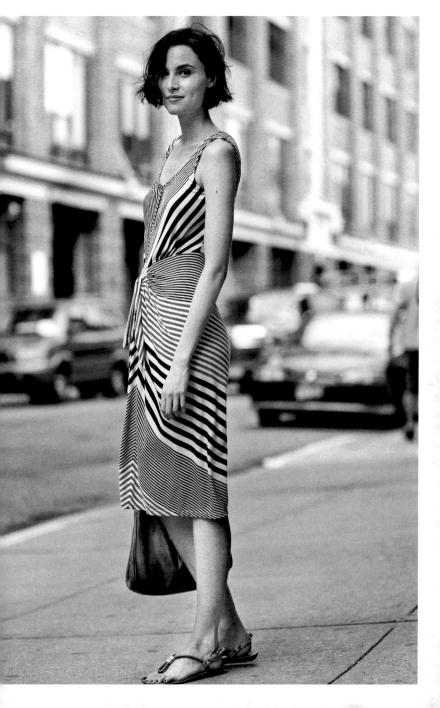

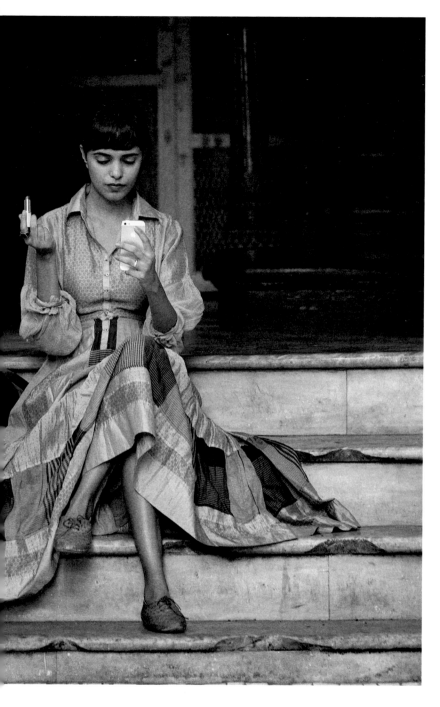

PERU

———

Peru's the place that, for me, is all about colour! Sorry, India.

On my first trip to Lima and Cusco I was taken aback by the subtle sophistication of the colour combinations worn by local women. Just look at the rich jewel-toned colors of the woman on the facing page. In the same town square of a tiny village not far from Lake Titicaca was a woman (page 132) wearing a shockingly bold orange sweater under a yellow marled knit cardigan, atop a gunmetal blue skirt.

I've seen just enough of Peru to want to make it at least a yearly stop on my global tours.

———

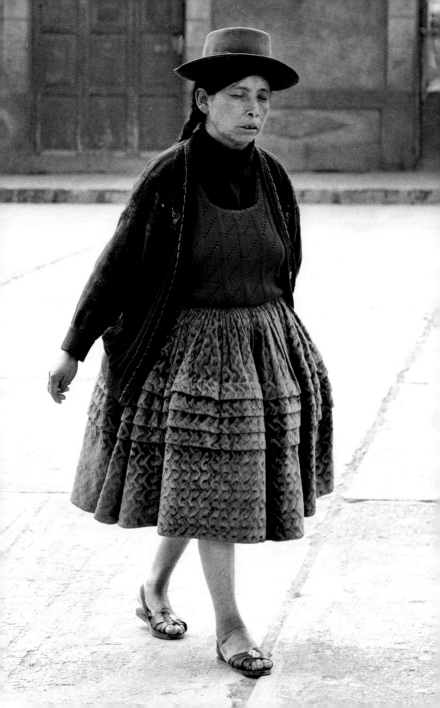

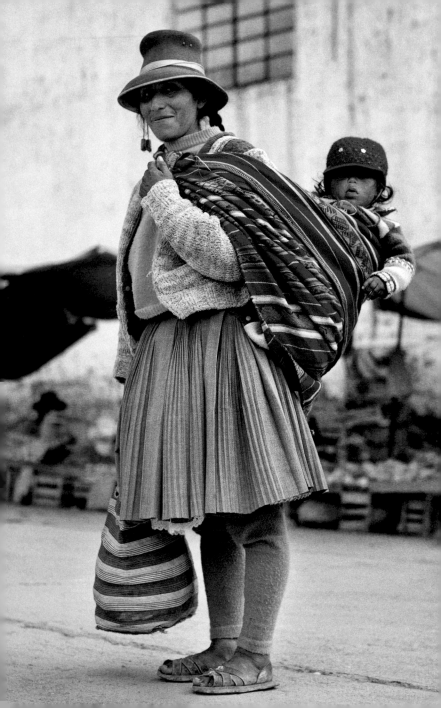

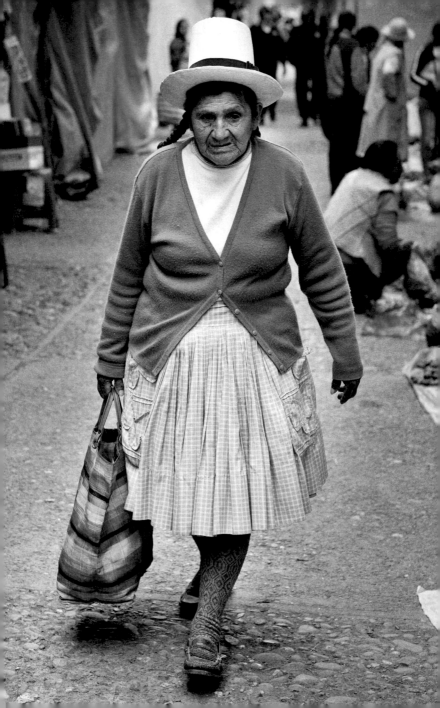

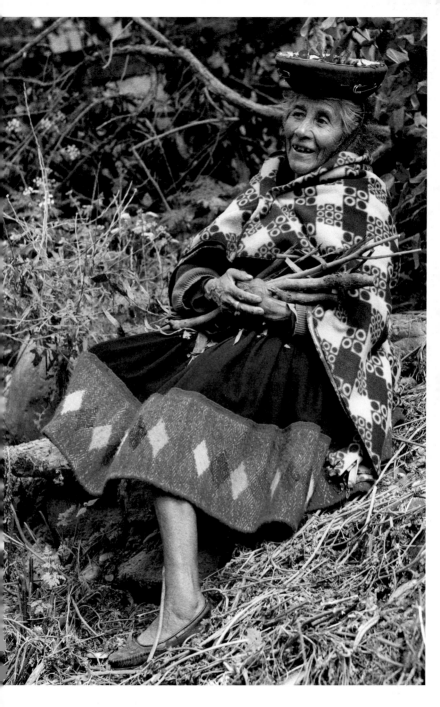

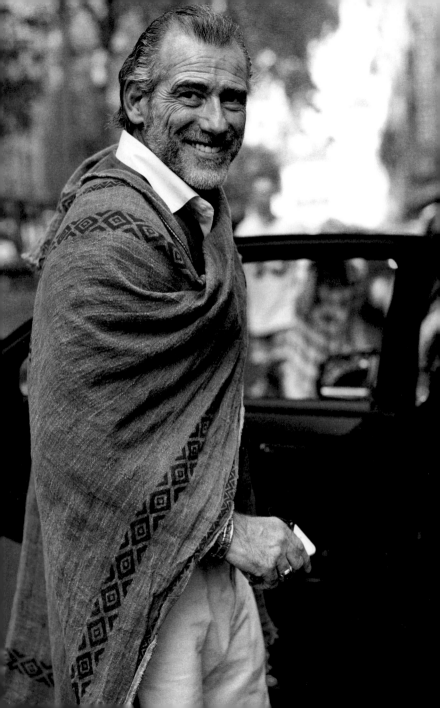

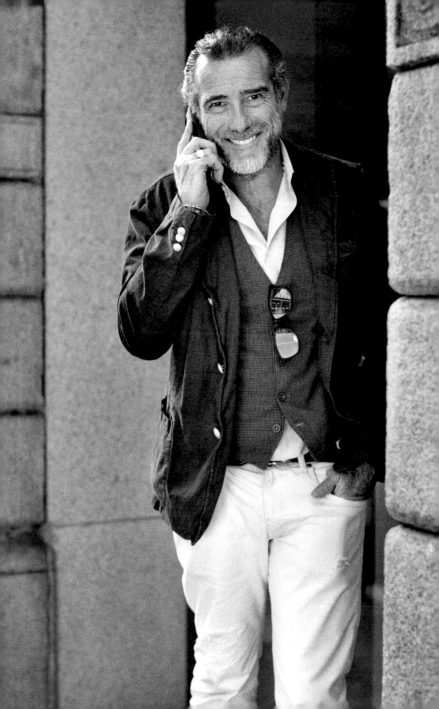

—

ON THE STREET...
PIAZZA OBERDAN,
MILAN

—

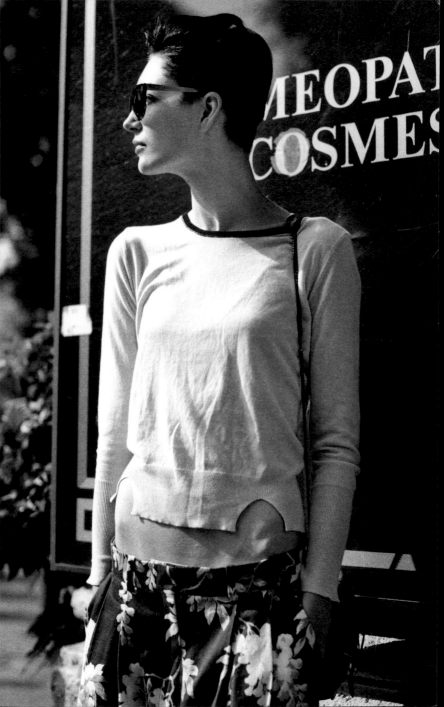

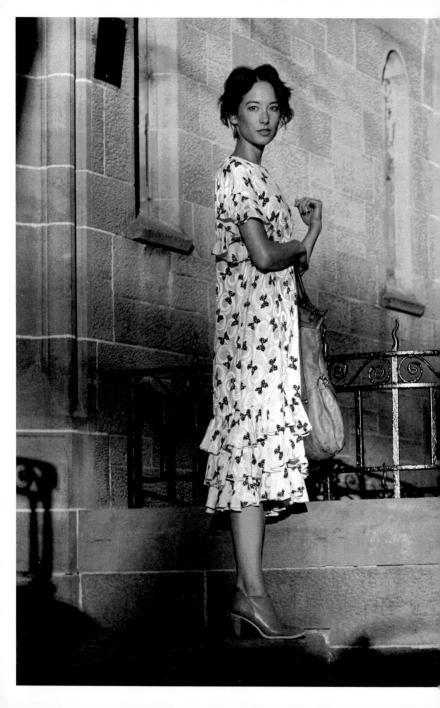

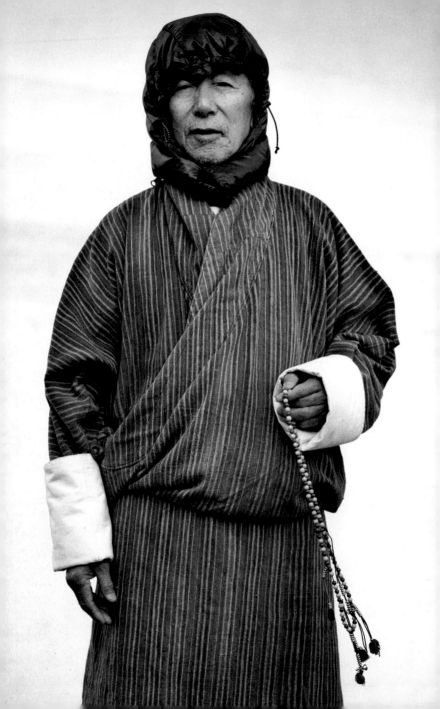

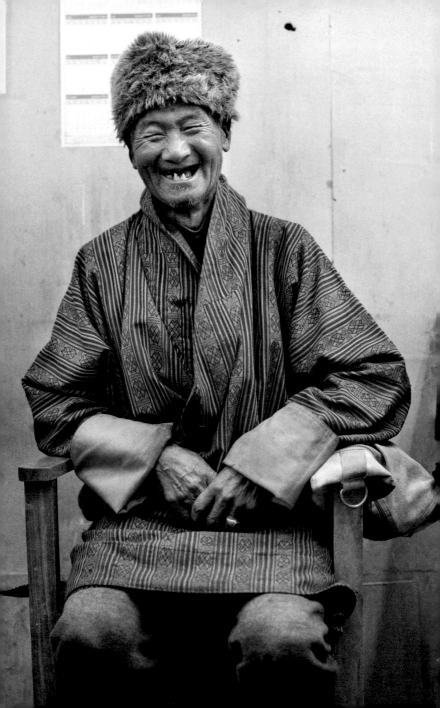

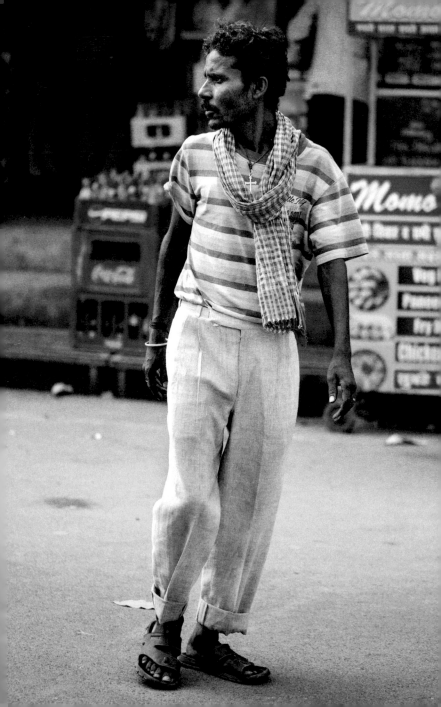

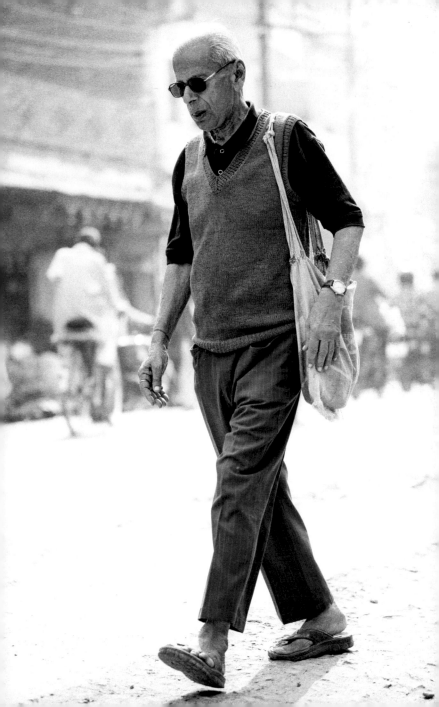

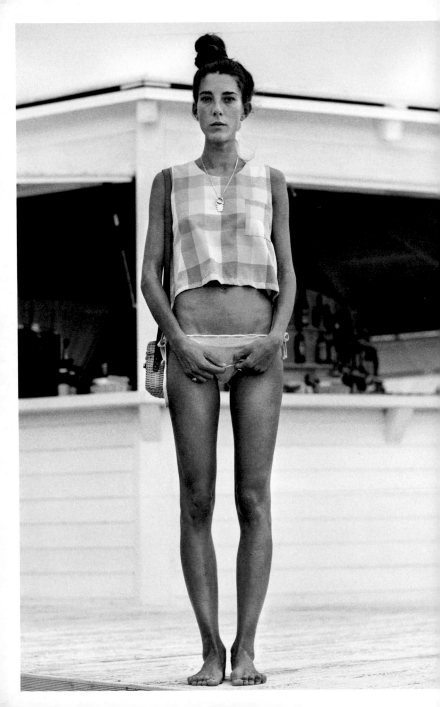

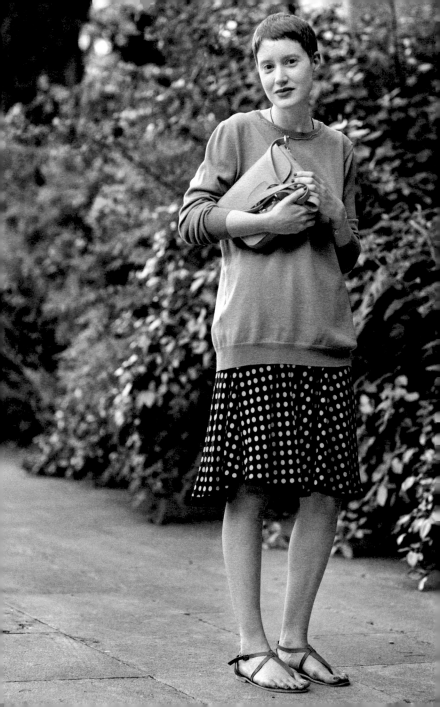

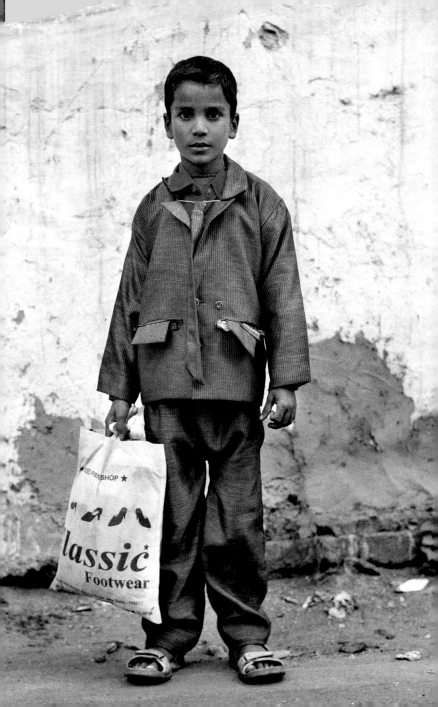

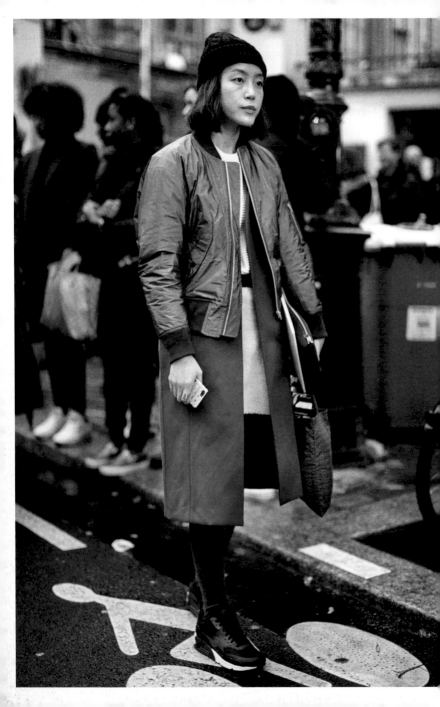

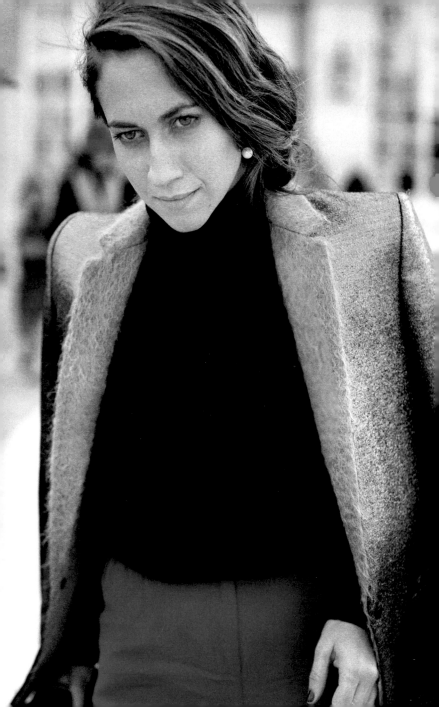

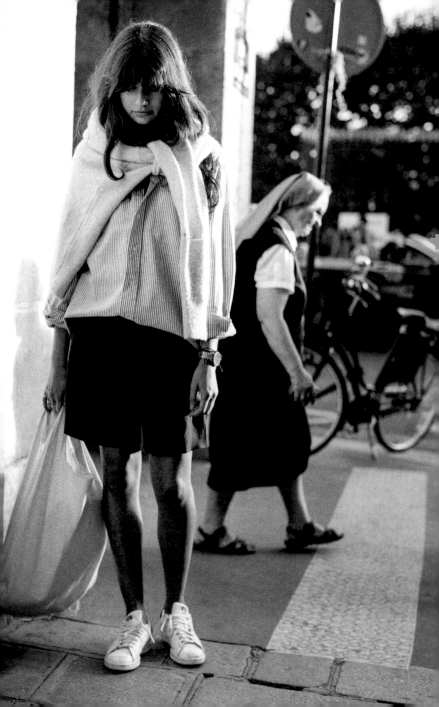

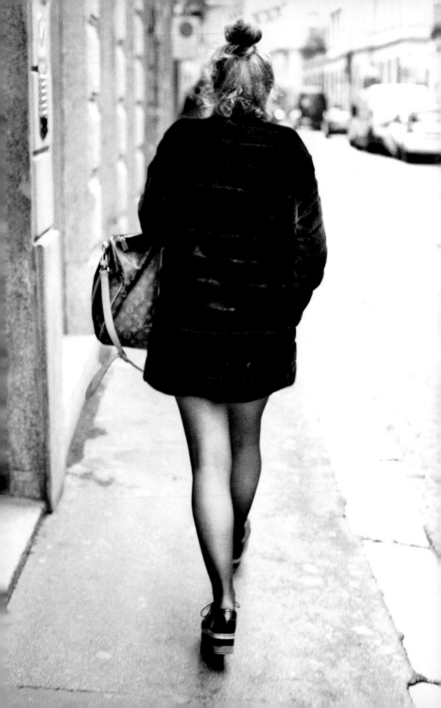

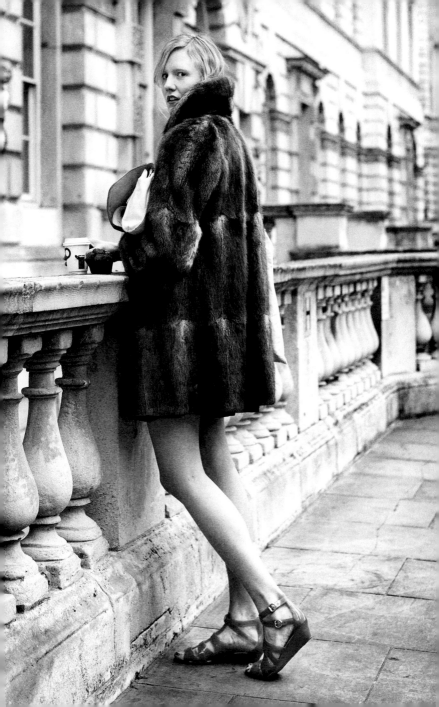

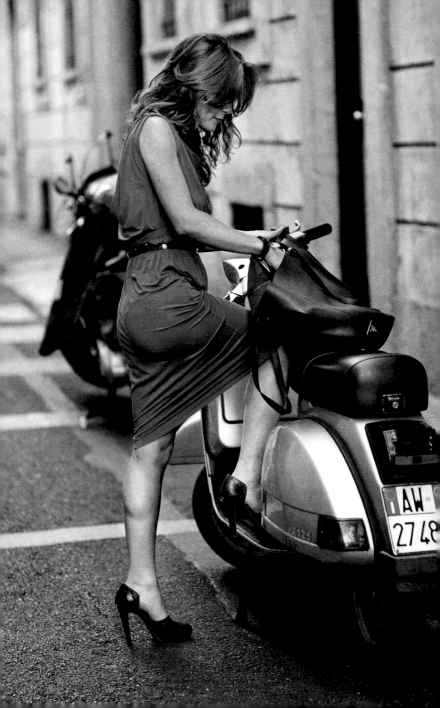

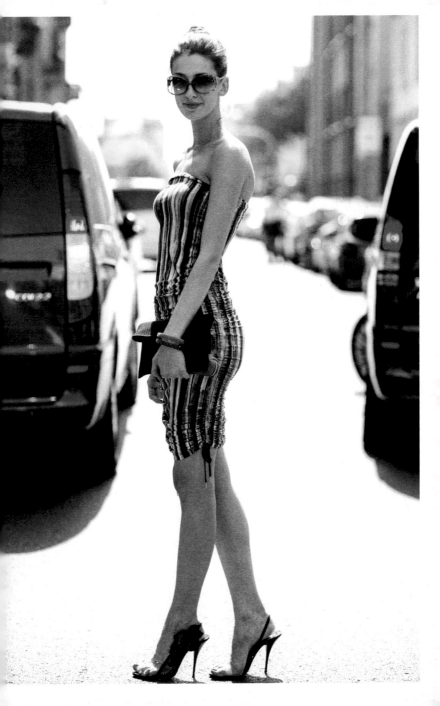

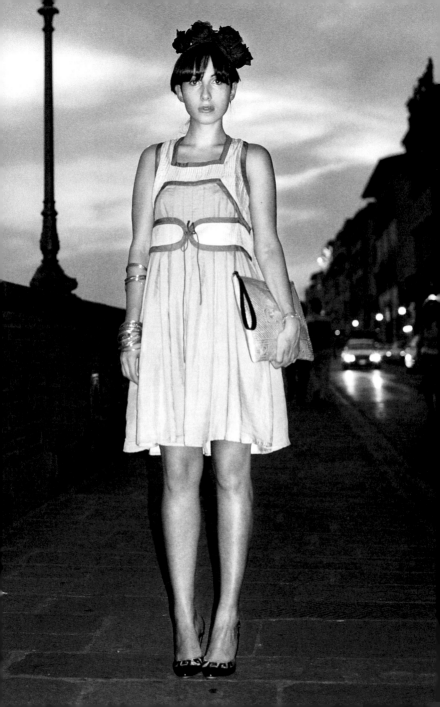

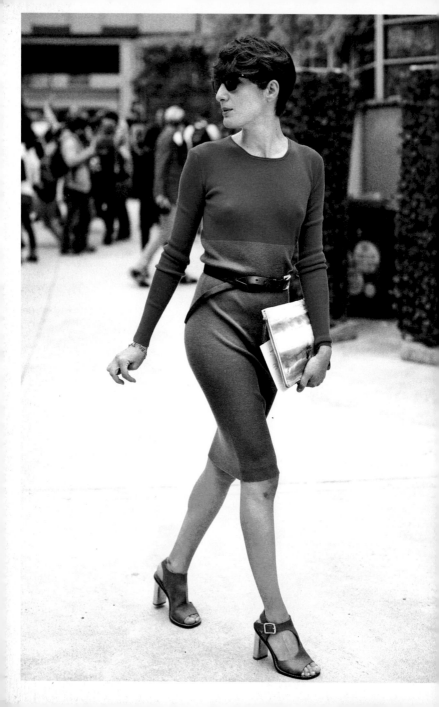

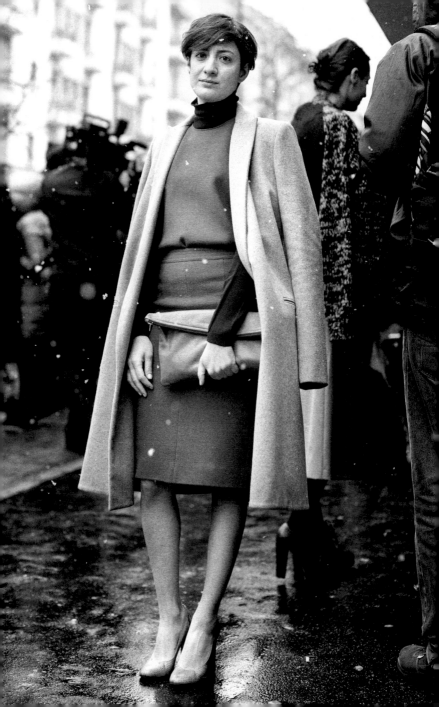

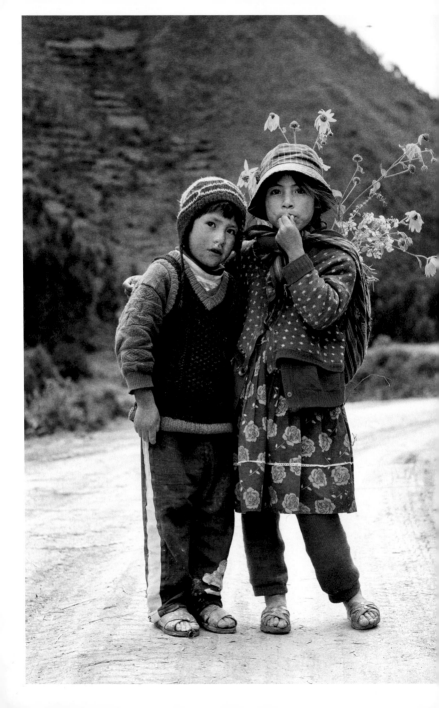

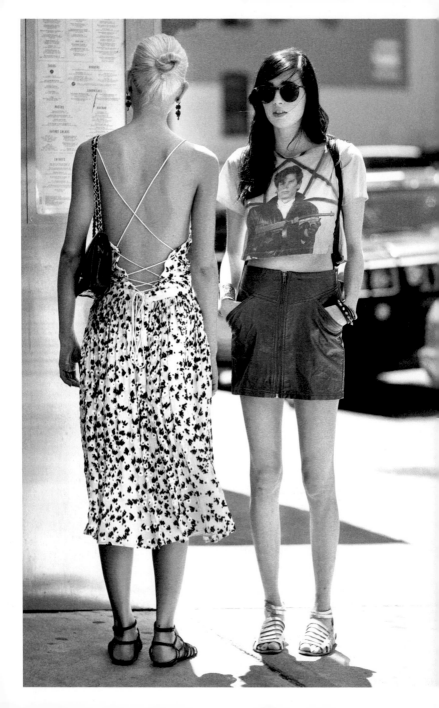

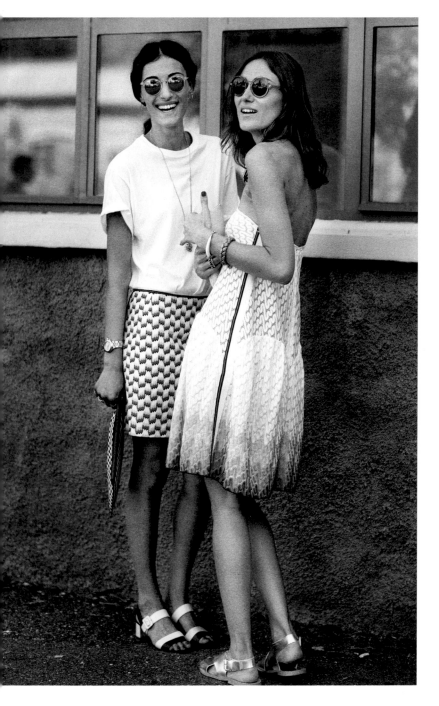

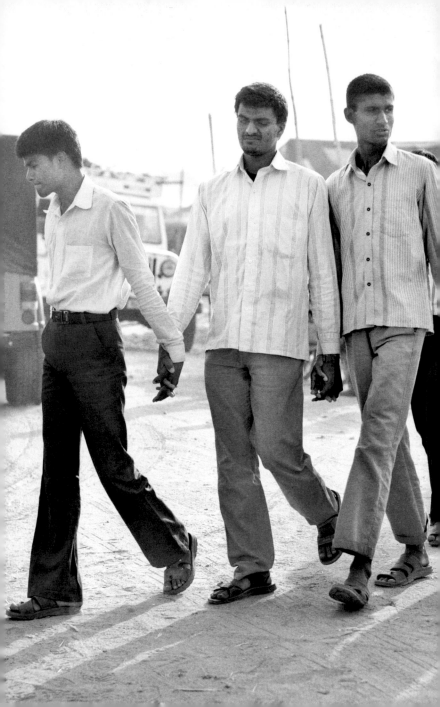

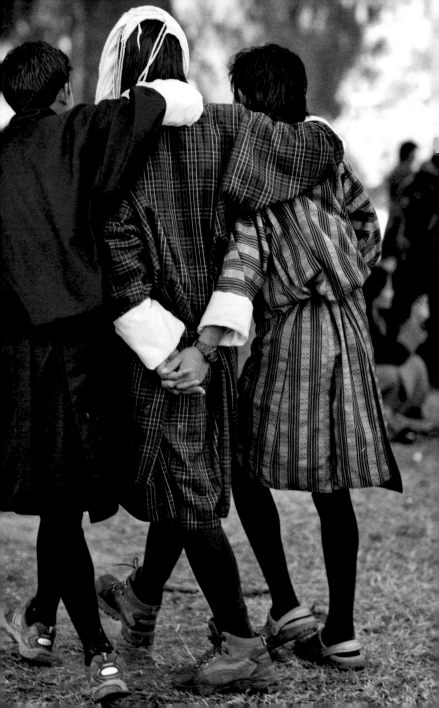

JOHANNESBURG, SOUTH AFRICA

——

It's humbling when you get to see first-hand how your work inspires others. I know my blog and Instagram have a lot of 'followers', but a follower is such an abstract notion. It doesn't sound real.

I was in Johannesburg, South Africa, with my friend Sam, and he was dying to introduce me to a group of local guys that called themselves 'The Smarties'. These young men lived in the township of Soweto (not far from the home of Nelson Mandela) in mostly very basic but clean cinderblock houses. They learned how to sew and spent their days creating outfits based on their heroes and The Sartorialist regulars like Alessandro Squarzi, Domenico Gianfrate and Lino Leluzzi. When I photographed Kabelo (page 170) he was wearing a white hat with a green, white and red band in homage to Luca Rubinacci, whose birthday was that day. I've known Luca for years, and I didn't even realize it was his birthday. The brown suit he's wearing in the photo was bought second hand and almost totally recut by Kabelo to fit his slender frame.

It really touches me deeply to think my images have moved these young men to make their reality one step closer to their dreams.

——

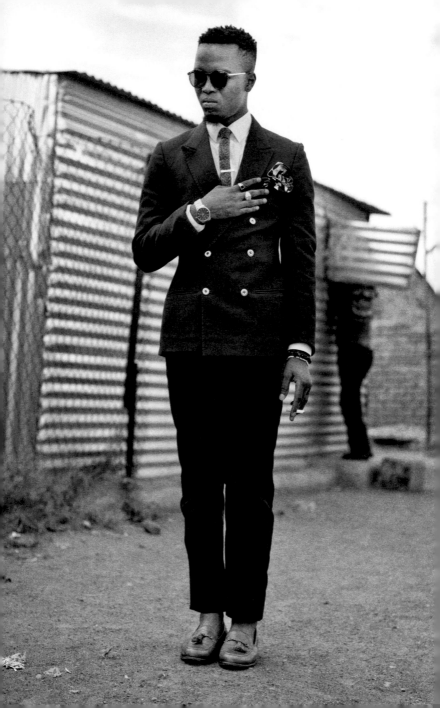

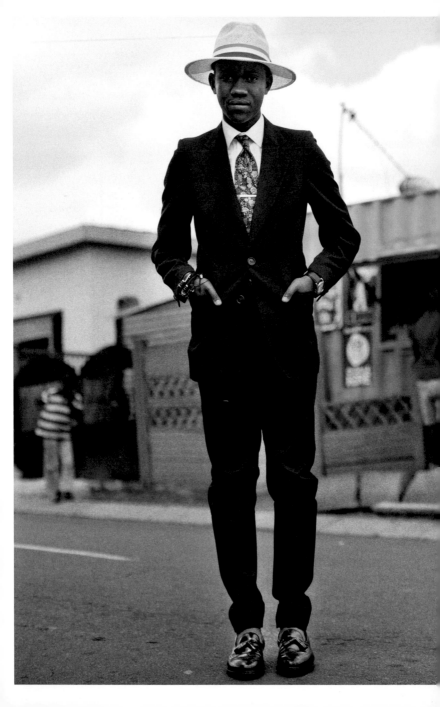

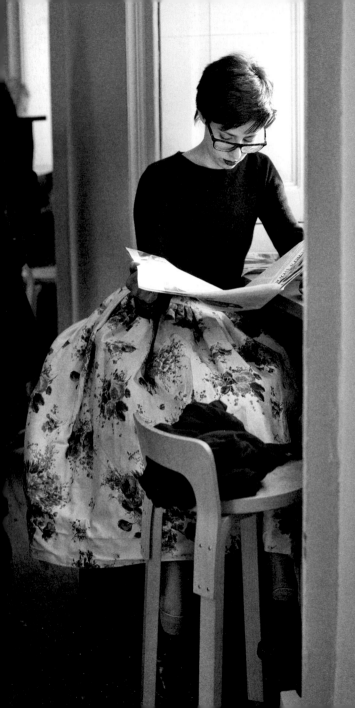

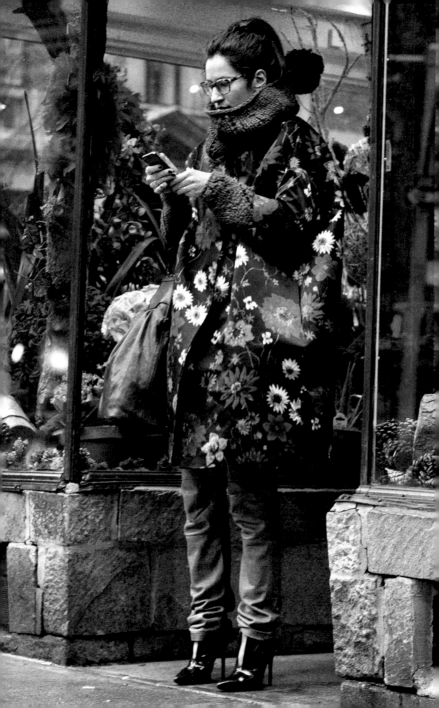

GREAT HAIR

If I were a style-conscious college student today and I had $200 to blow, I would not spend it on clothes.

I would spend it on a great haircut.

I think most of us agree that real style is about more than just clothes. Look at the images on the following pages and be honest: each person would have just as strong a visual impact if you couldn't see their clothes at all. A good cut can last several months and a great cut can be worn in two or three different ways. Best of all a good cut can be worn every day, so you're going to look great, every day.

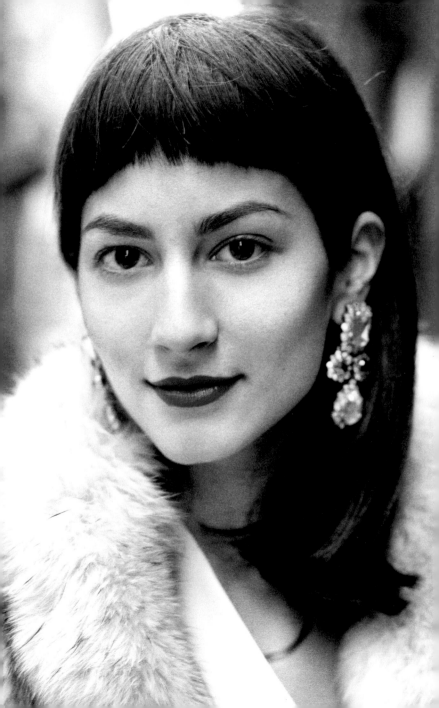

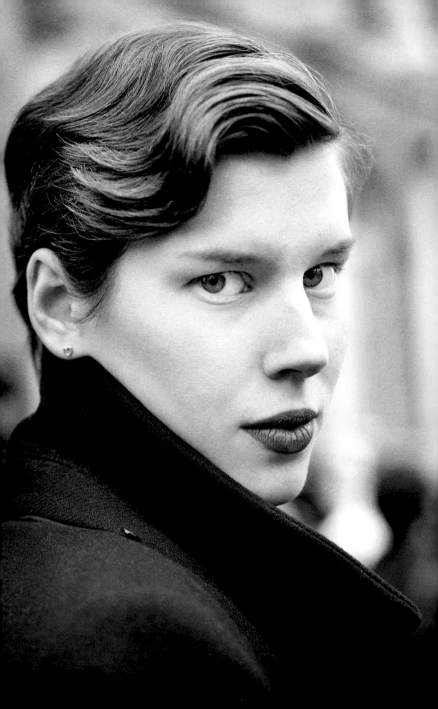

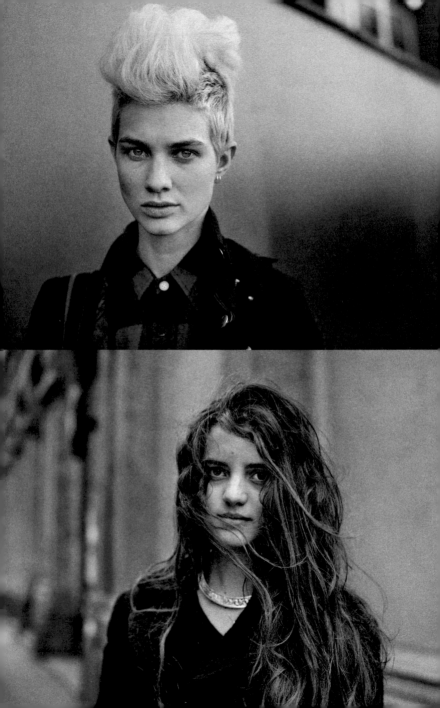

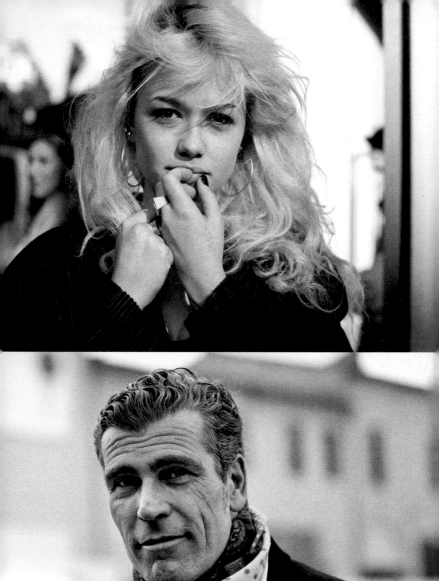
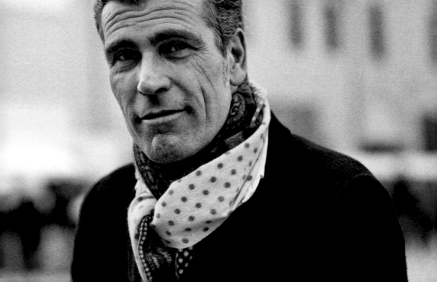

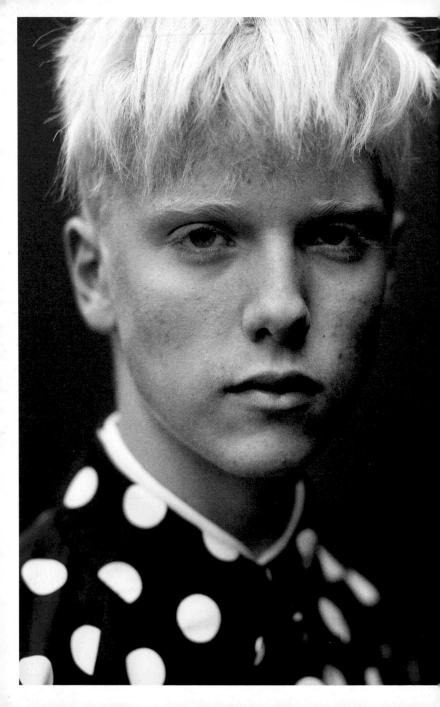

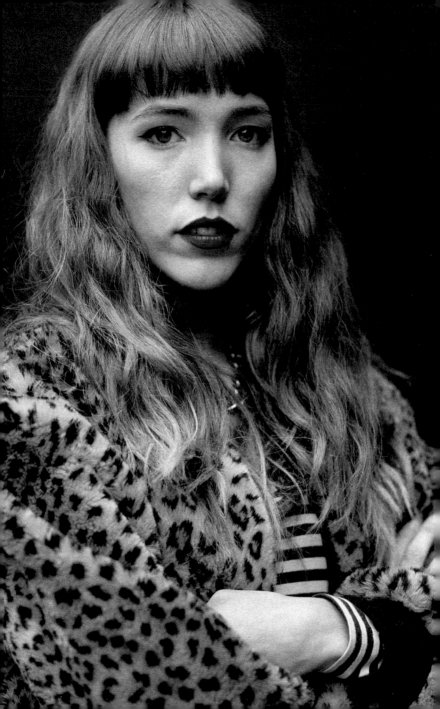

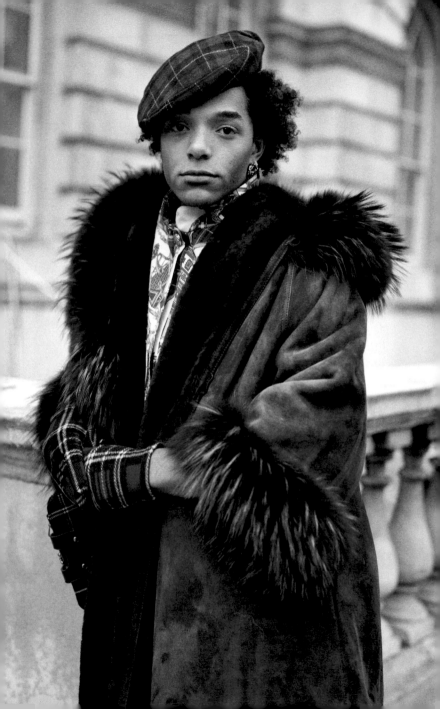

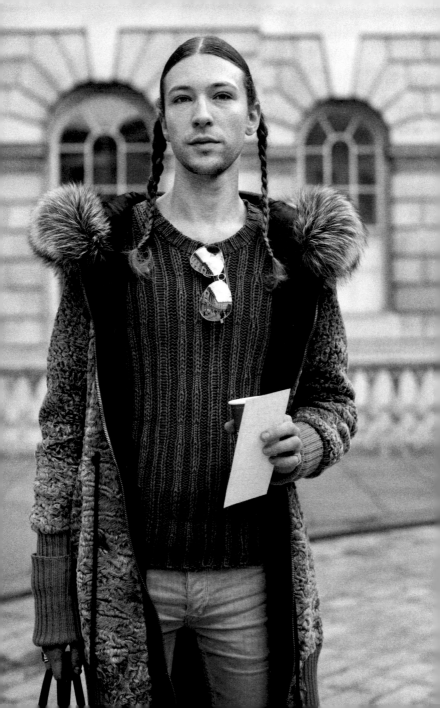

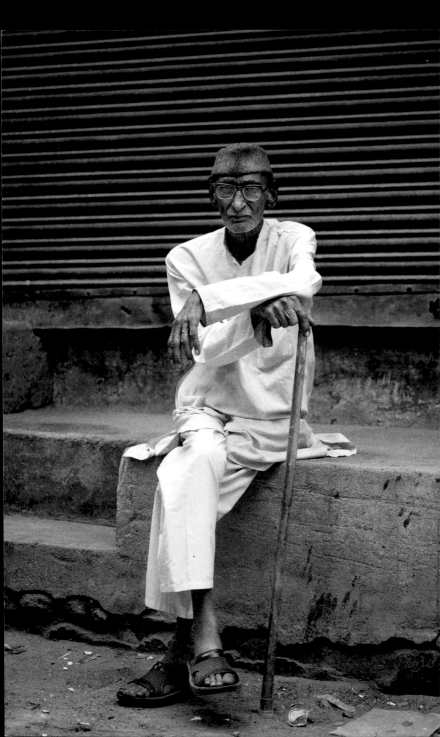

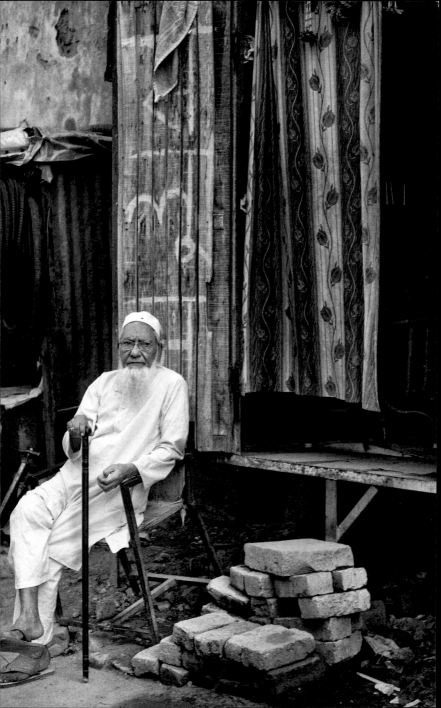

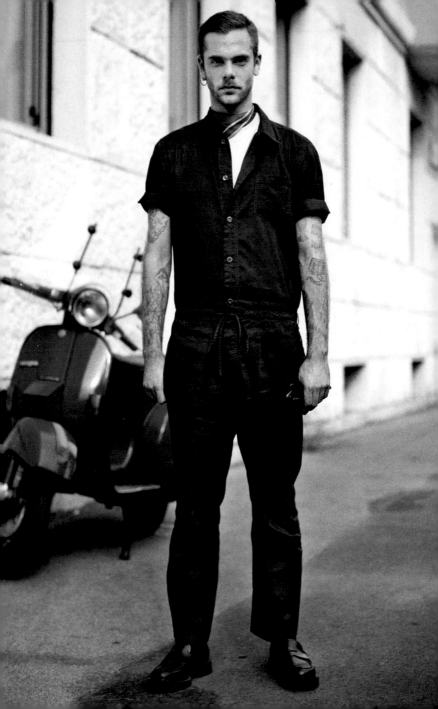

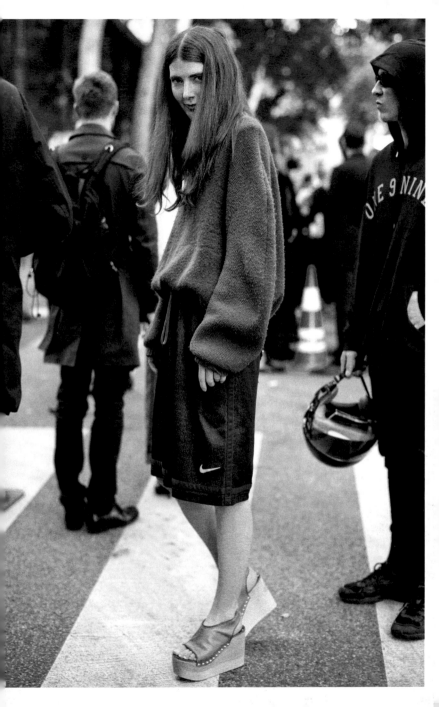

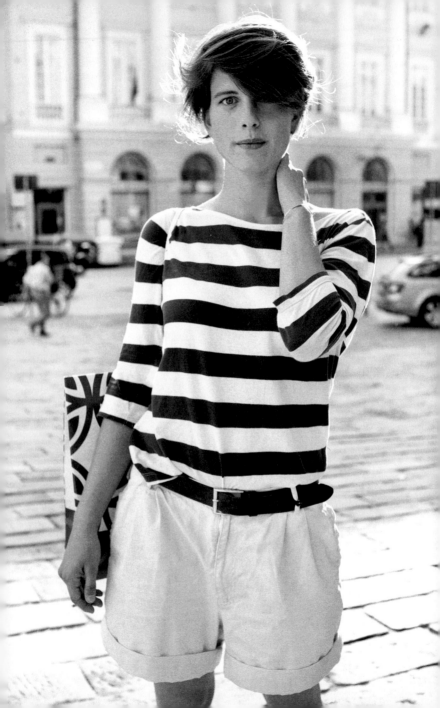

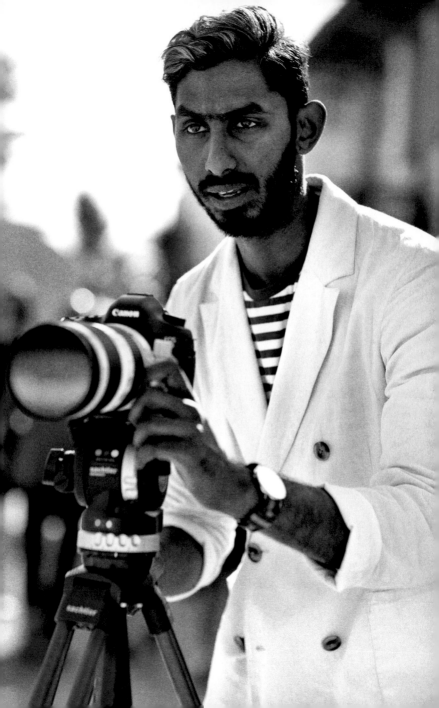

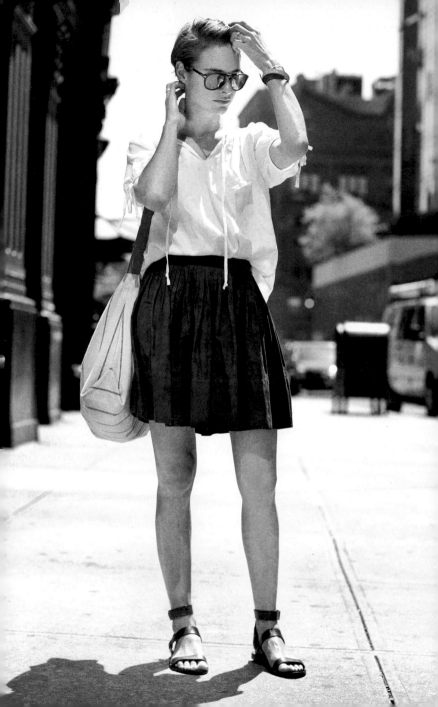

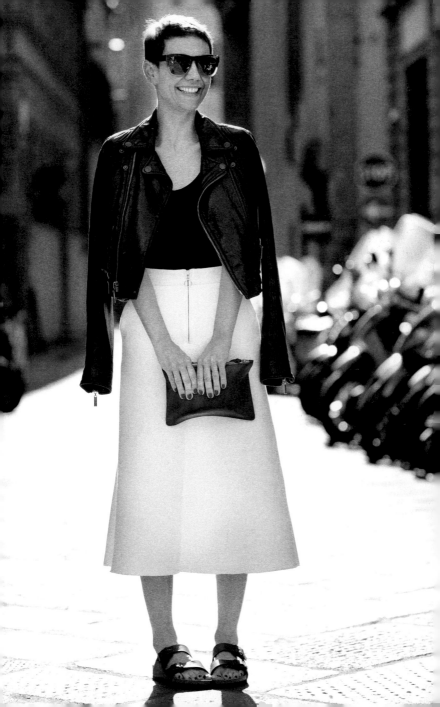

—

GIOVANNI DARIO LAUDICINA

—

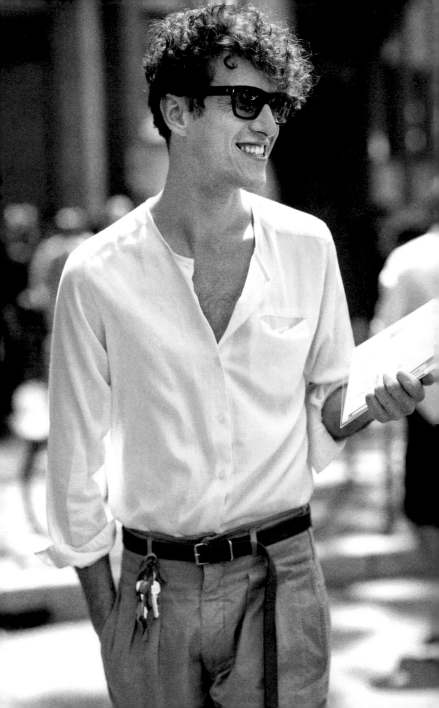

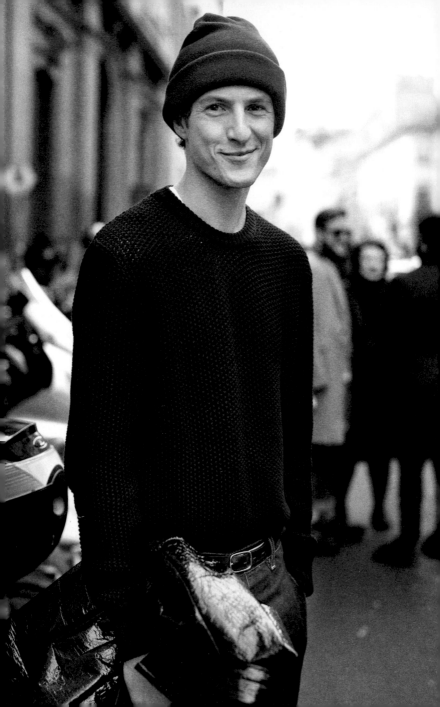

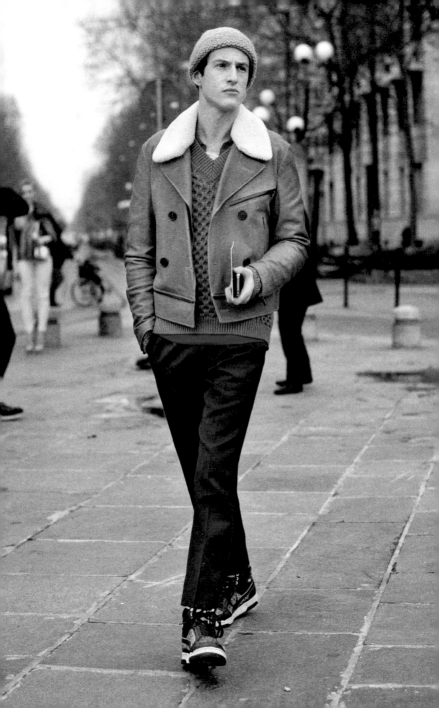

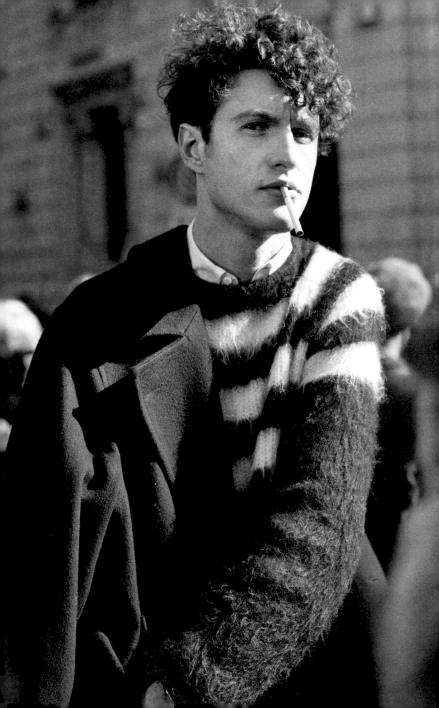

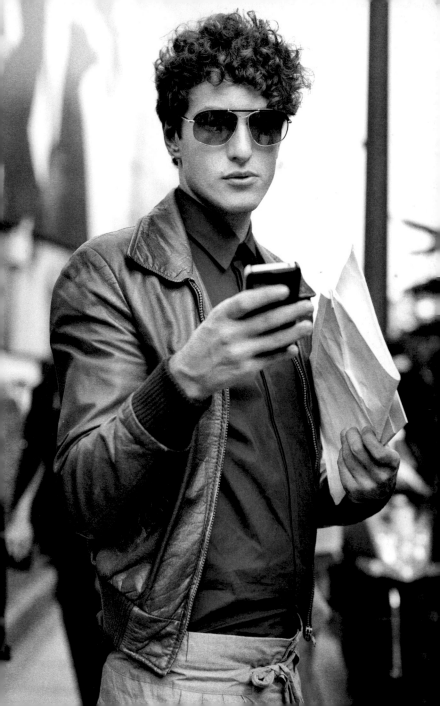

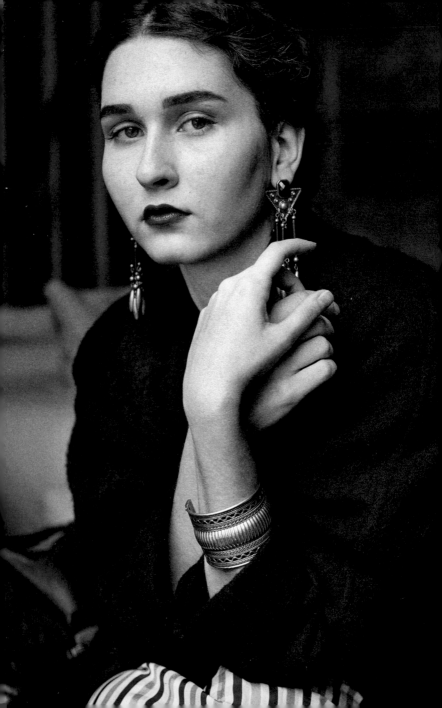

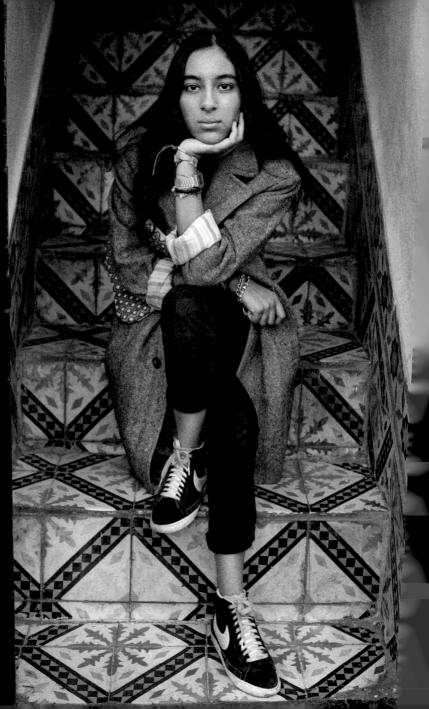

BHUTAN

There has to be at least one arrow-in-leg, arrow-in-arm, arrow-in-chest injury every weekend in the hospitals of Bhutan. The first day of my tour in the Land of Happiness my guide took me to see some gentlemen enjoying the Bhutan National Pastime of archery. I expected eagle-eyed, sinewy-muscled warriors practicing a sacred and ancient ritual. What I found, to my relief and enjoyment, was basically a softball game played with pointed sticks and bows instead of balls and bats. All the familiar stereotypes of manhood were present: former high-school alpha male trying to hold on to past glory, office worker trying to prove he's an all-around guy, family man dying for a little male comradery, the guy that takes his hobby way too seriously – but most prevalent by far was the pretty-drunk-guy-maybe-too-drunk-to-be-playing-with-arrows.

So these guys are shooting arrows across a distance about the length of an American football field, aiming at a round target the size of a dinner plate. The non-shooting team stands on the target side, shouting to the archers after each shot 'wide right!' 'too short!' 'too high!' However, as the beer flows, caution dwindles and some sort of unprovoked bravery kicks in, meaning people stand closer and closer to the target. I don't know about you but as I drink alcohol my eyesight blurs and my reaction time definitely slows! At least once a weekend someone must yell 'far righOOOOOUUUUCCCHHH!!!!'

It's a relief sometimes when you travel half way around the world and instead of feeling alone in an exotic land that you will never truly understand, you can take at least some comfort in the ability to identify the Bhutanese equivalent of guys called Chuck, Sean and Larry.

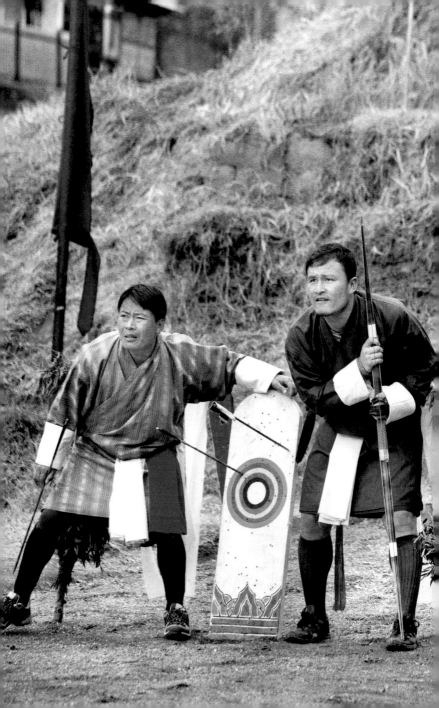

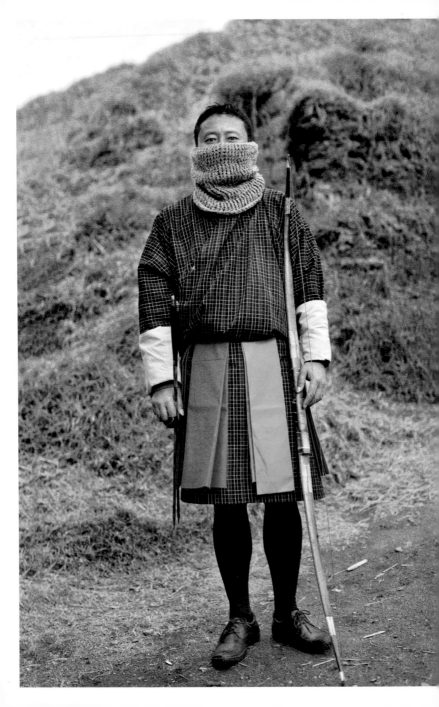

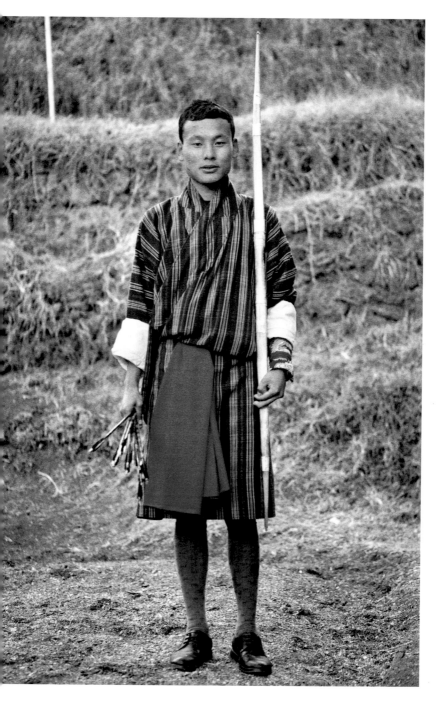

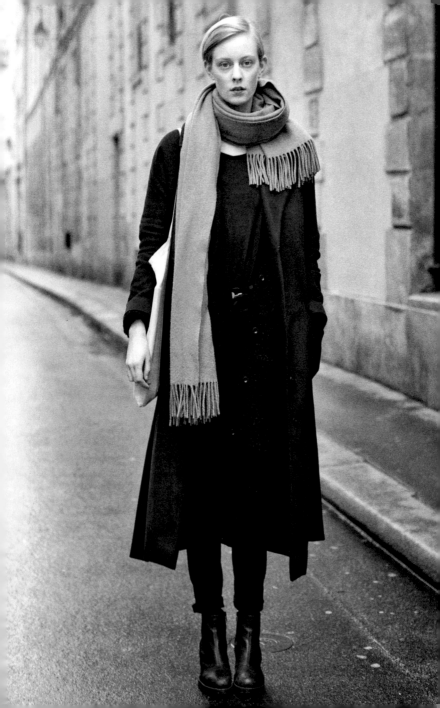

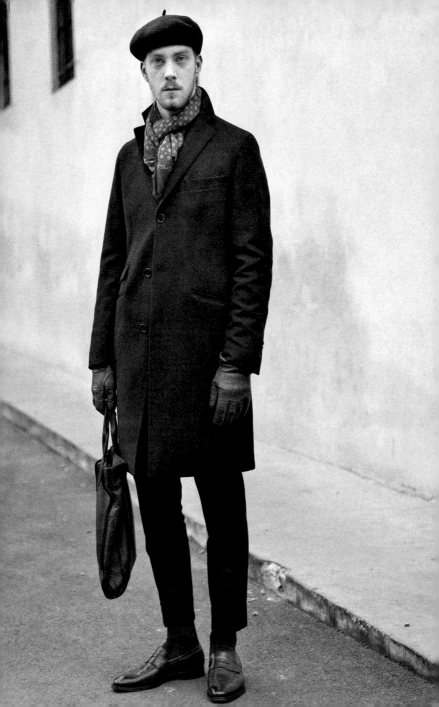

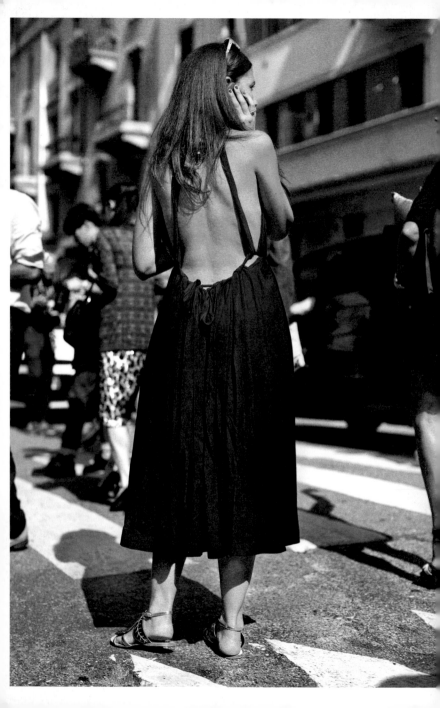

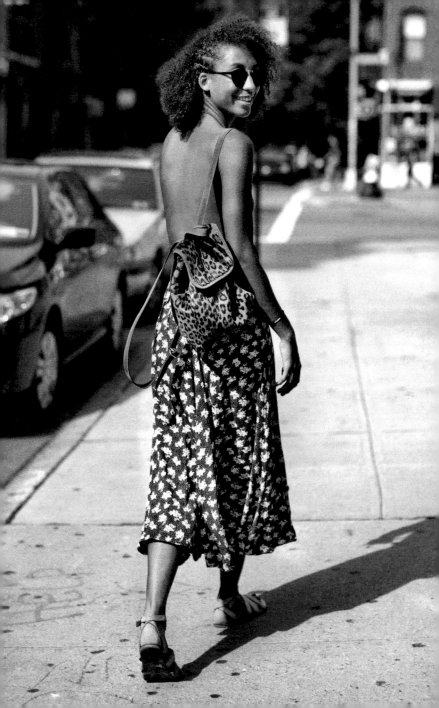

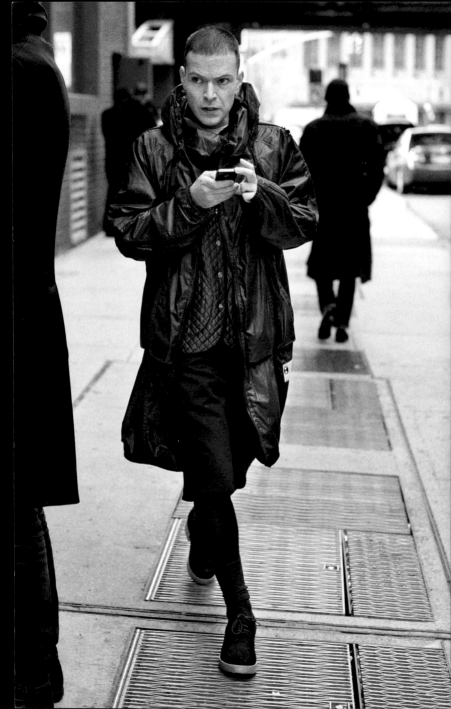

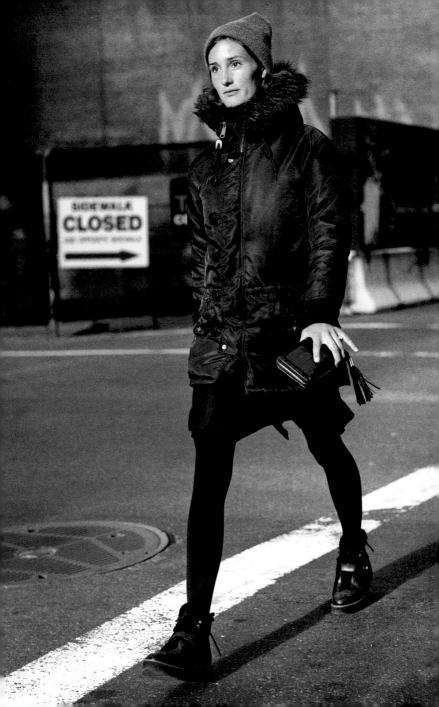

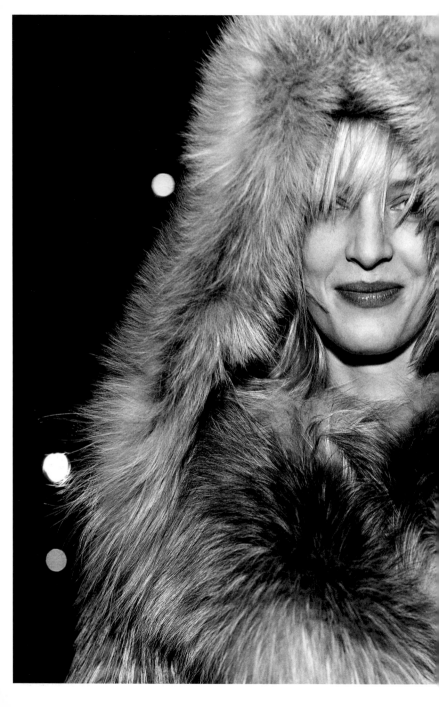

—

ON THE STREET...
CENTRO STORICO
BARI, ITALY

—

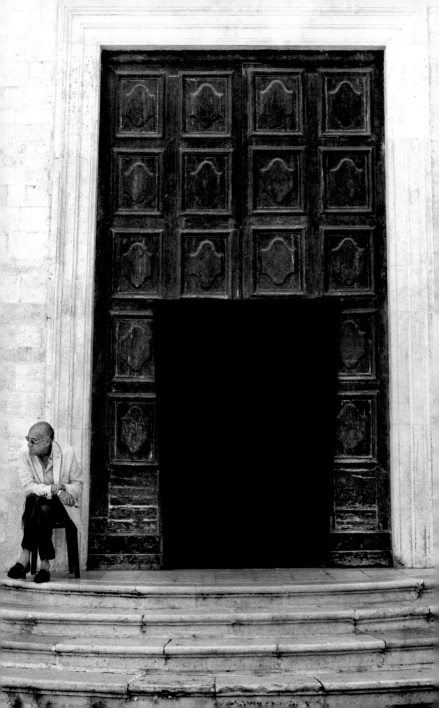

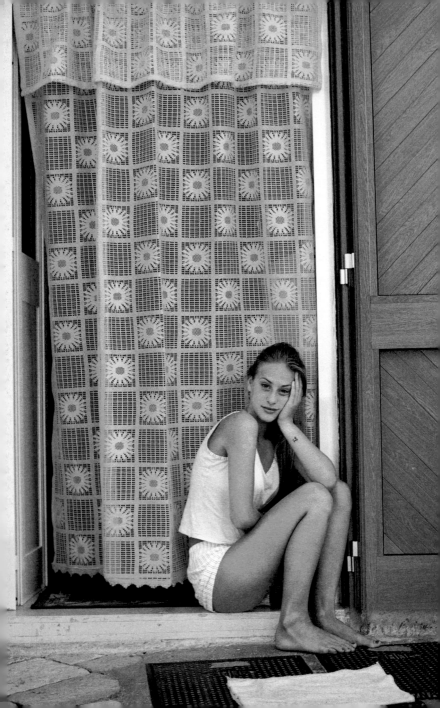

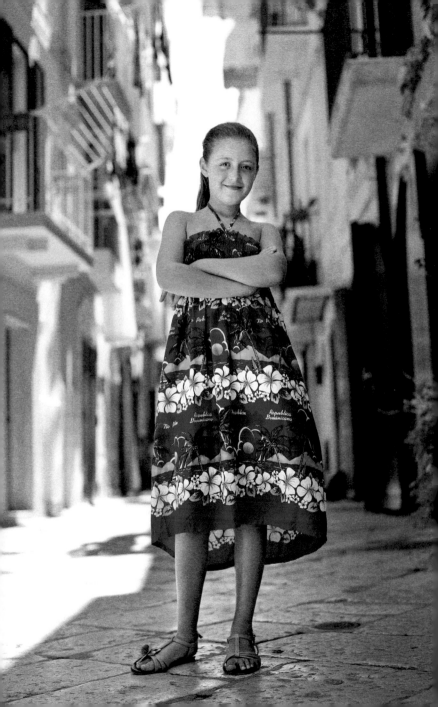

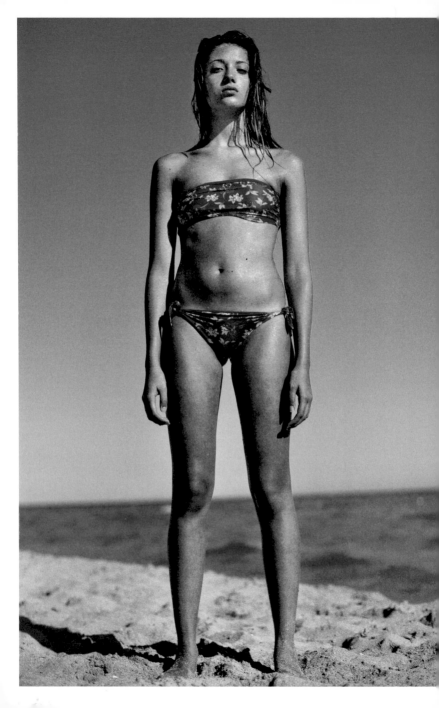

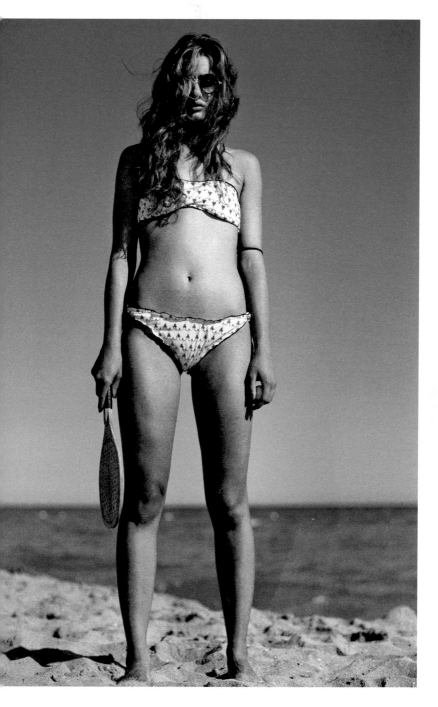

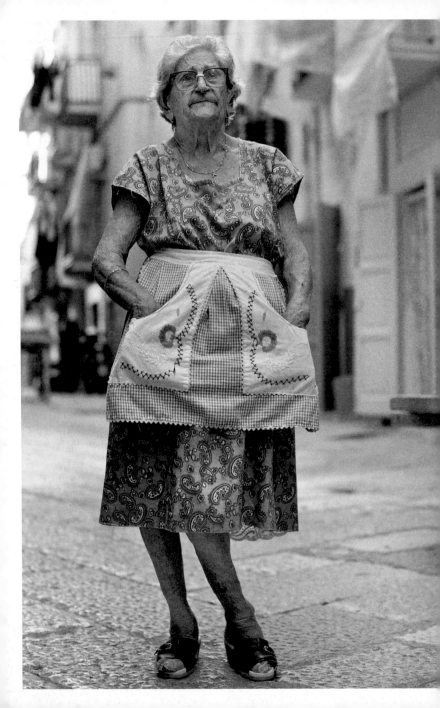

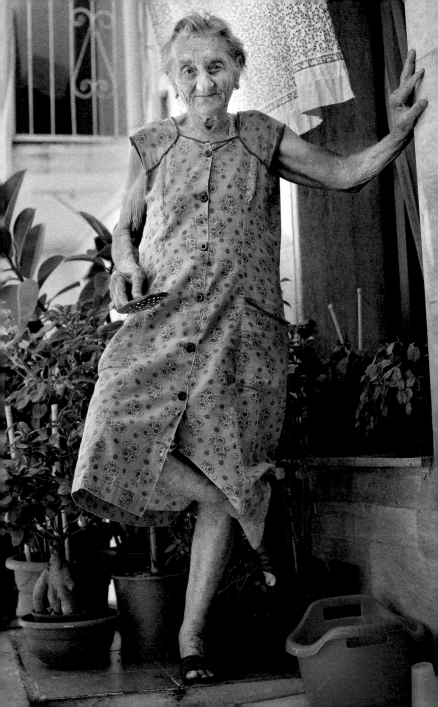

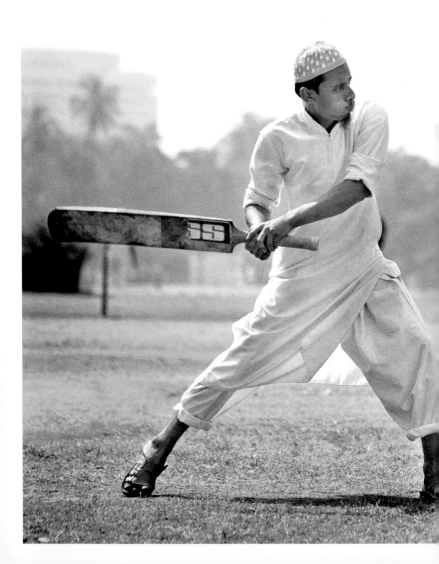

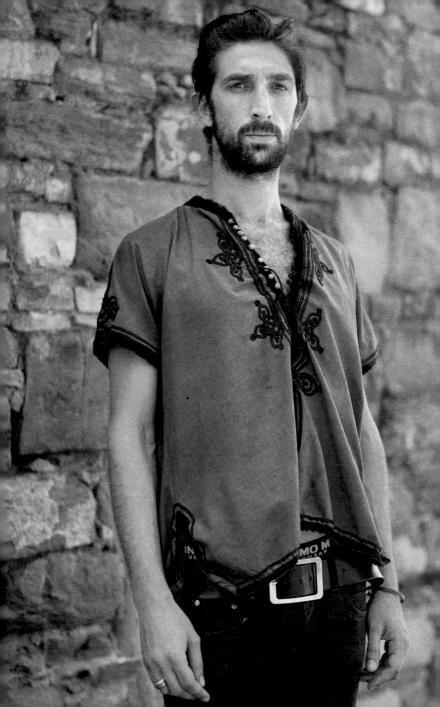

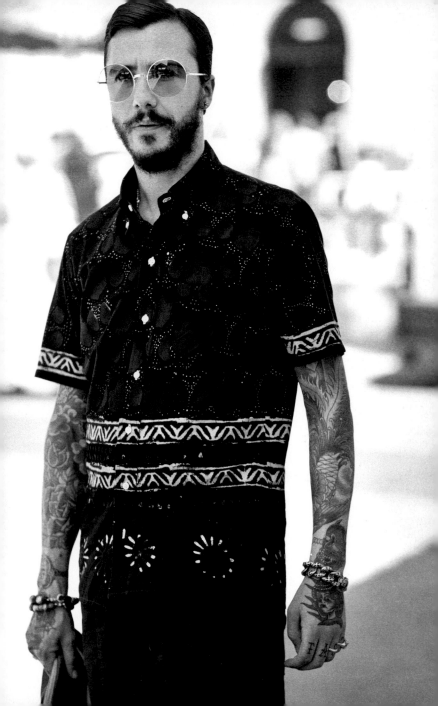

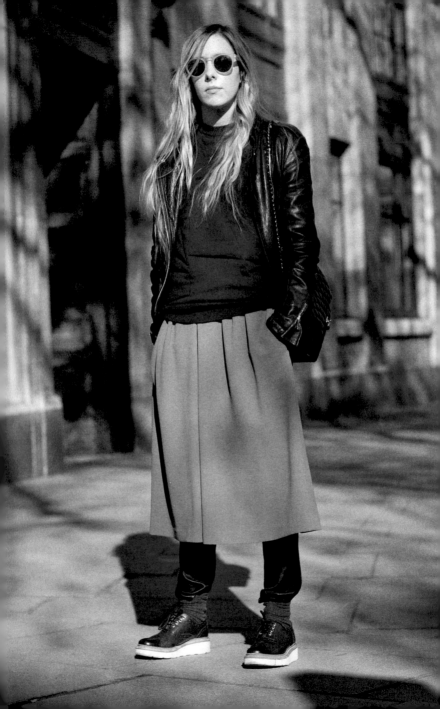

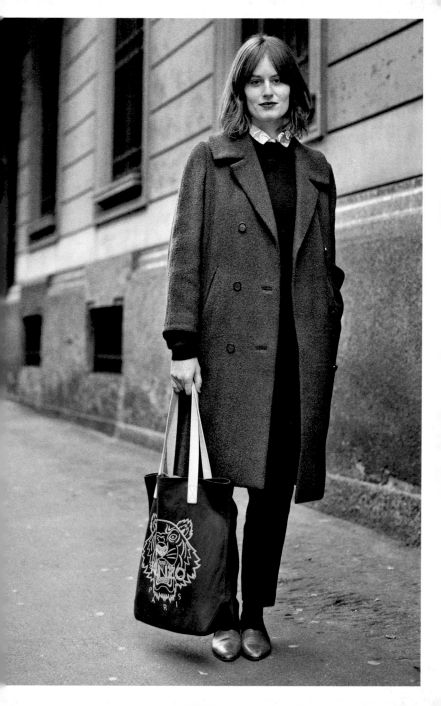

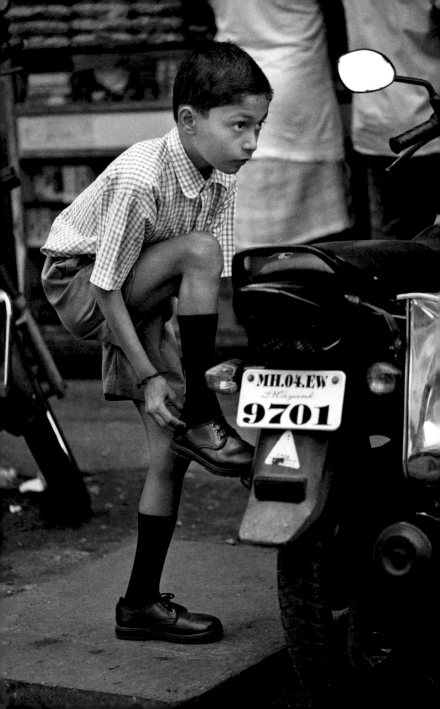

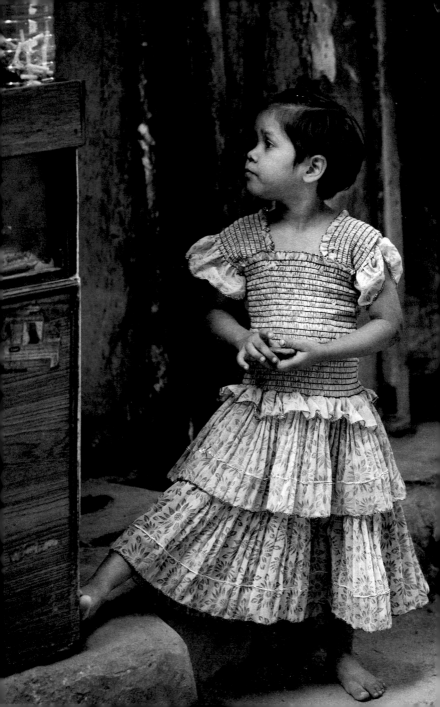

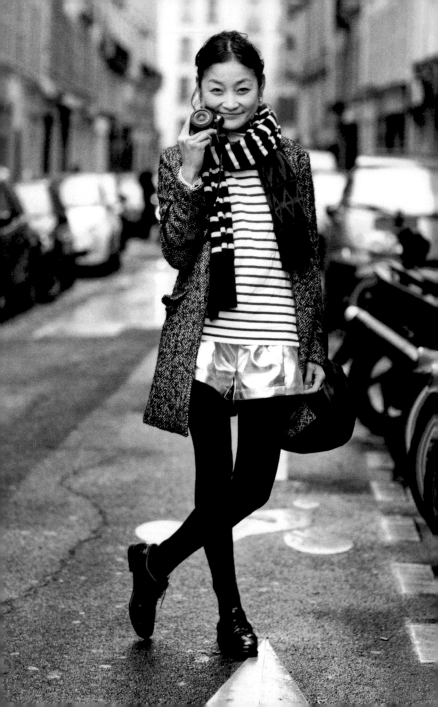

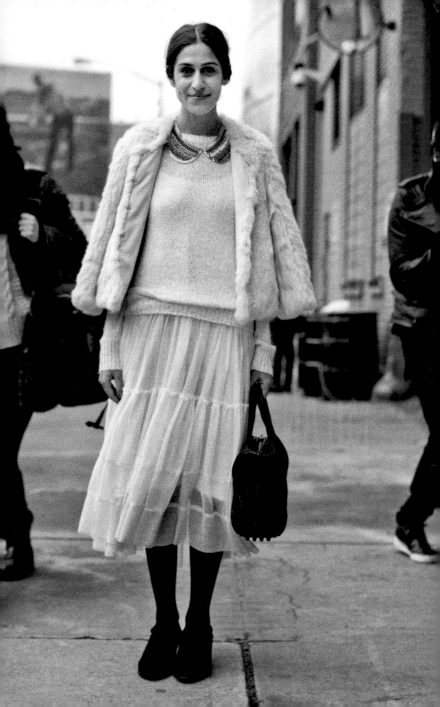

—

ON THE STREET...
FRANCA SOZZANI,
MILAN

—

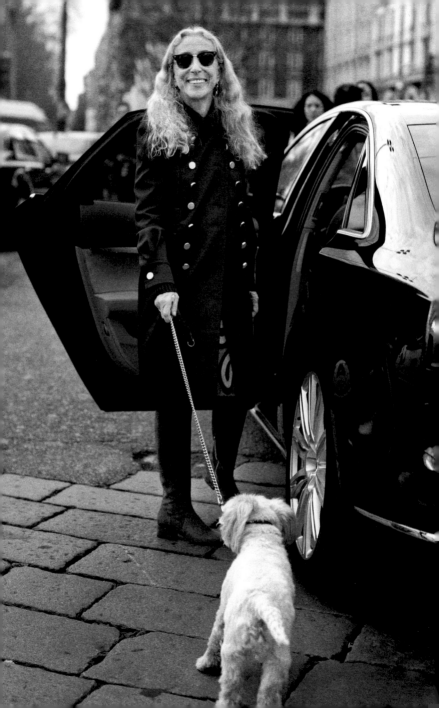

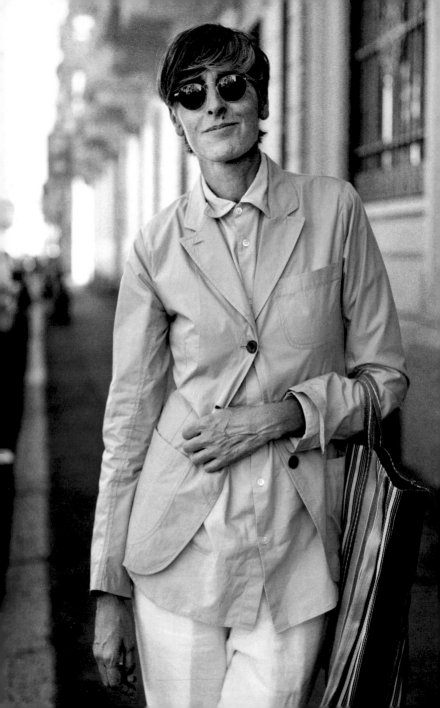

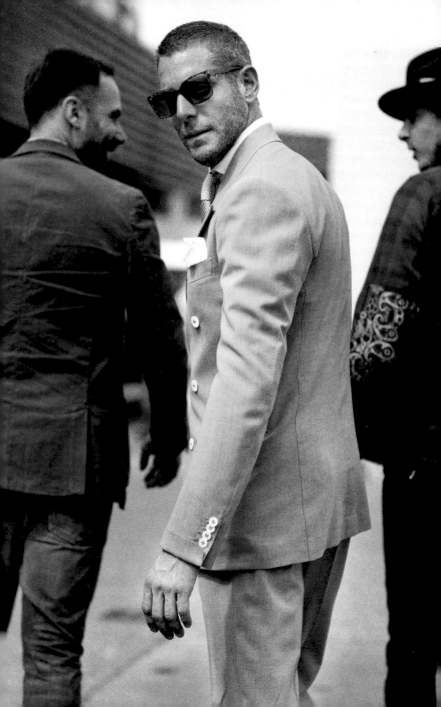

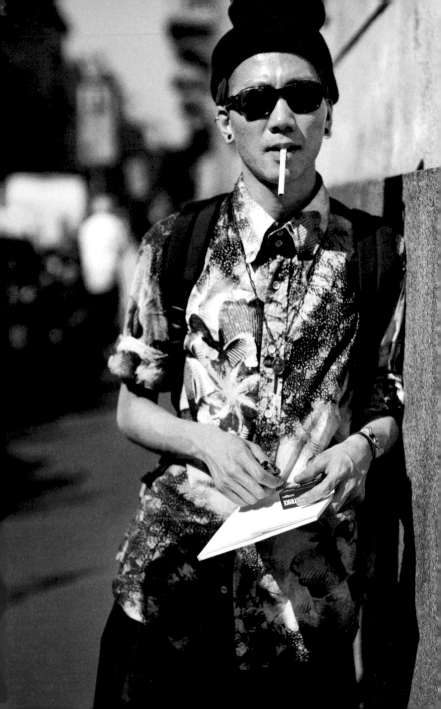

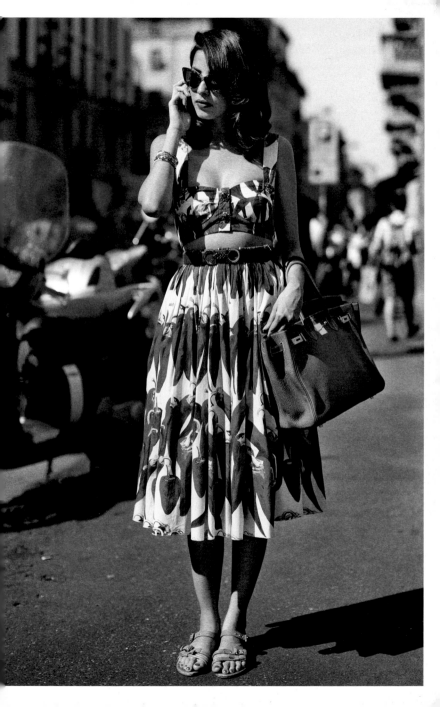

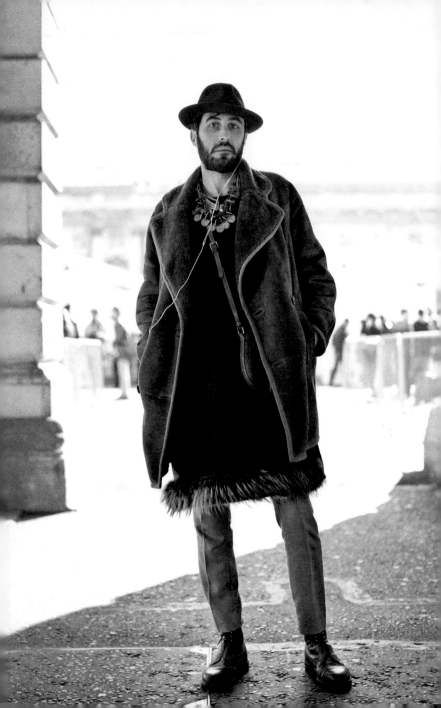

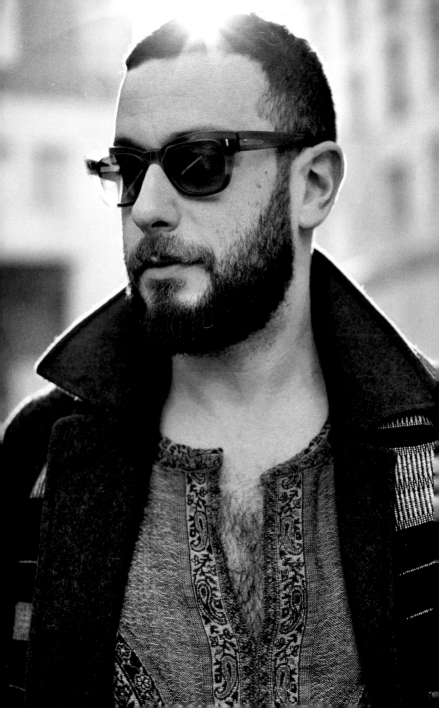

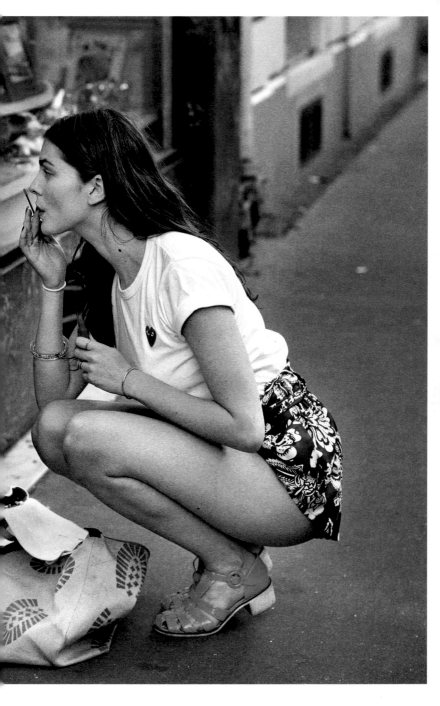

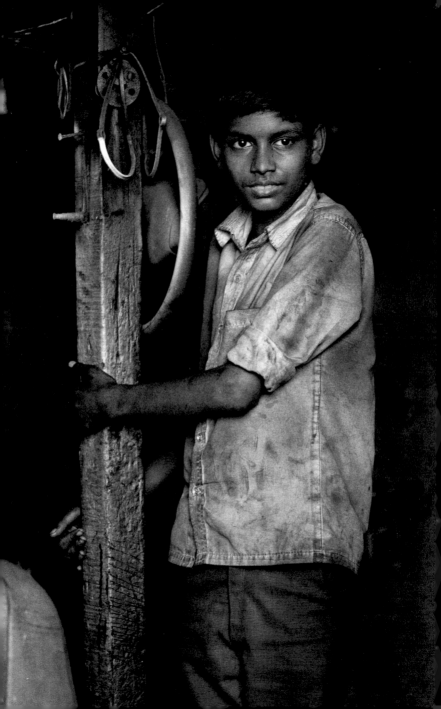

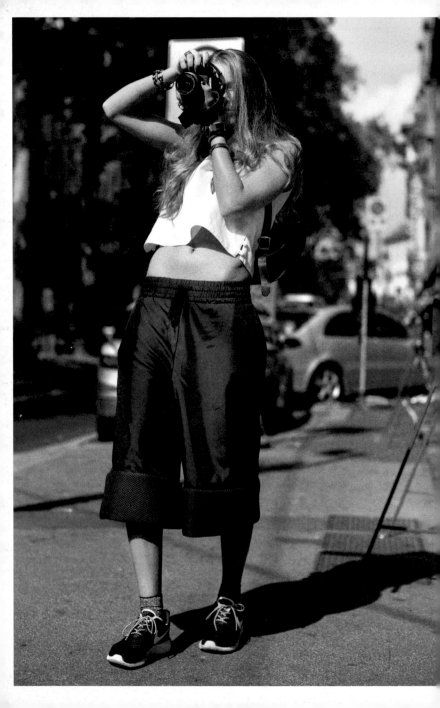

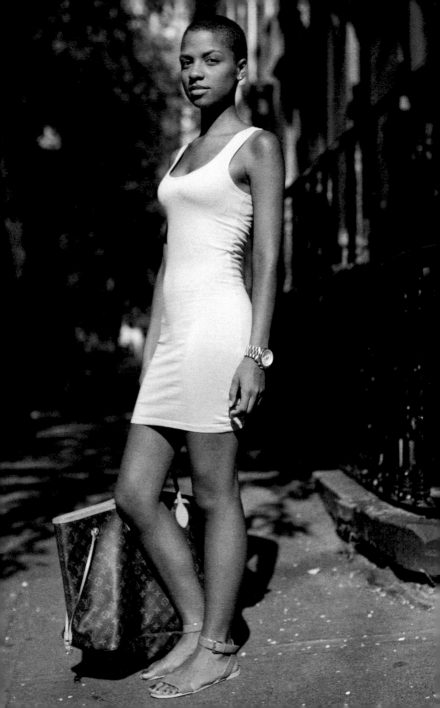

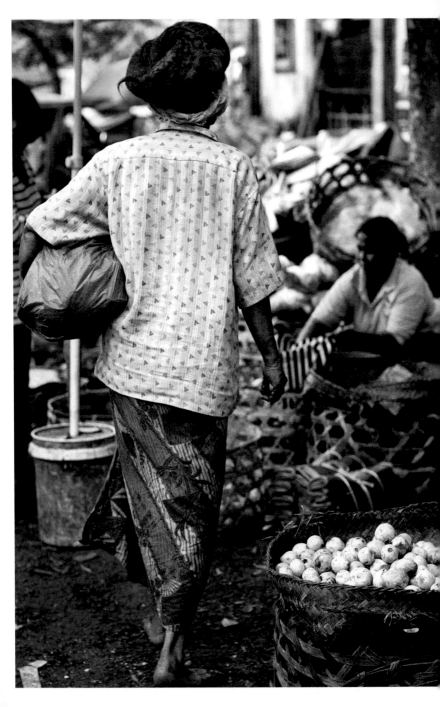

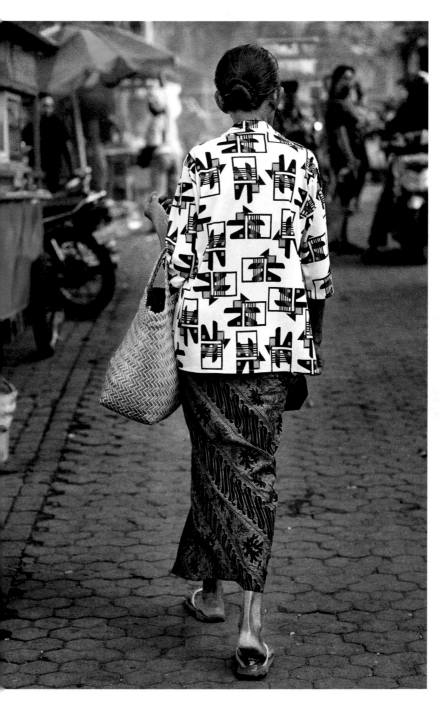

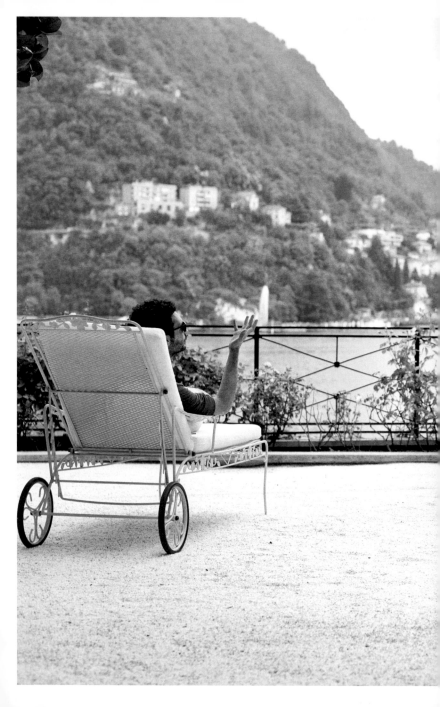

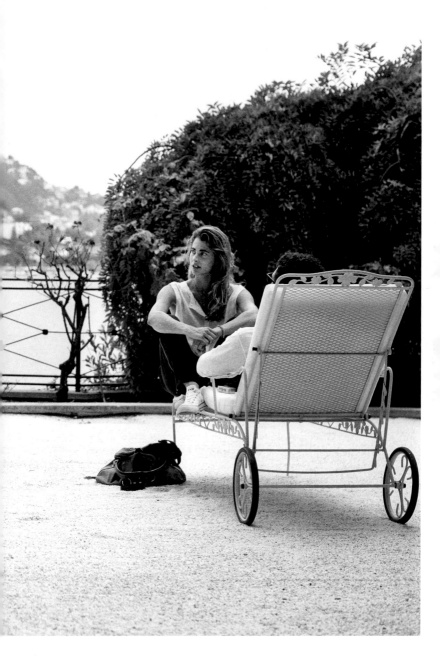

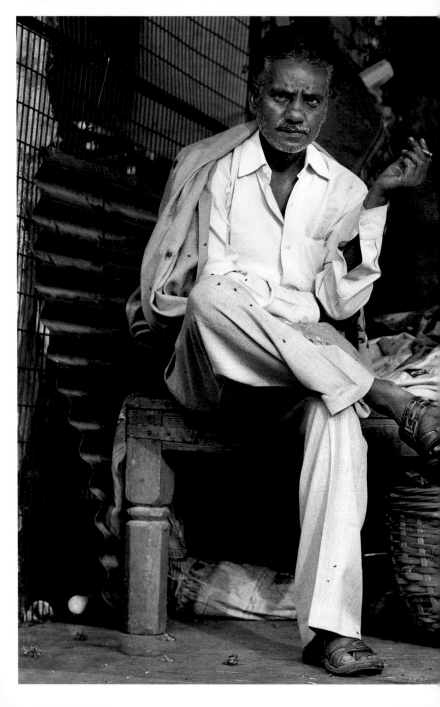

LUNCH FOR 25

When I started The Sartorialist, I seriously considered creating
a best-dressed list.

Being a photographer, what I realized was I didn't want to *write*
a best-dressed list, I wanted to *see* a best-dressed list.

Several years later, I found myself sitting in a small trattoria in
Florence having lunch. As I looked around the room, I realized
I had never been in one place with so many elegant well-dressed
men. This scene was what my best-dressed list should look like.

So I created my annual 'Lunch for 25' six months later and held
it in the same trattoria, with a hand-picked group of men that
comprised what I considered were the best-dressed men from all
over the world.

I love the photographs that came from these get-togethers but
the film, which can be found on YouTube, is the best film project
I've ever done.

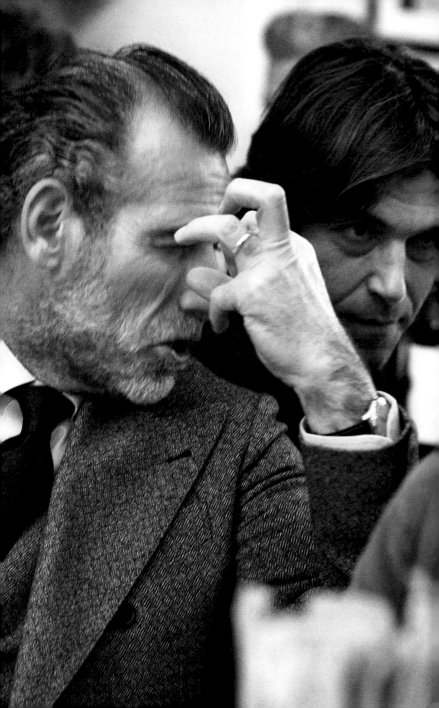

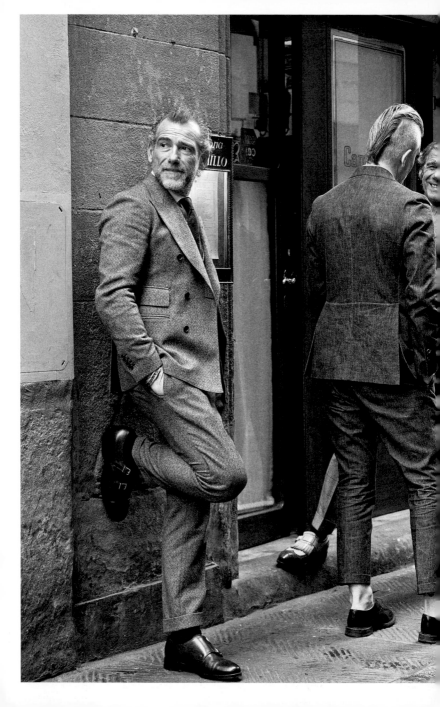

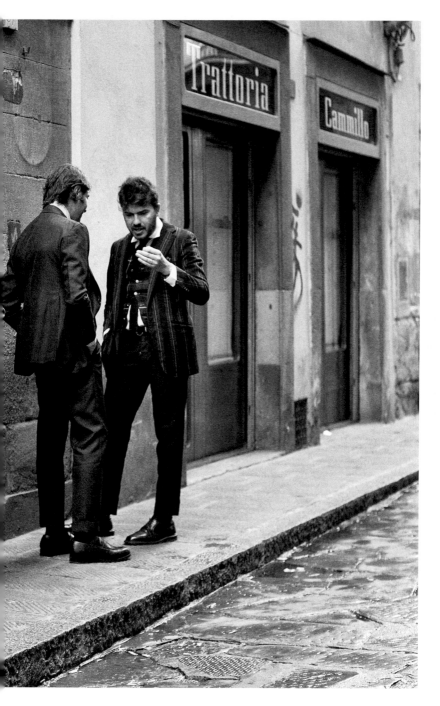

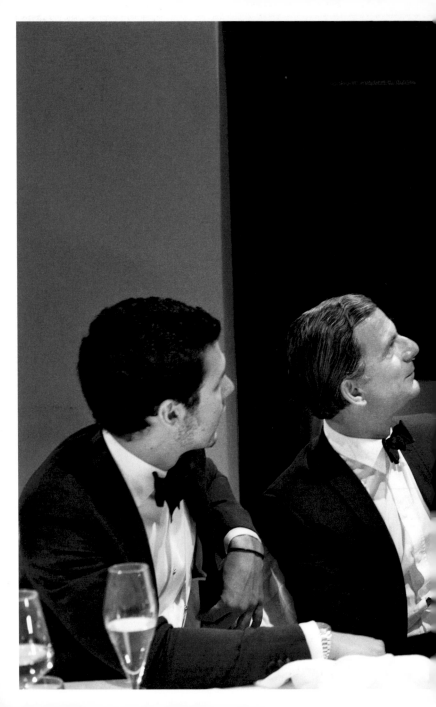

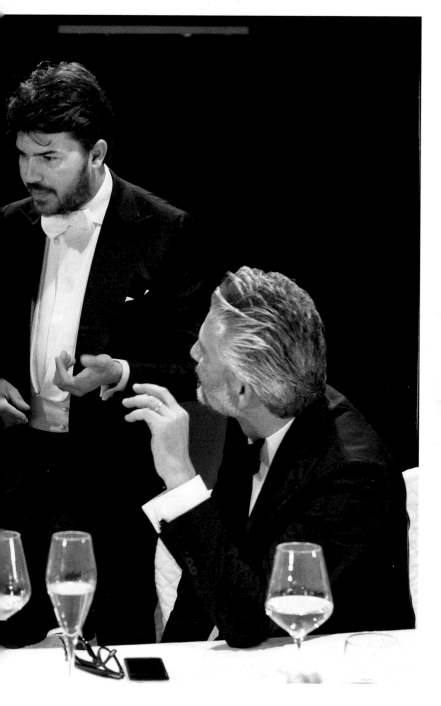

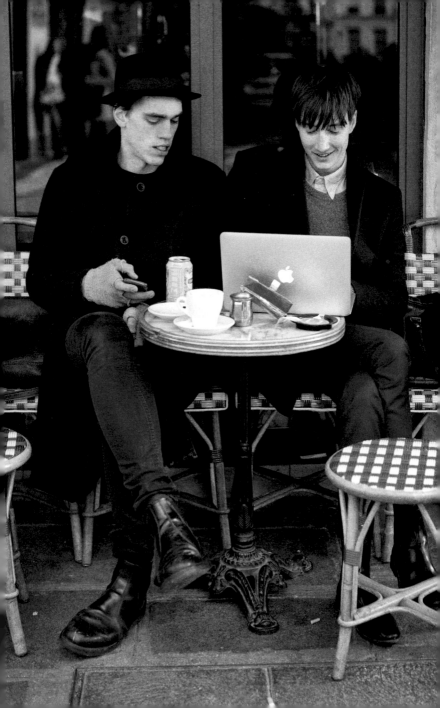

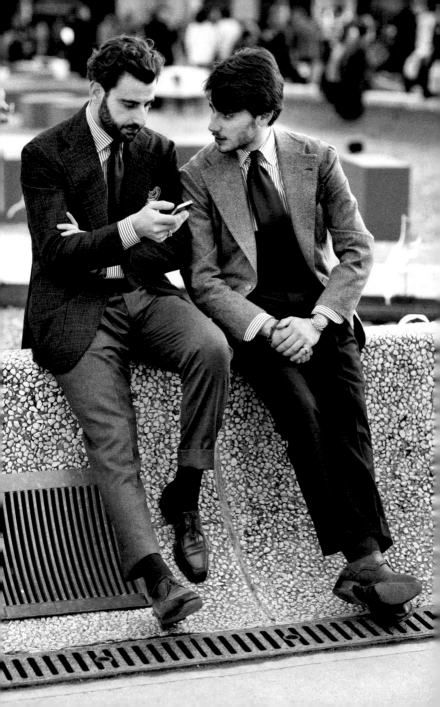

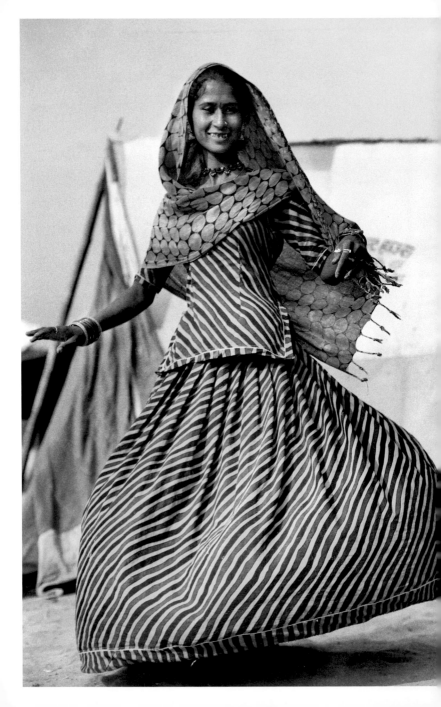

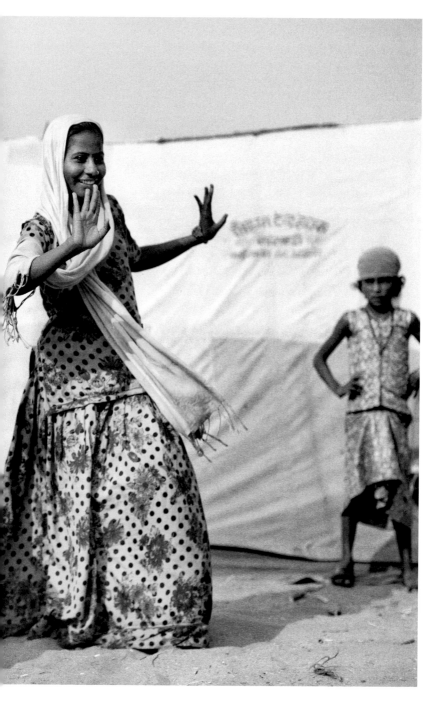

VARANASI, INDIA

—

One of the things I love most about street photography is that it requires patience, often hours of it, with little hope of success. However the fact that at any given moment you could take the best photo of your career is the thing that keeps most photographers on the hunt.

I took this photo on the last full shooting day of an exhausting but very rewarding two week trip to India. I was on the edge of Varanasi, hot, sweaty, and trying to convince myself it was ok to go back to the hotel a little early. I gave myself five more blocks before I'd jump on a bike rickshaw back to the hotel. But when I turned the very next corner I stumbled upon this open air coal pit with this beautiful young man covered in coal dust, dressed in all black and with a haircut worthy of Guido Palau. It was a scene as gritty and beautiful as a Dickens tale.

Just like that, my energy was back.

I'm not saying this is the best photo I've ever taken but it's one of the photos I think of when reminding myself to keep pushing that rock.

—

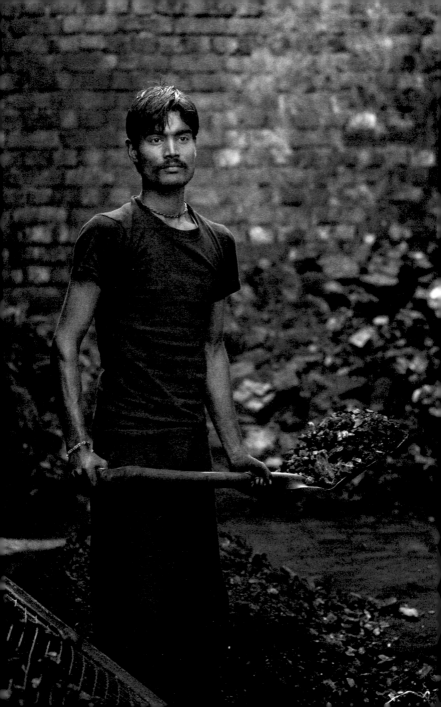

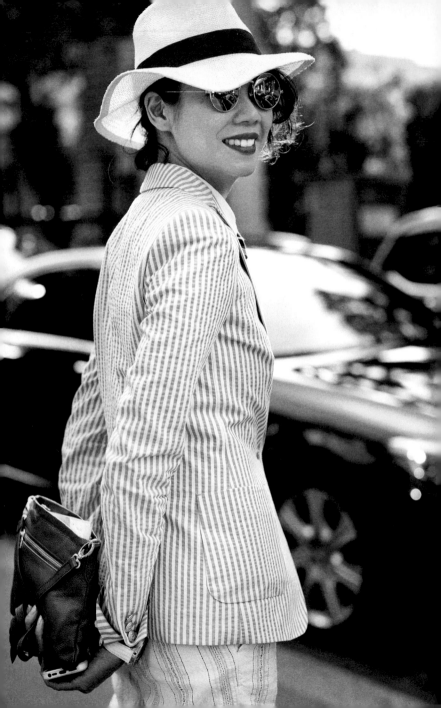

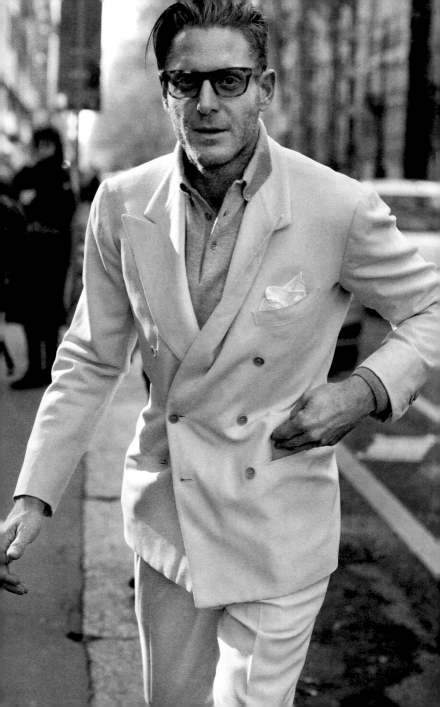

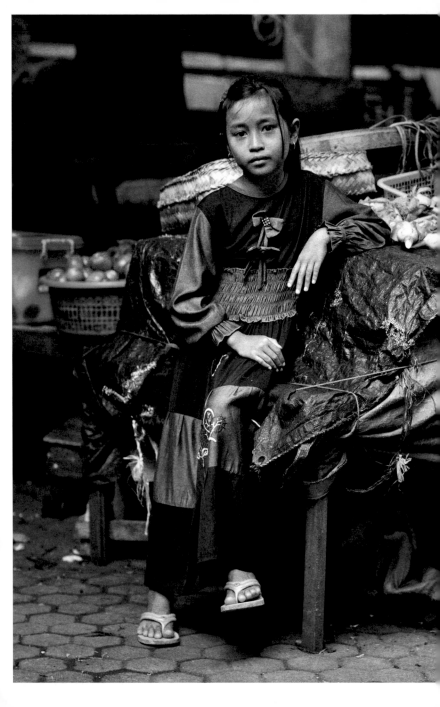

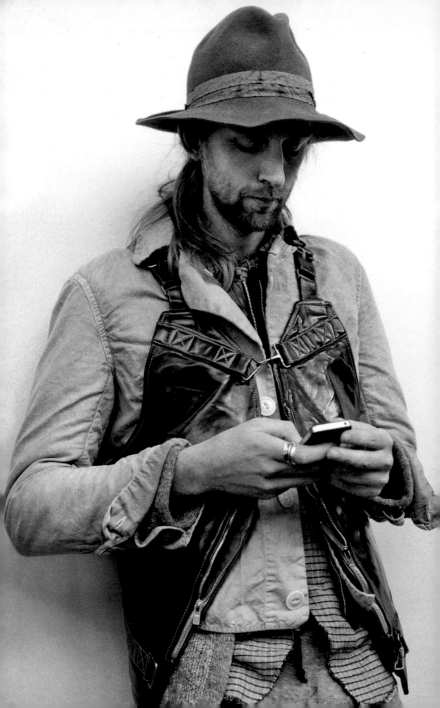

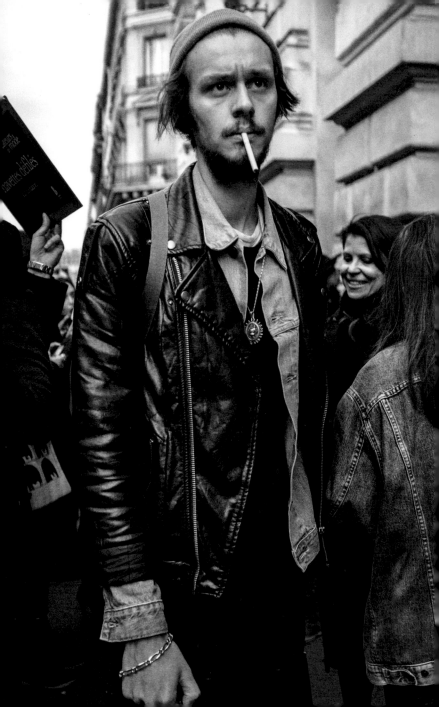

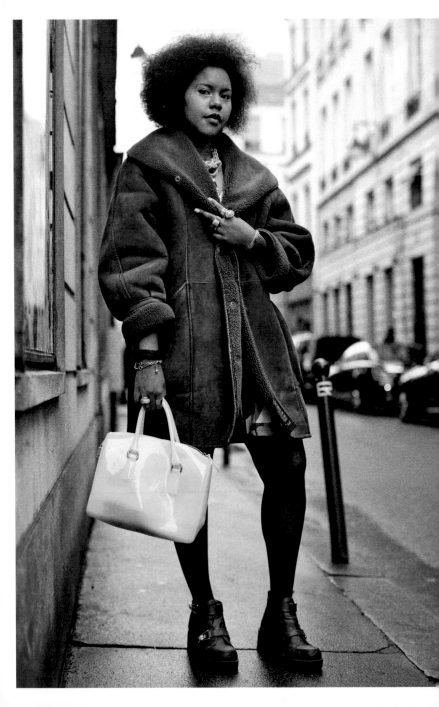

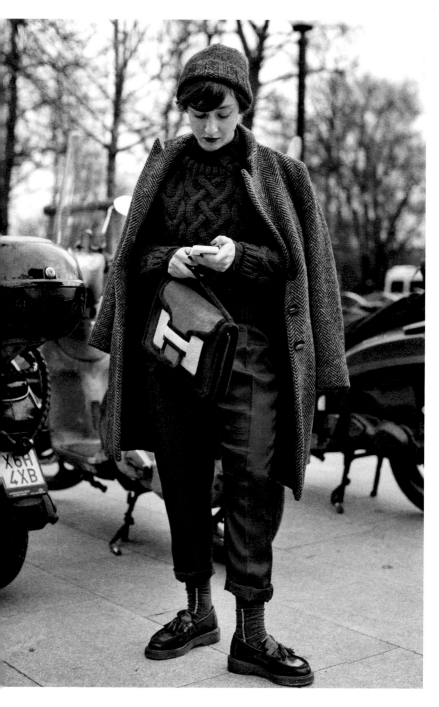

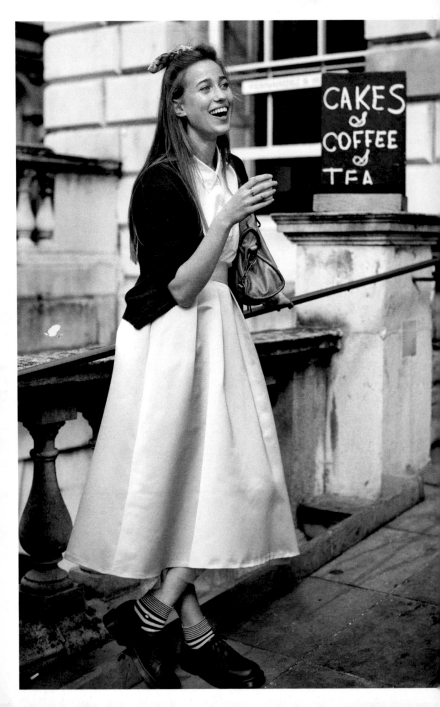

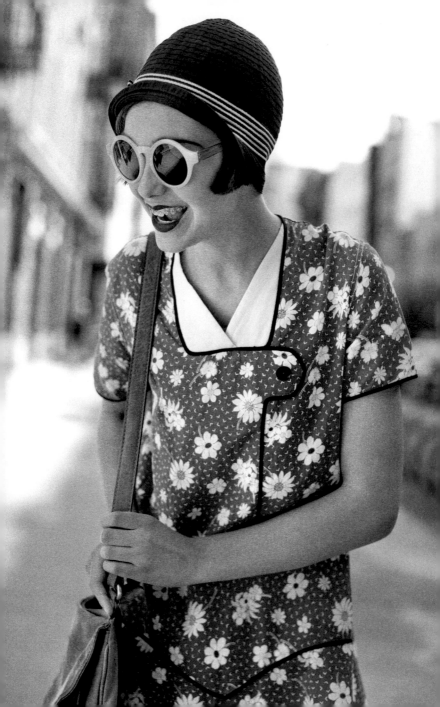

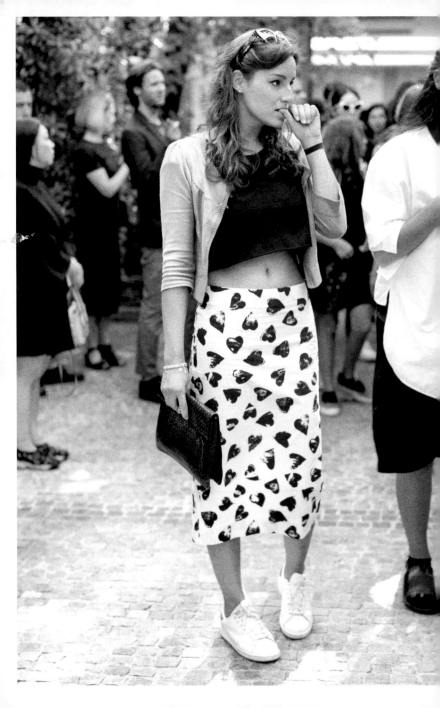

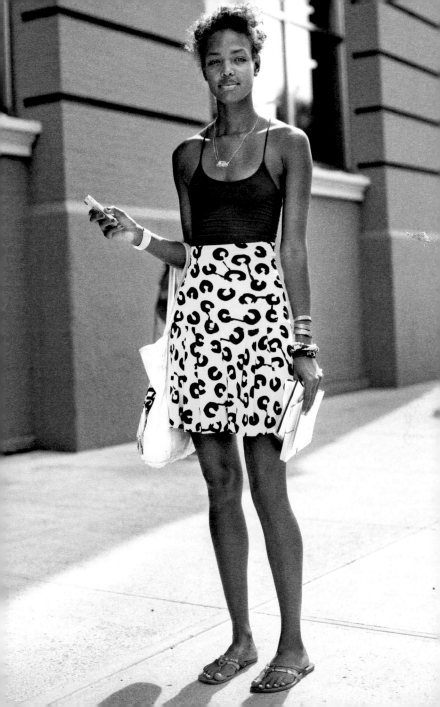

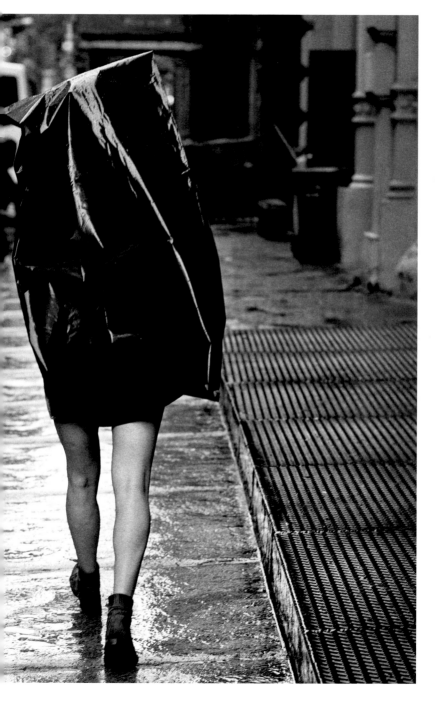

—

STUDIO PORTRAITS FLORENCE, ITALY

—

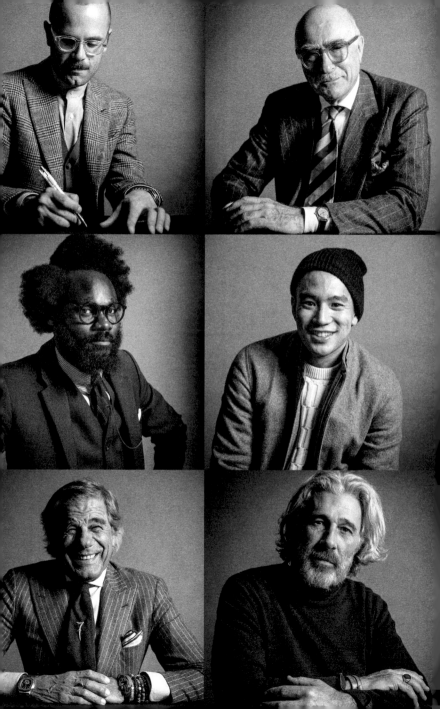

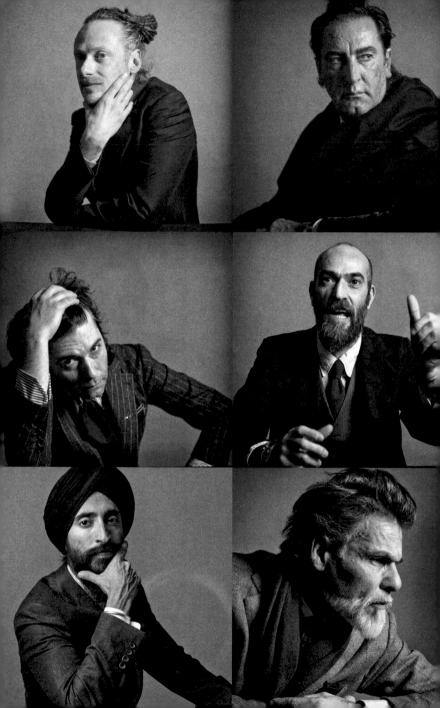

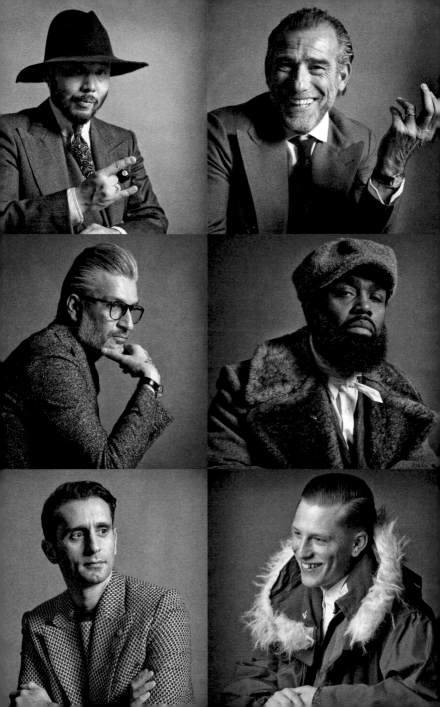

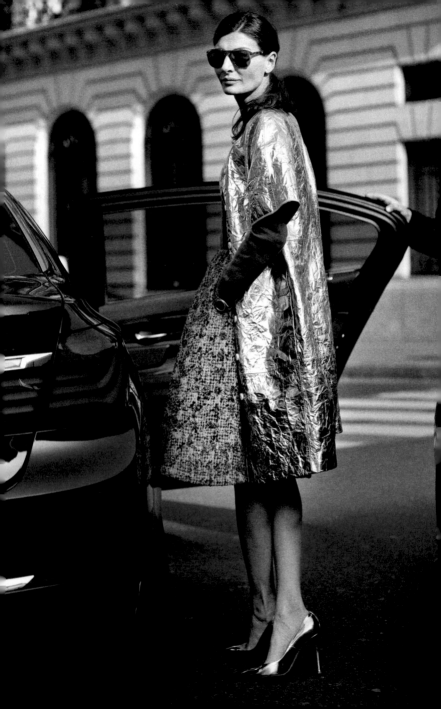

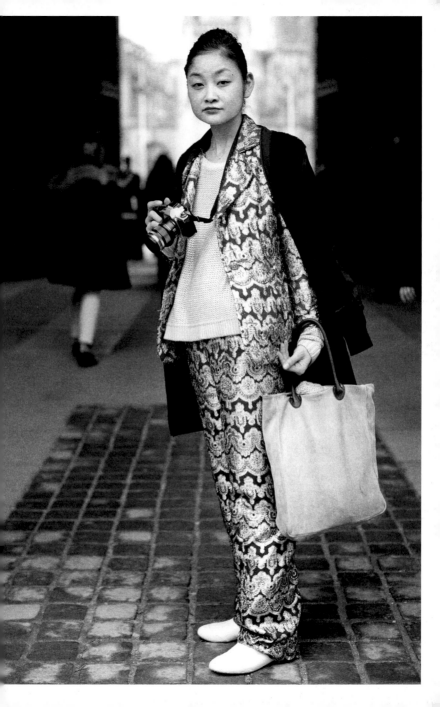

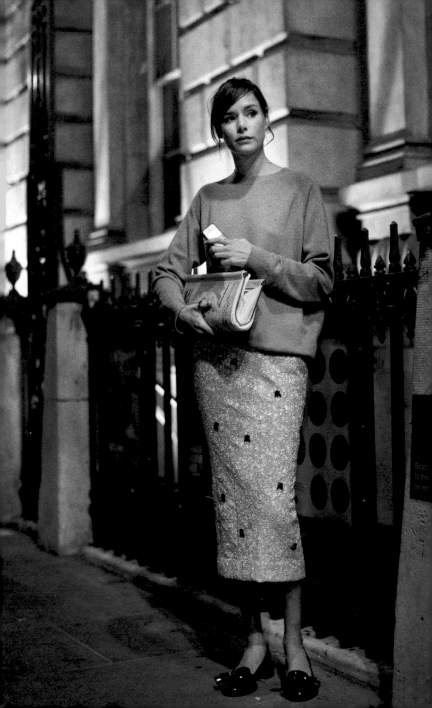

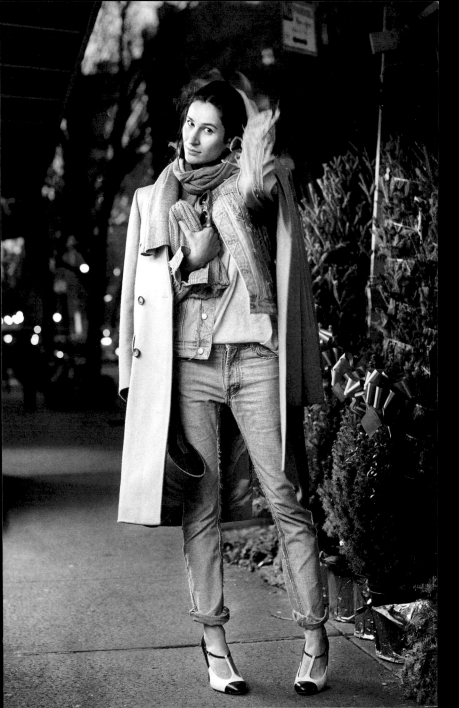

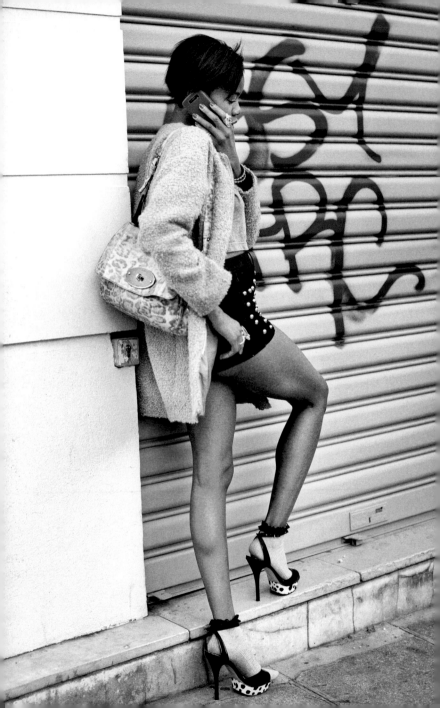

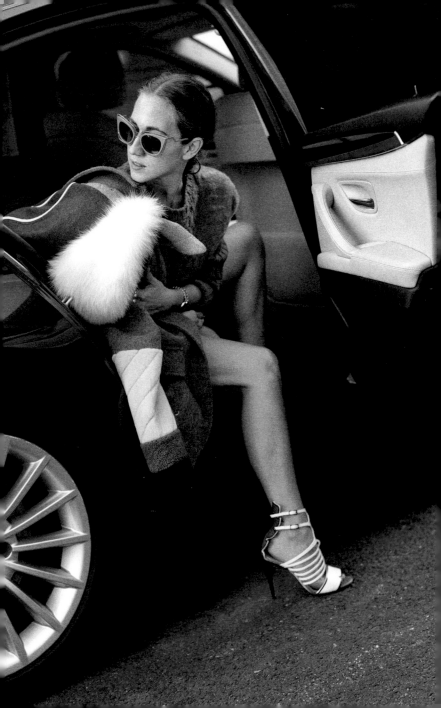

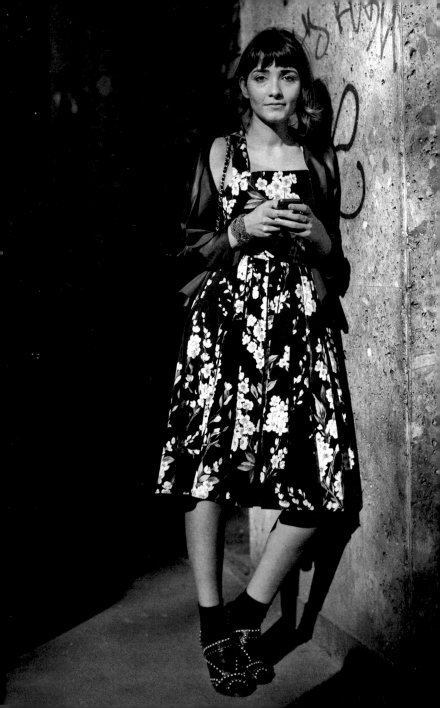

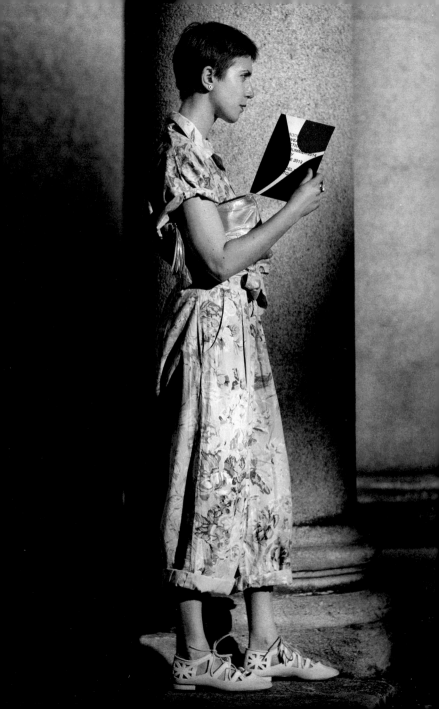

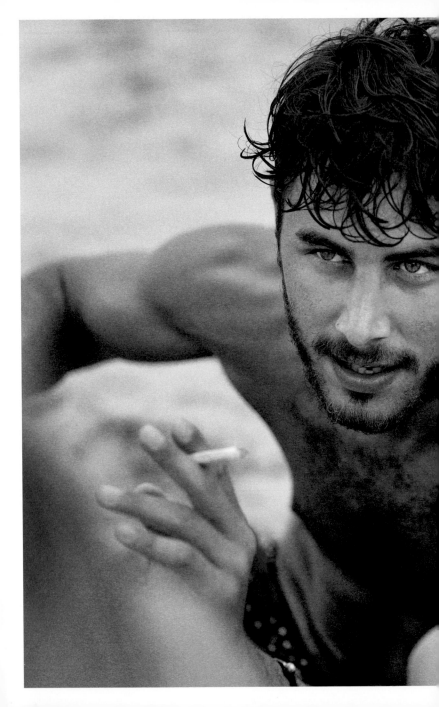

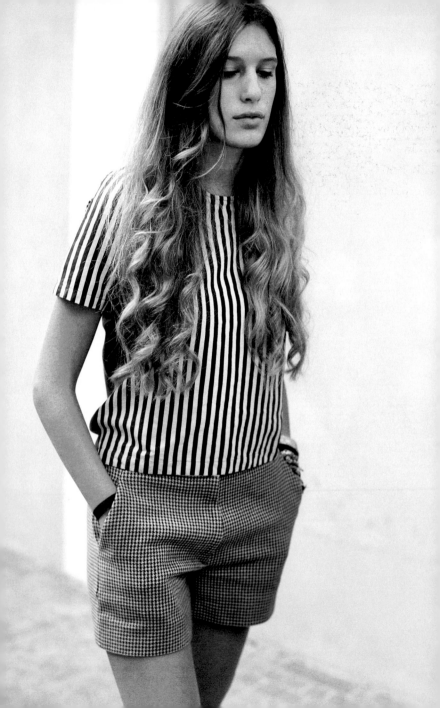

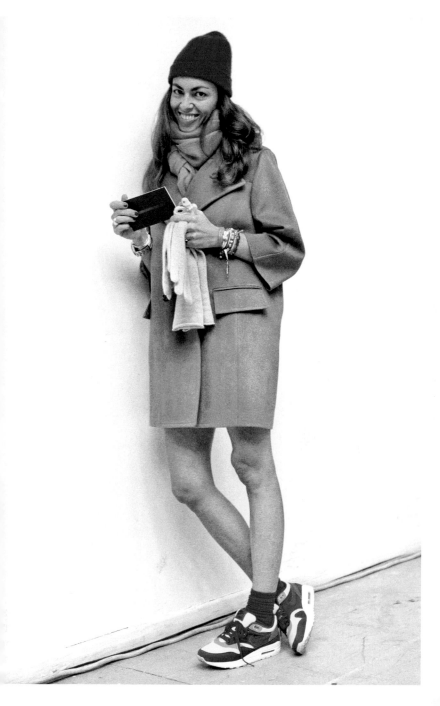

—

ON THE STREET...
ANDREA, DUBAI

—

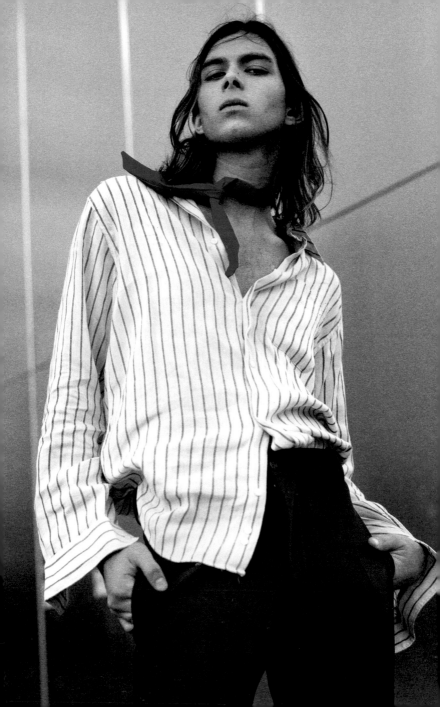

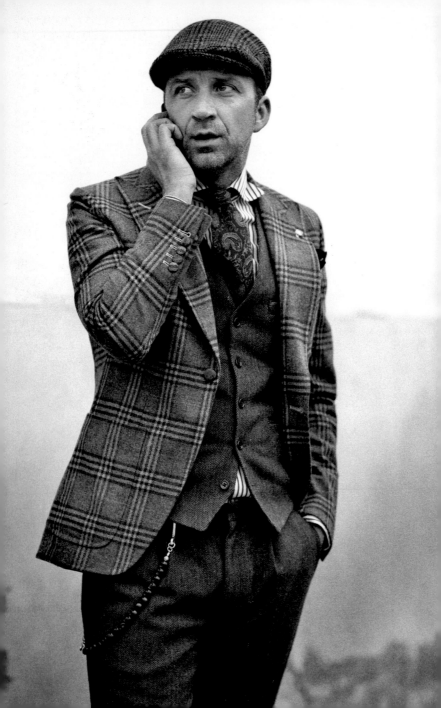

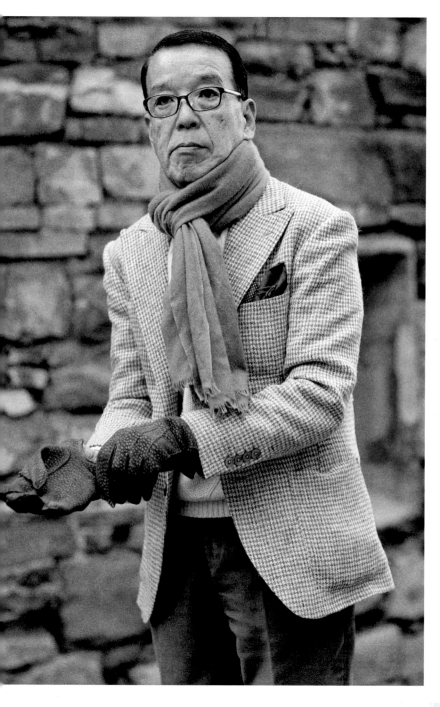

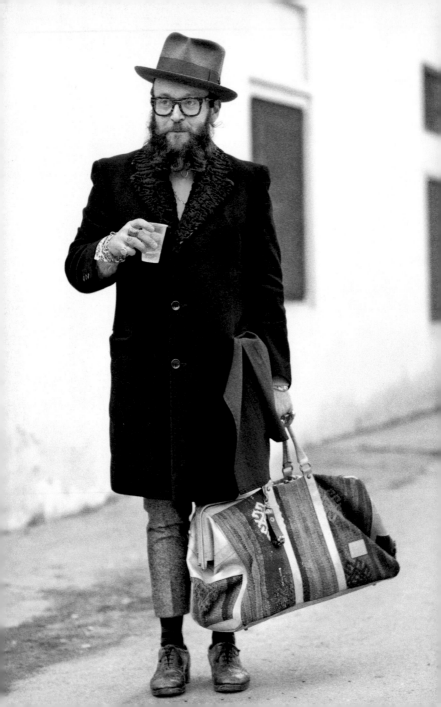

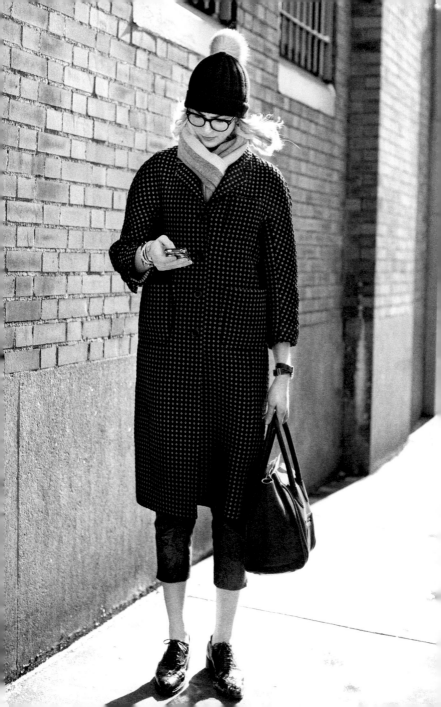

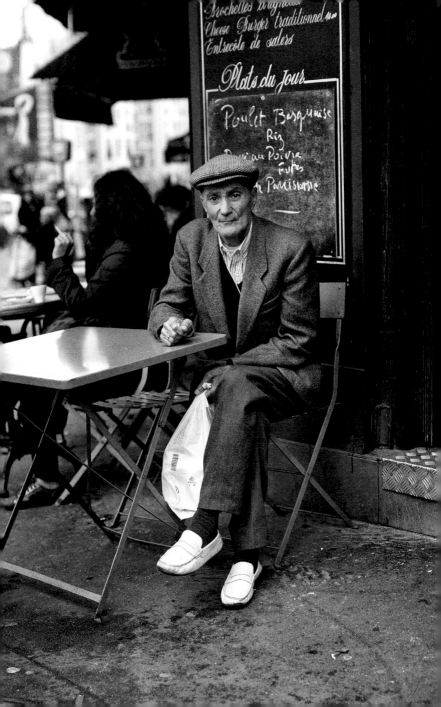

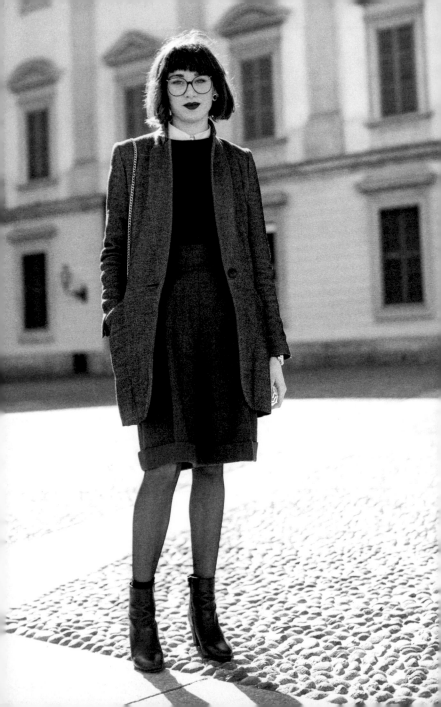

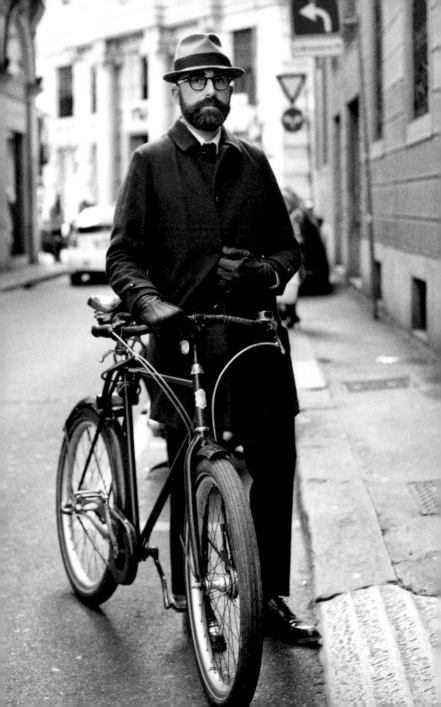

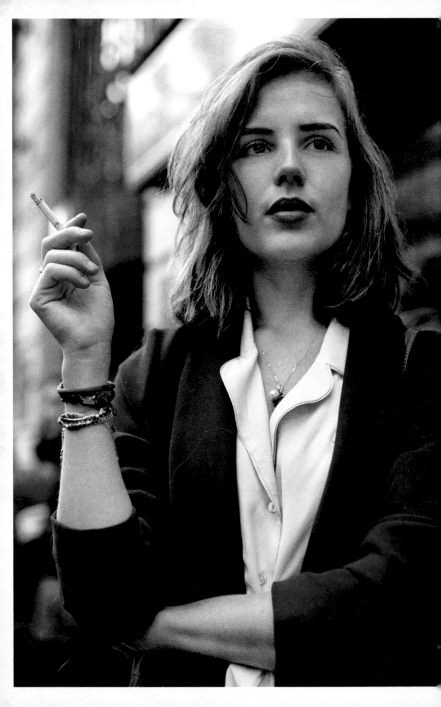

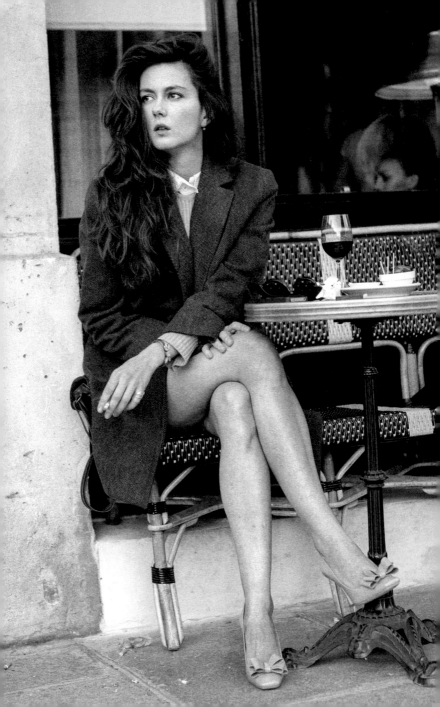

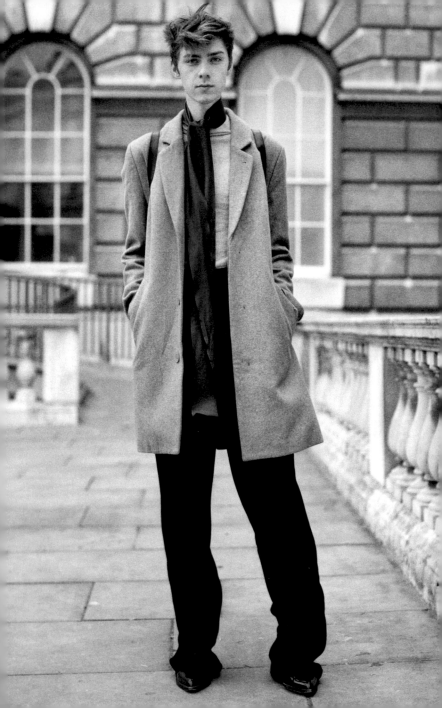

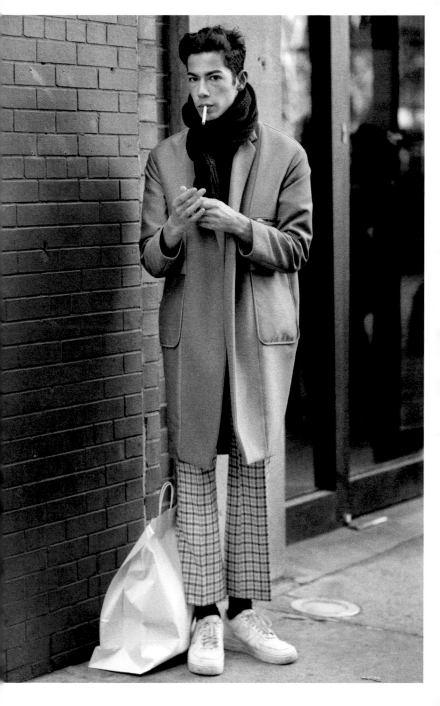

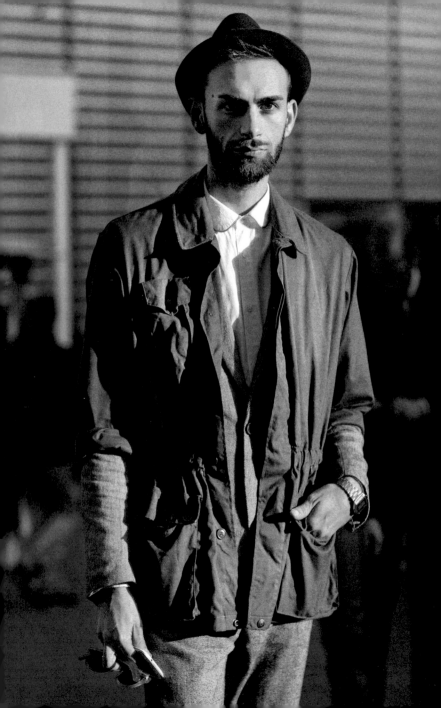

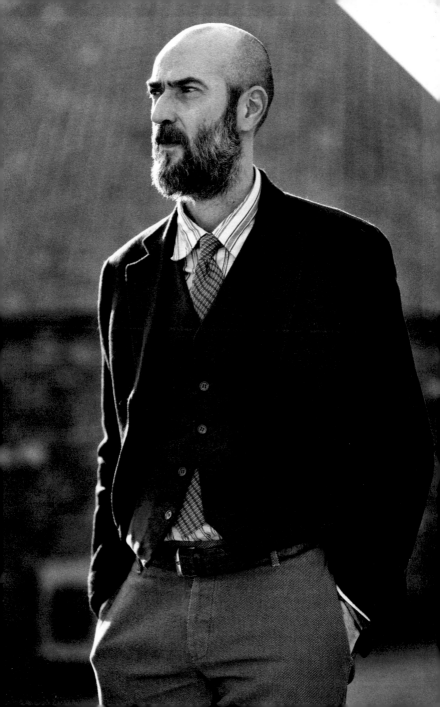

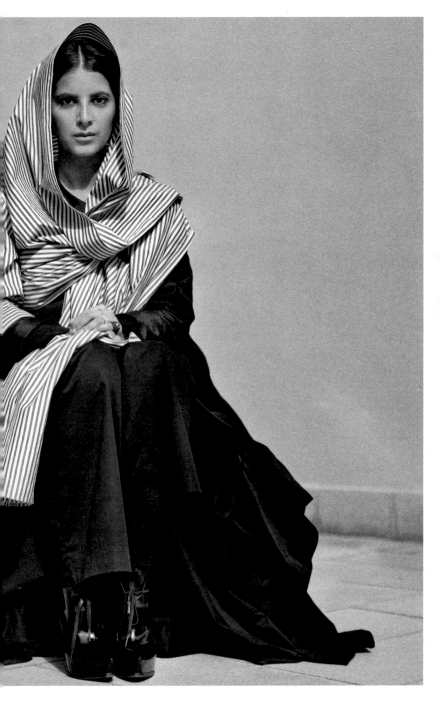

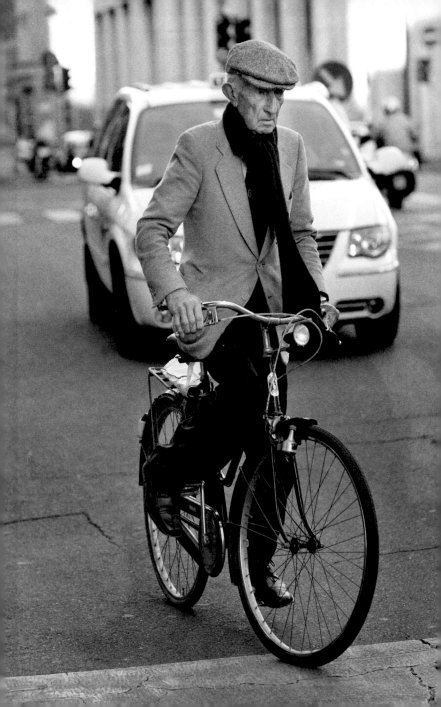

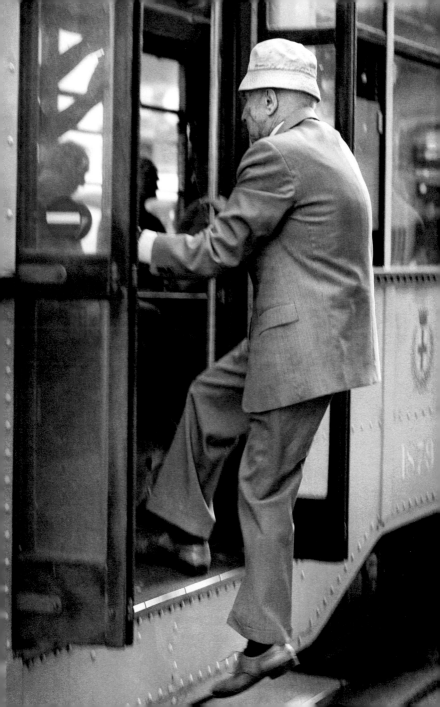

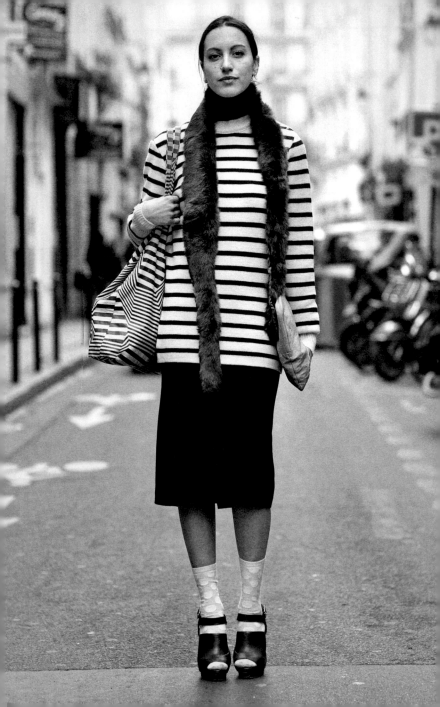

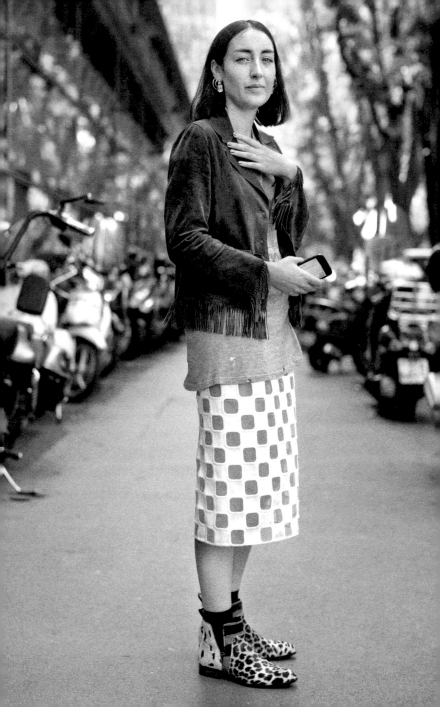

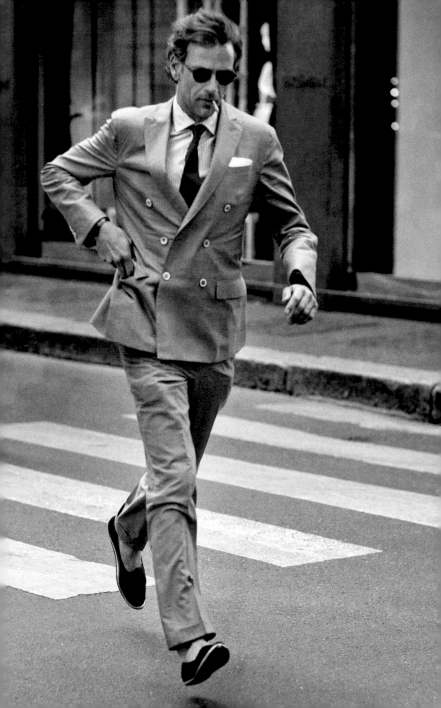

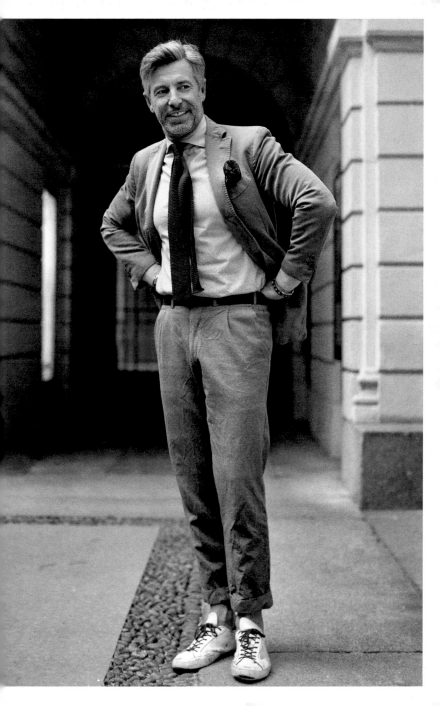

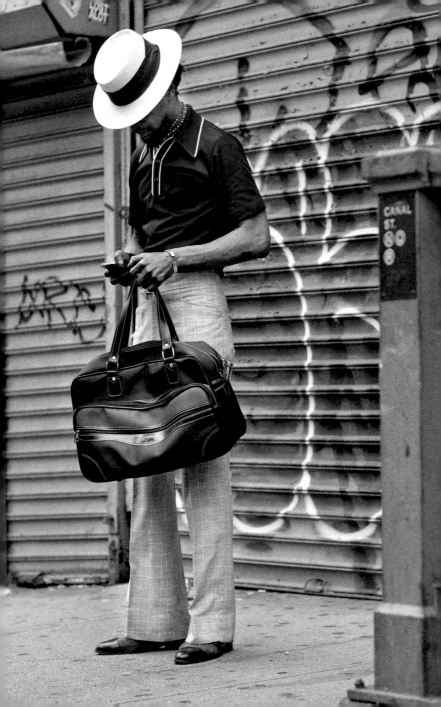

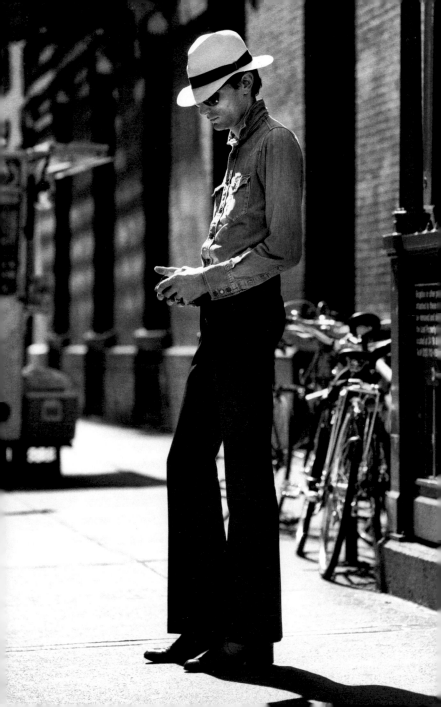

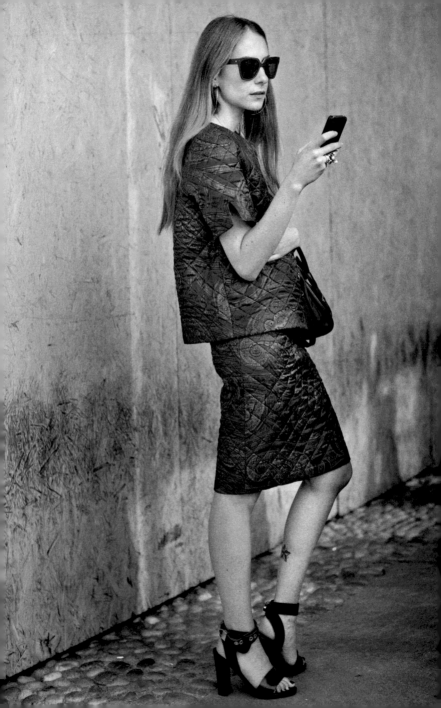

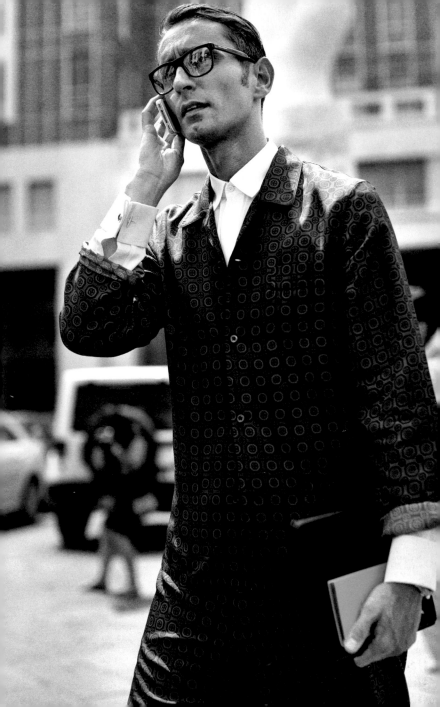

YUEH

I've watched Yueh's slow and sometimes painful transition from the boy he was born as to the woman he has always wanted to be.

When I ran into him last summer in Milan he had evolved dramatically since our last encounter, and further still since I last shot him (pages 28-9 in my second book, *Closer*). This time, he was wearing a black mesh t-shirt, a thin black bandeau underneath and well-worn, faded blue jeans. The light was late afternoon perfection so I asked if I could take a photo of him, with the special request to remove the bandeau. It was clear that because of treatment he would soon be developing breasts and that I wouldn't have another chance to capture this specific but small window of time as his body became her body. Yueh is a creative person and it only took him a moment to agree that the photo would be much more compelling that way. What I found very touching is that it took him a few deep breaths before he removed his top there on the street. His mental transformation to womanhood was so complete and ingrained but the physical reality was still catching up.

I admire so much the bravery it takes for people to take control of their life and own who they are inside. You would think that in 2015 this would be a foregone conclusion, but outside of progressive big cities like New York or Tokyo, the road is being paved by brave souls like Yueh.

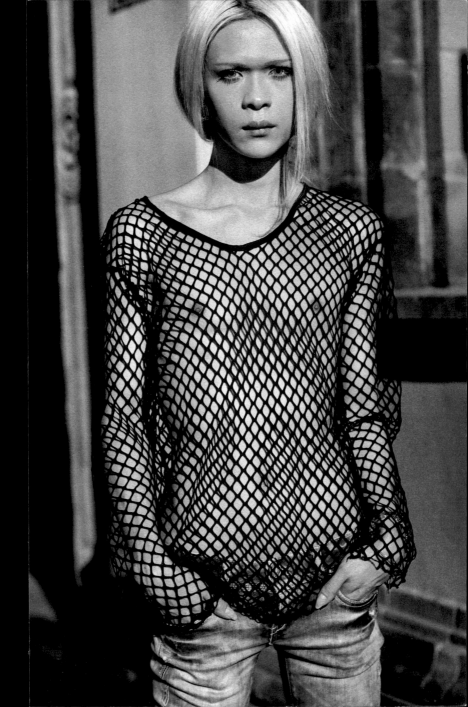

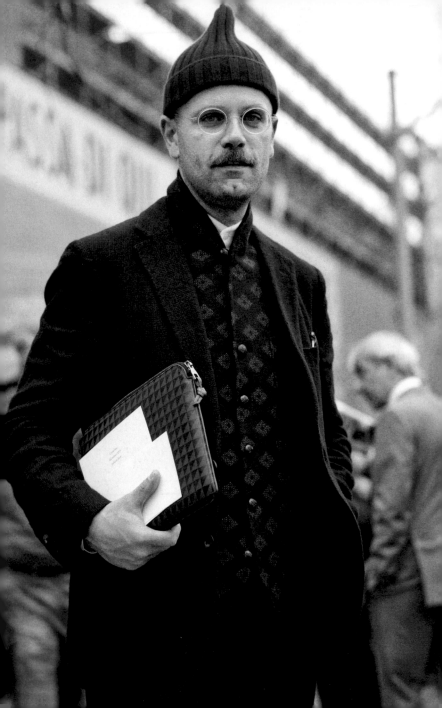

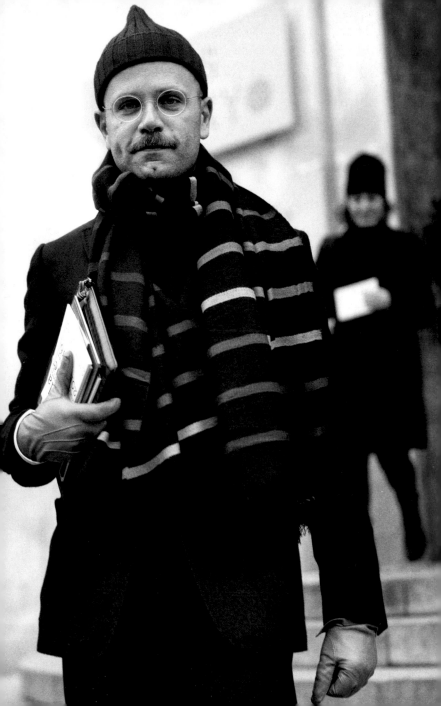

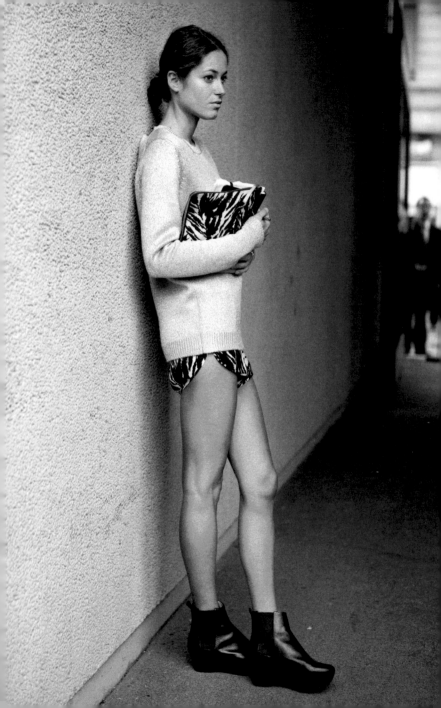

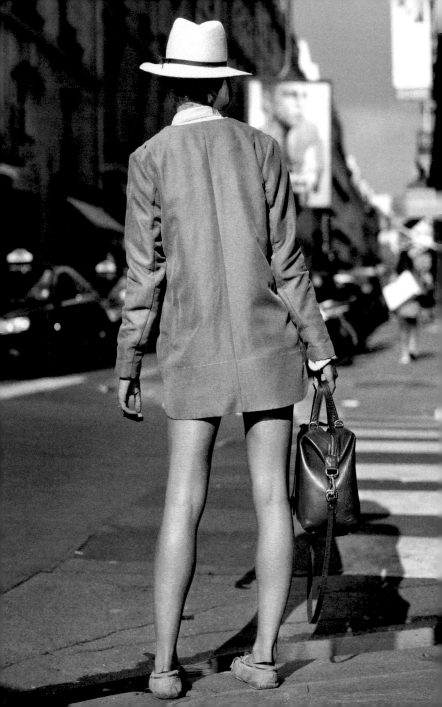

—

ON THE STREET...
VARANASI, INDIA

—

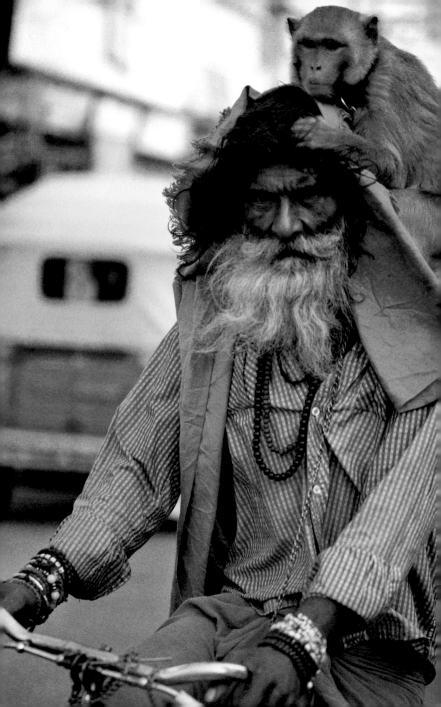

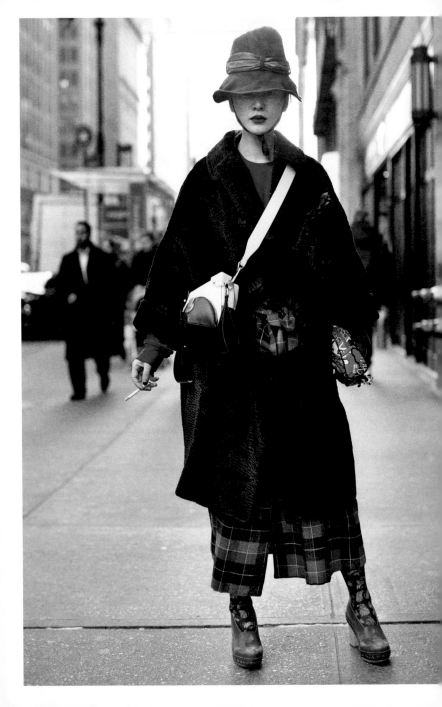

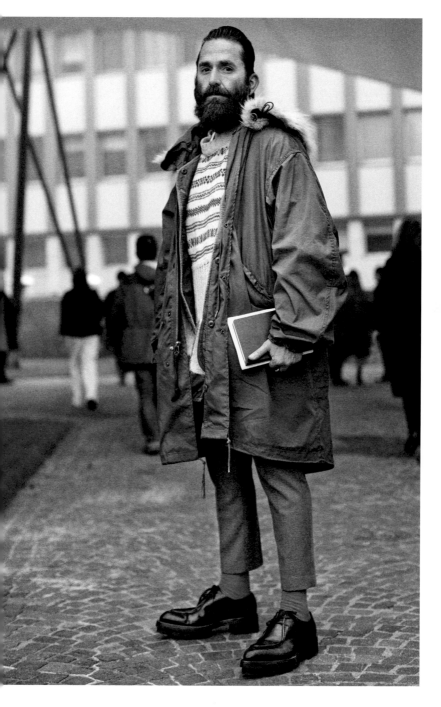

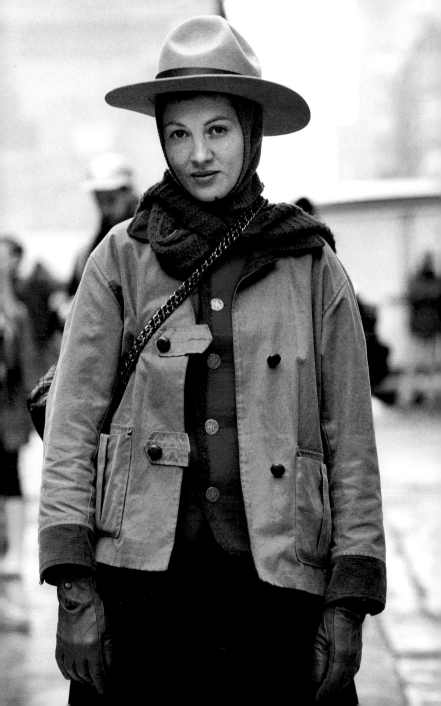

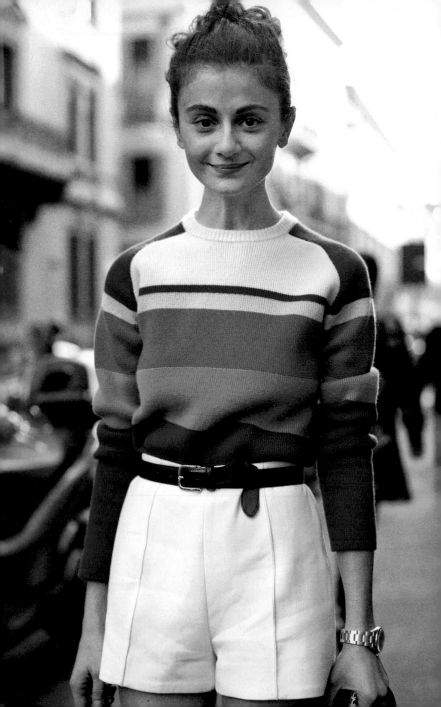

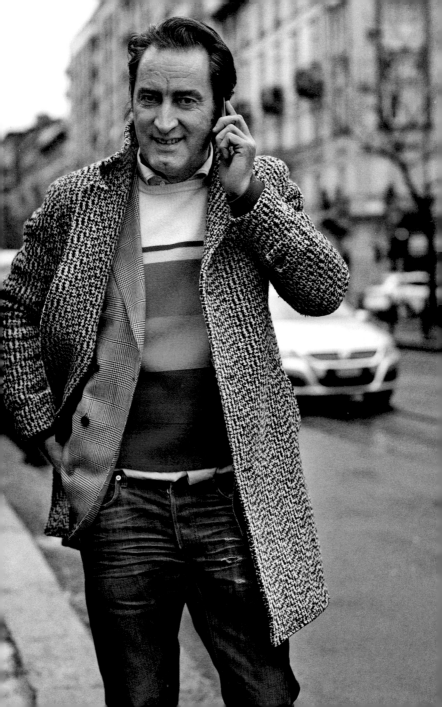

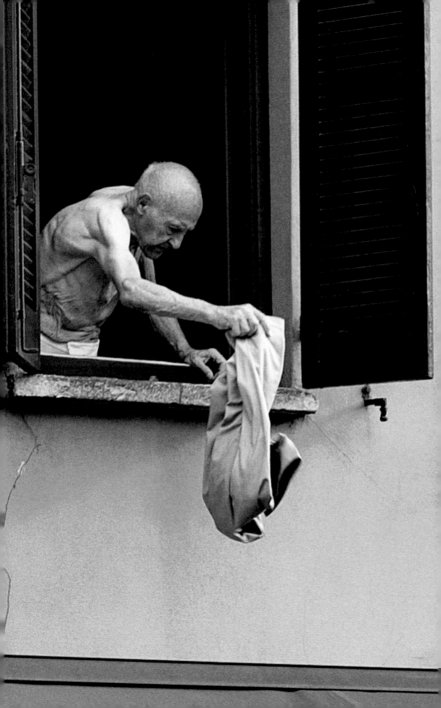

—

ON THE STREET...
WEST 33RD ST.,
NEW YORK

—

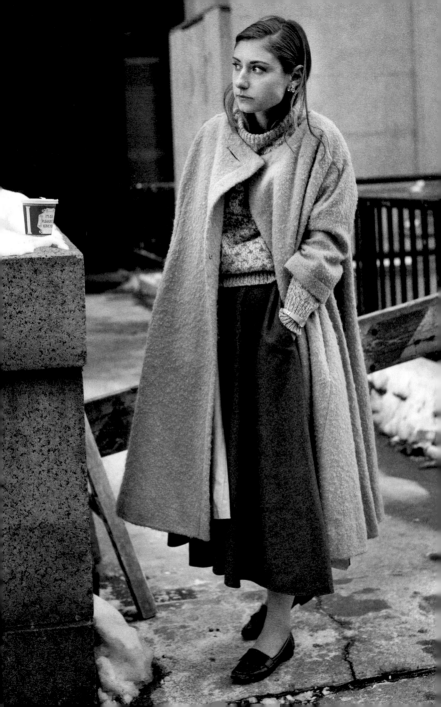

THE WHITE GLOVES OF VARANASI

Sometimes your eyes see something that your brain can't figure out fast enough. I LOVE that feeling.

I've tried to train myself, when this happens, to start shooting and figure it out later.

I'm in Varanasi, India, on the back of a bike-rickshaw, going surprisingly fast considering the road is packed with hundreds of other rickshaws, cows, bikes and the occasional car. Emerging from the on-coming traffic is the fiercest cyclist I've ever seen. So powerful, fast and vivid when set against the bland, muddy-coloured workforce on their morning commute. As she comes into focus I see she's covered head to toe in a riot of colours, both floral and graphic. Her head-wrap, covering her entire face and upper body, her blouse and pants, stream behind her, trying to keep up.

Most striking of all were her steel-straight arms covered in long white gloves right out of a 1950s prom. Already everything about her was surprising but the gloves seemed such an odd addition that they stuck out in my mind's eye.

Later that day, I saw another young lady covered head to toe in rich sunset jewel-tones with the same long white gloves. Then again the next morning, a girl in sober black and red with the same long white gloves. This was a true micro-trend. I asked my guide if it was religion-based or to protect against the dusty streets. She laughed and said, 'It's bloody sunny and we like to stay as fair as possible! We don't want dark arm-tans like farmers!'

Just another example that no matter how far from home I travel the simple human condition of vanity is alive and well everywhere.

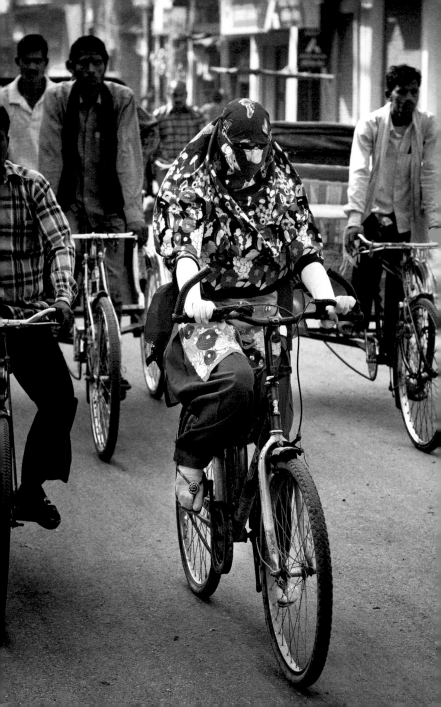

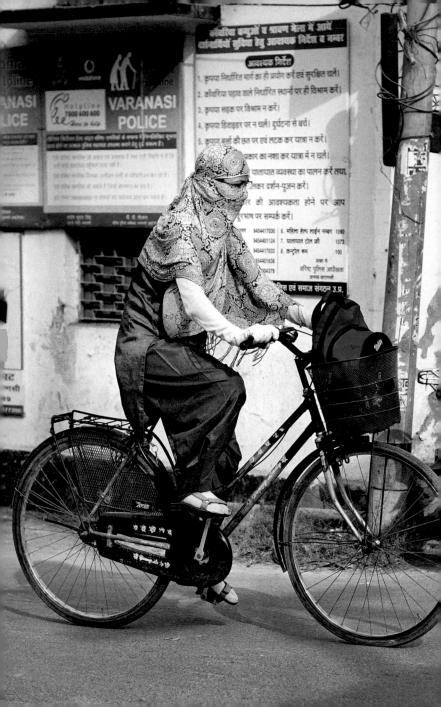

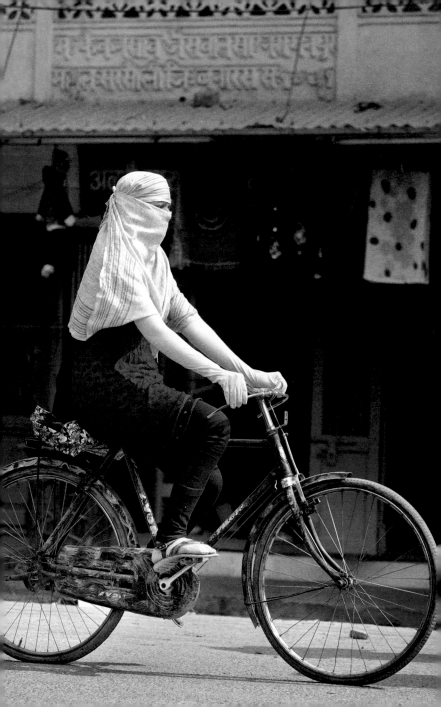

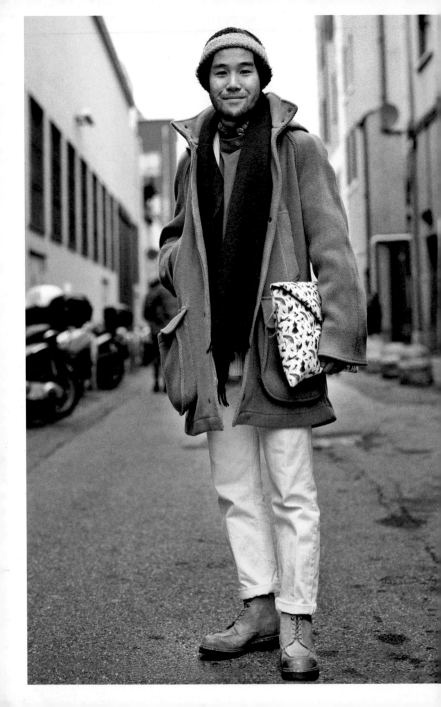

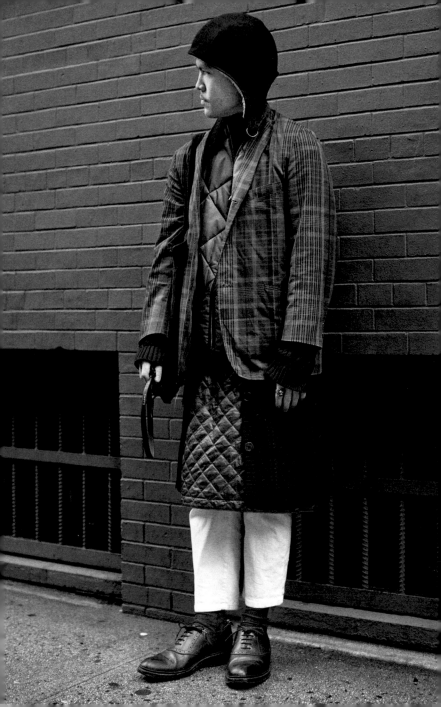

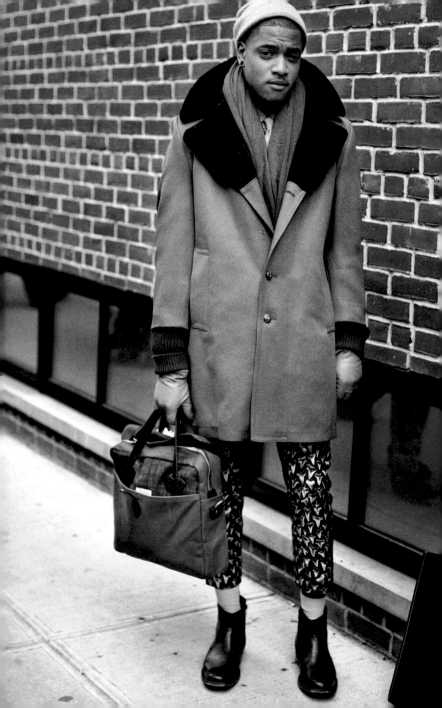

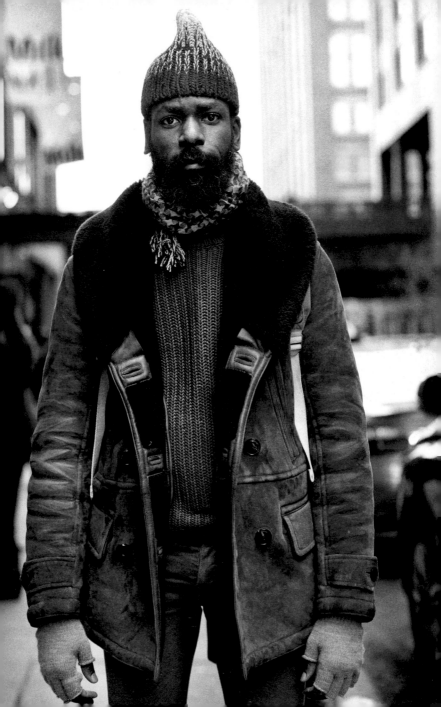

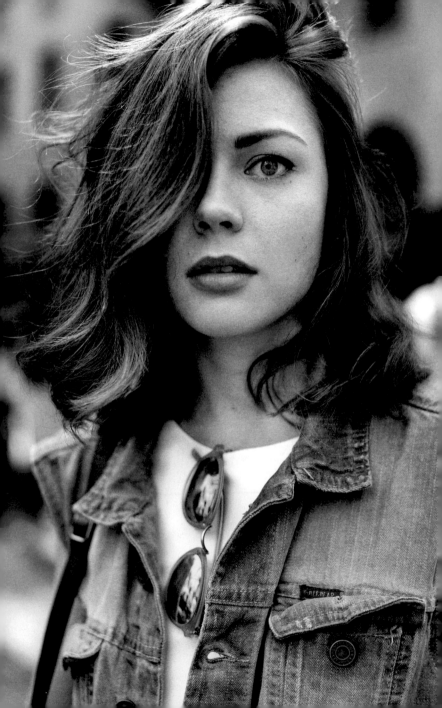

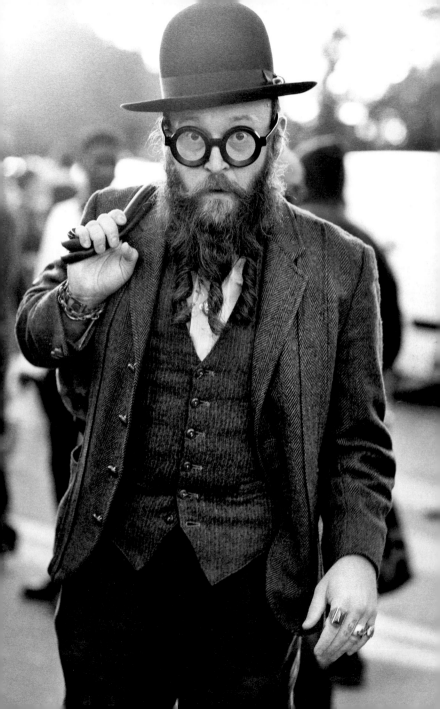

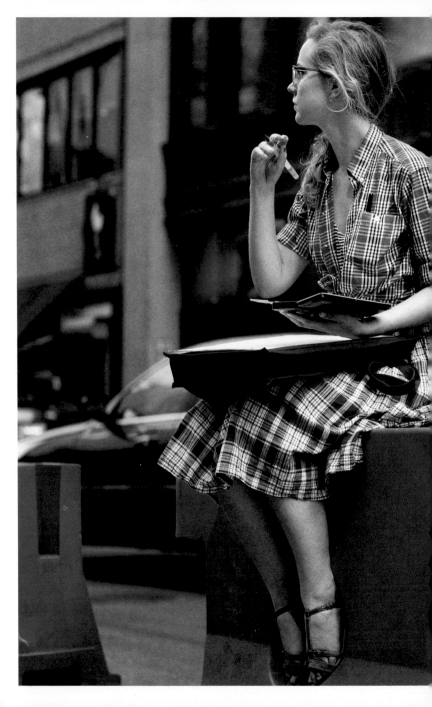

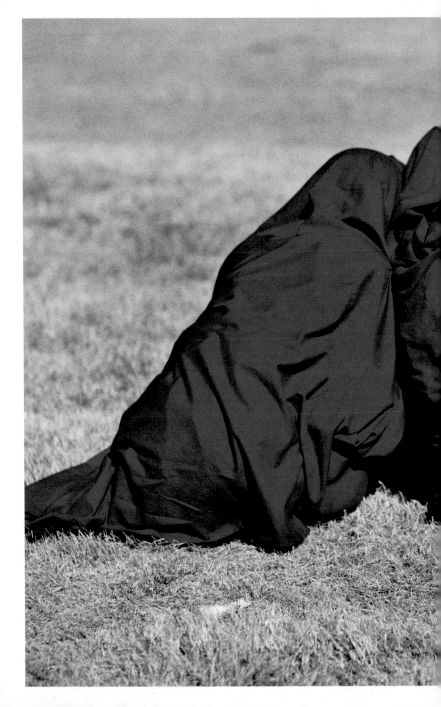

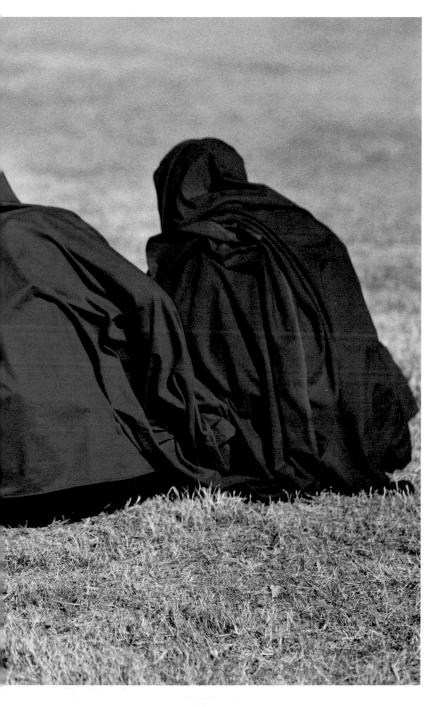

—

ON THE STREET...
JOHANNESBURG,
SOUTH AFRICA

—

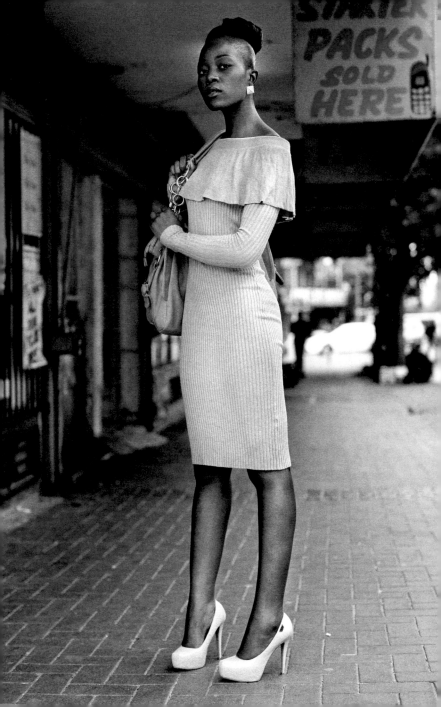

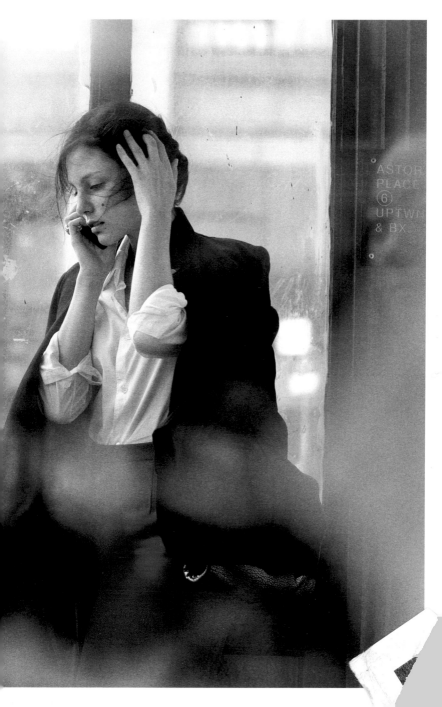

ASTOR
PLACE
⑥
UPTW
& BX

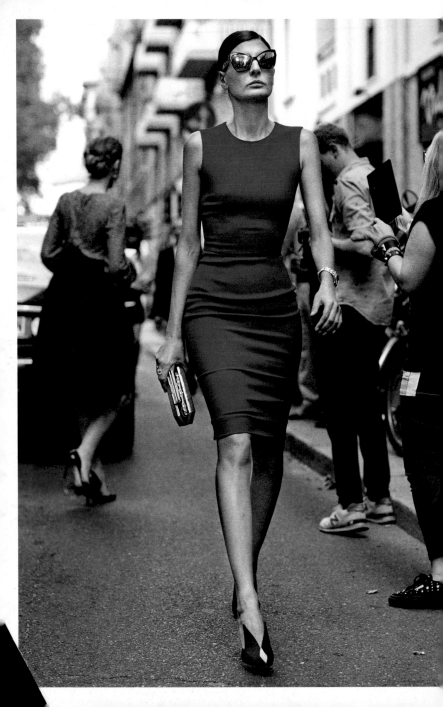

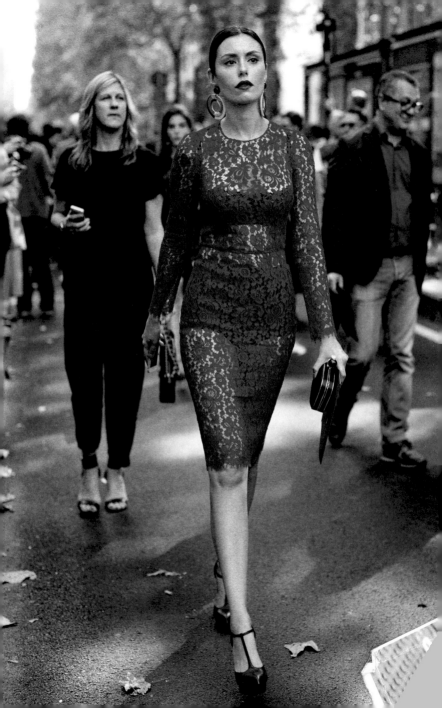

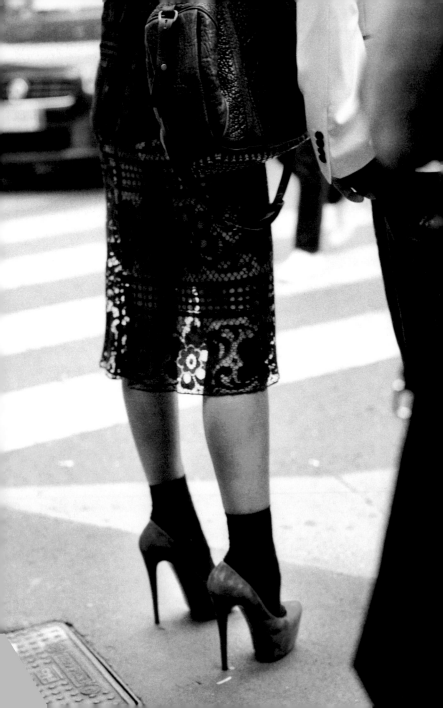

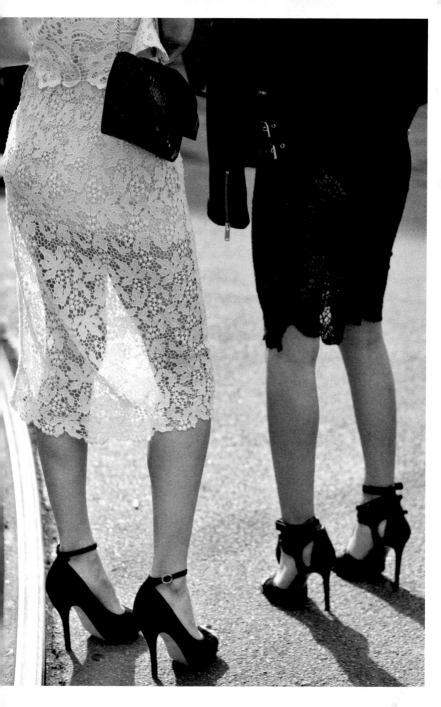

—

ON THE STREET...
CORSO VENEZIA,
MILAN

—

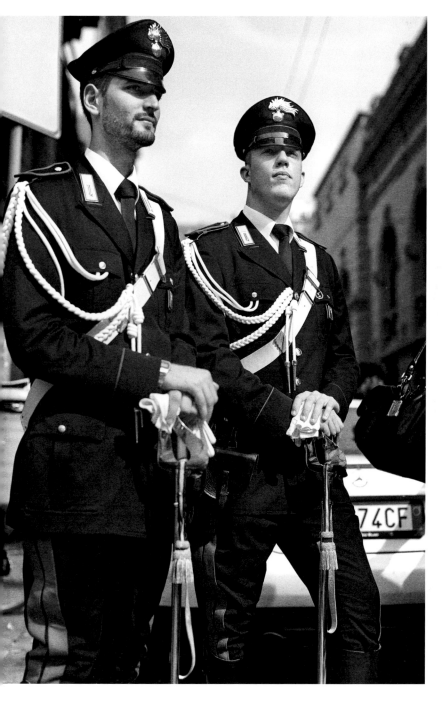

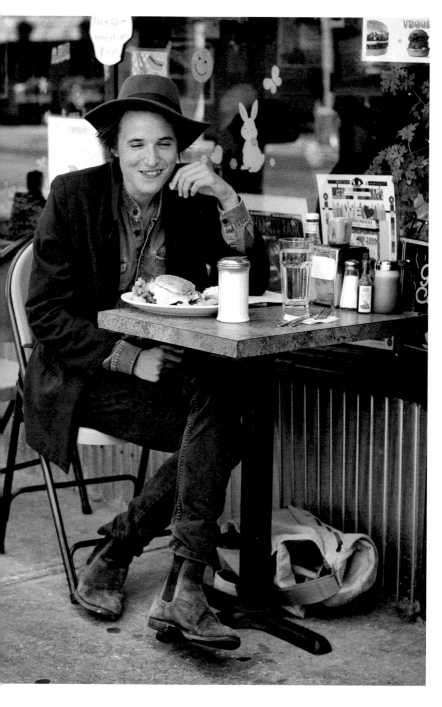

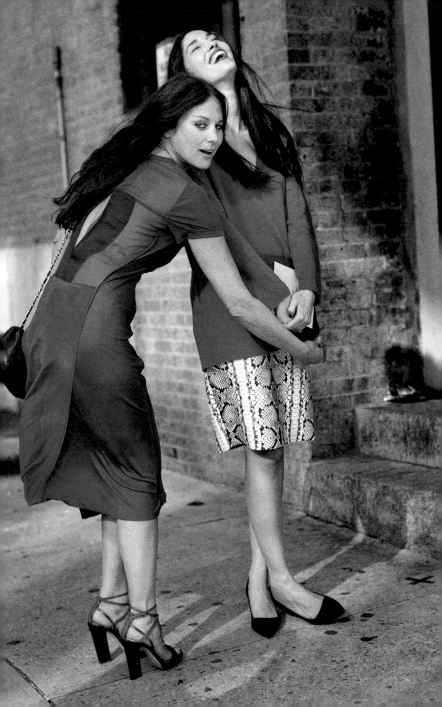

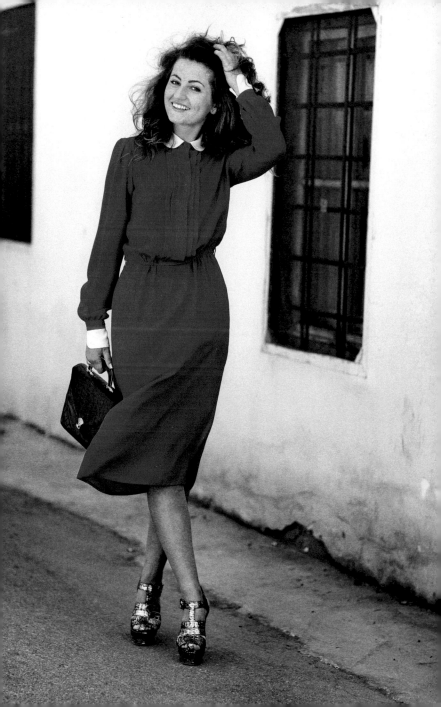

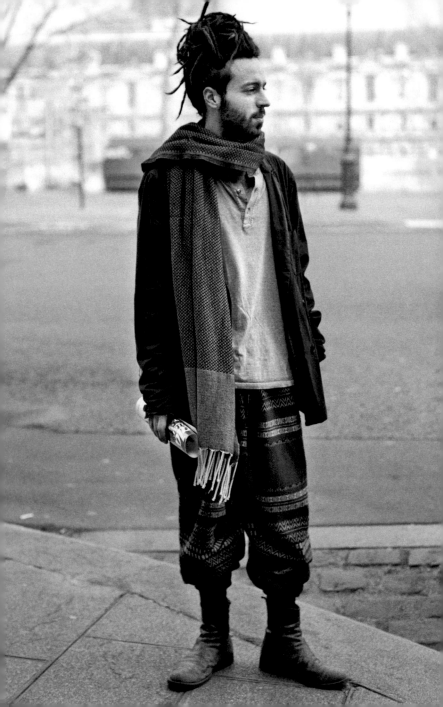

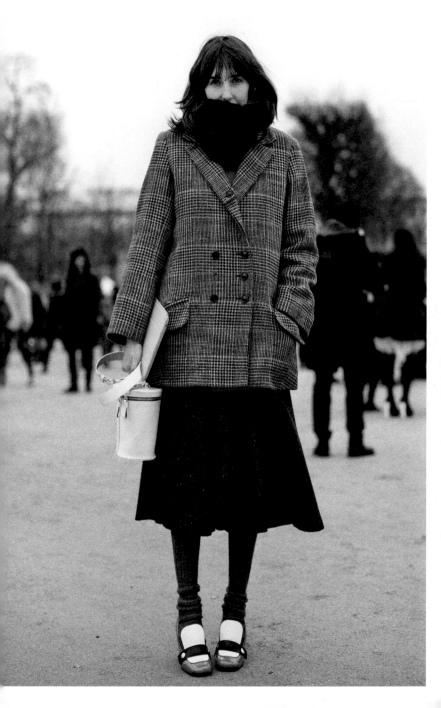

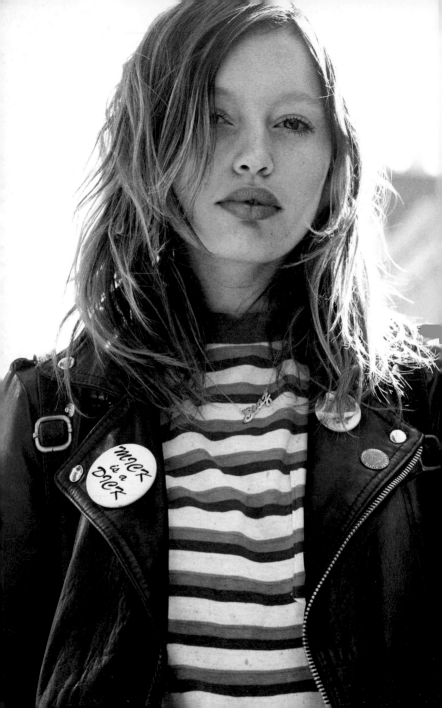

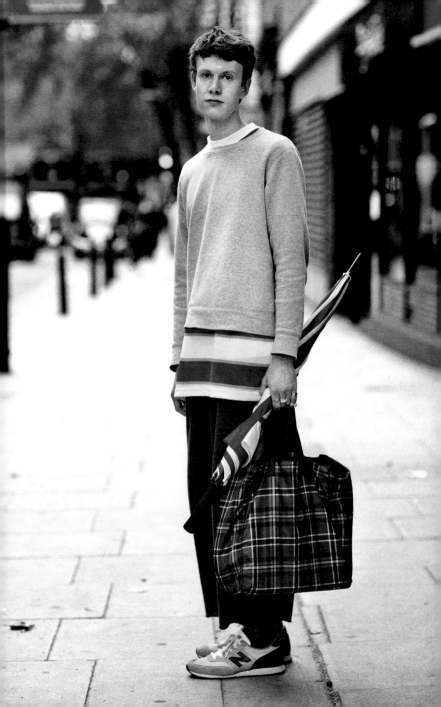

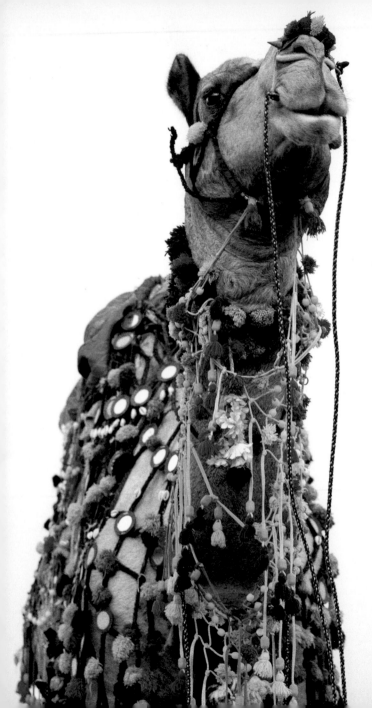

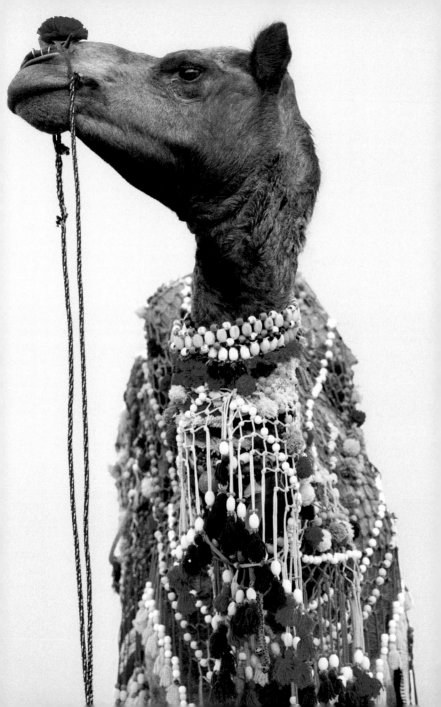

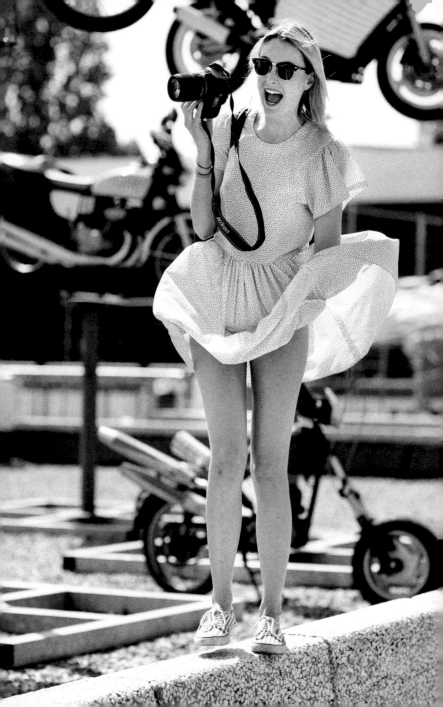

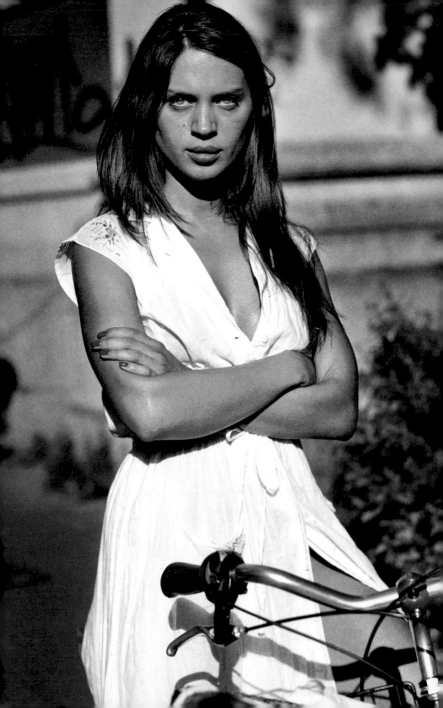

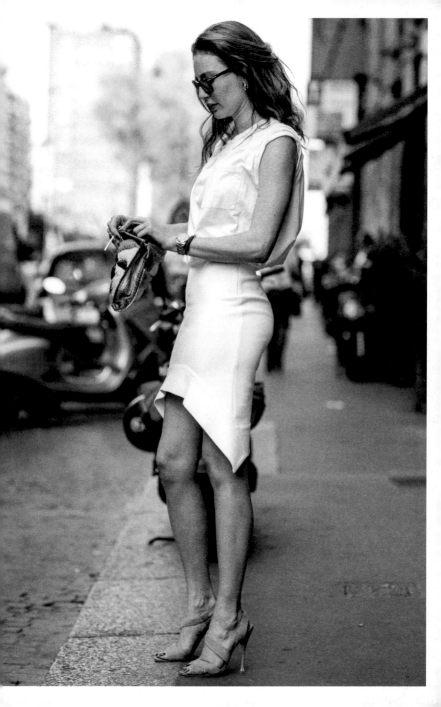

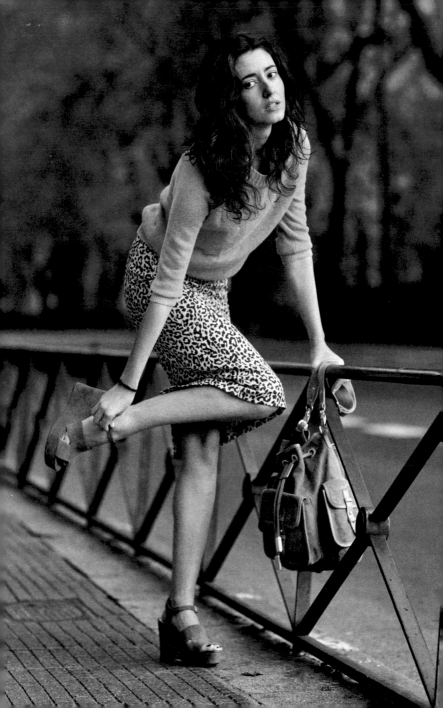

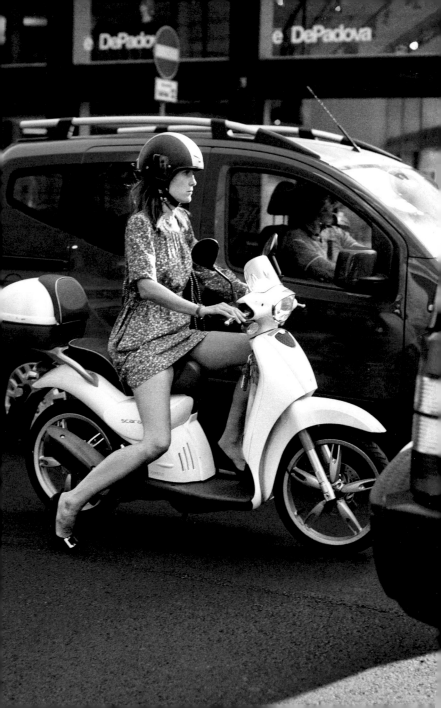

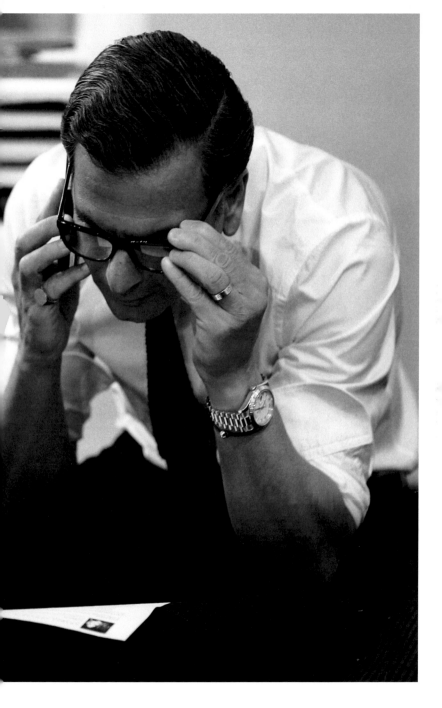

—

ON THE STREET...
THE BAND LEADER,
NEW DELHI

—

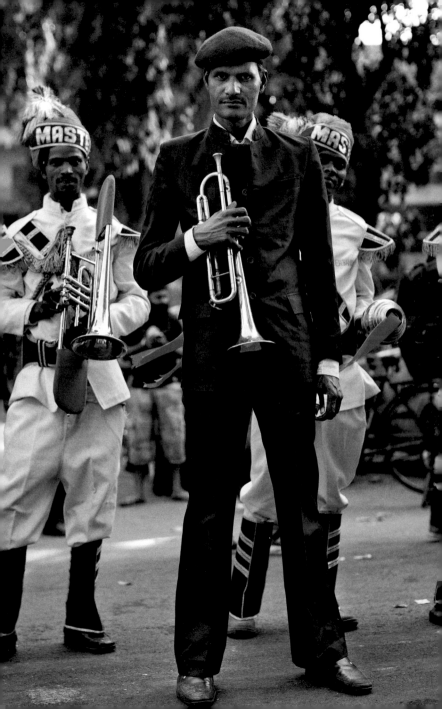

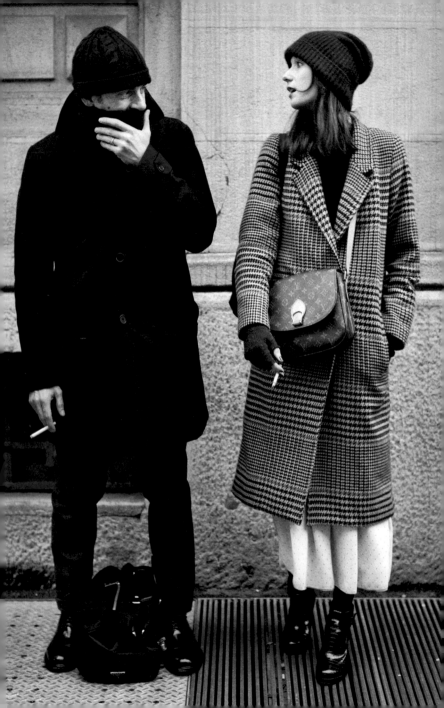

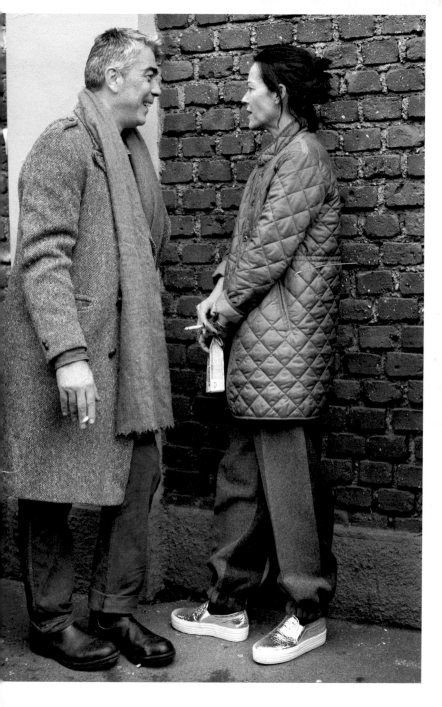

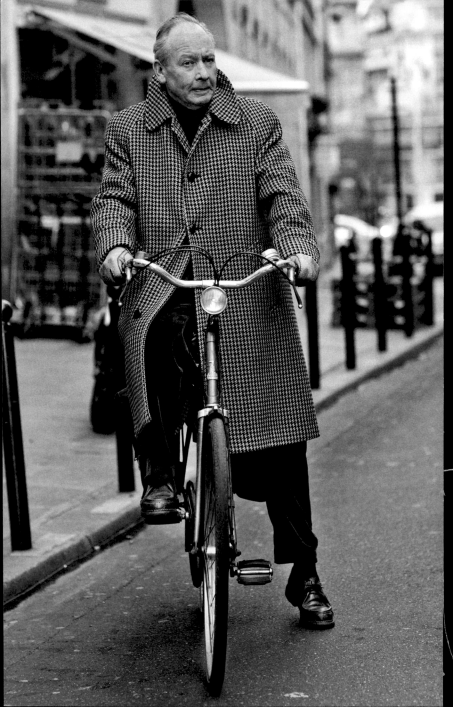

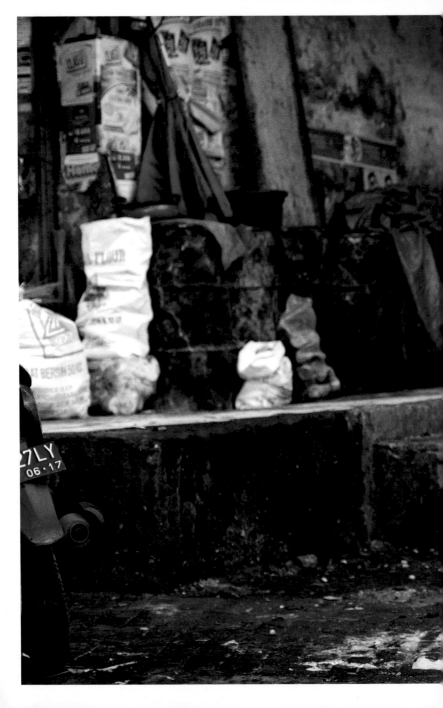

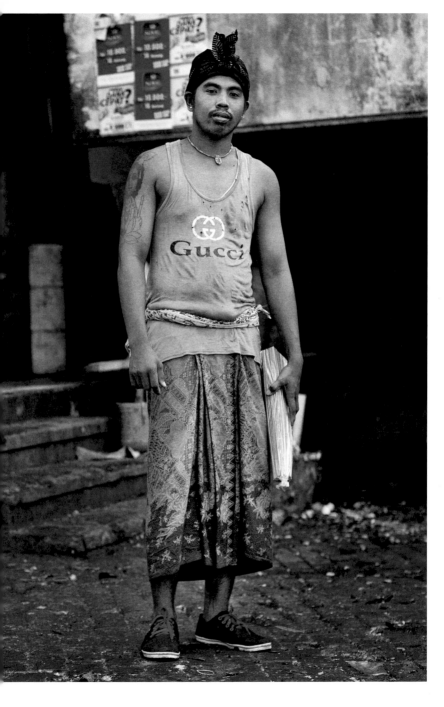

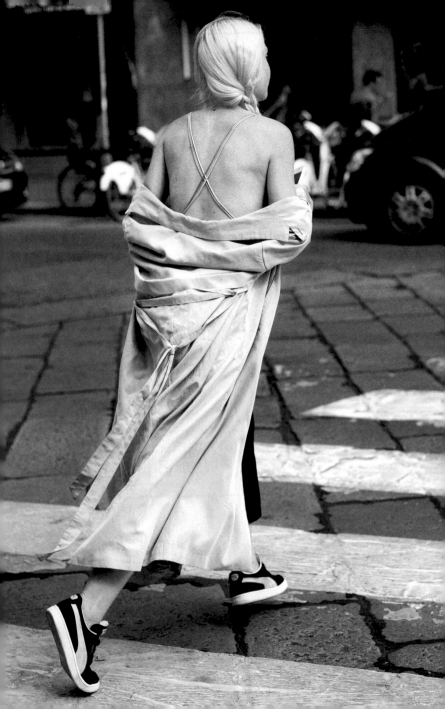

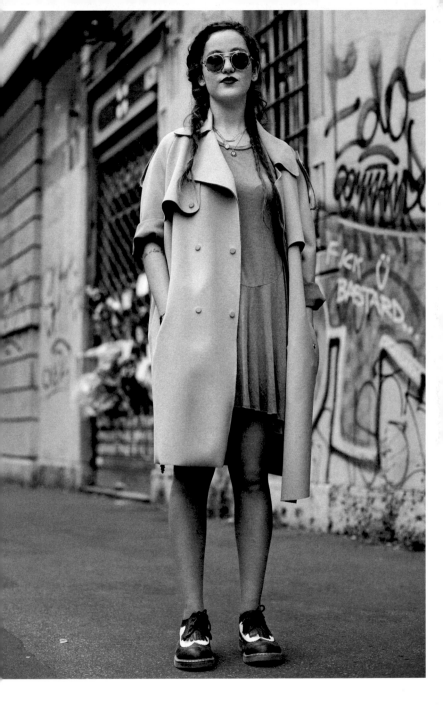

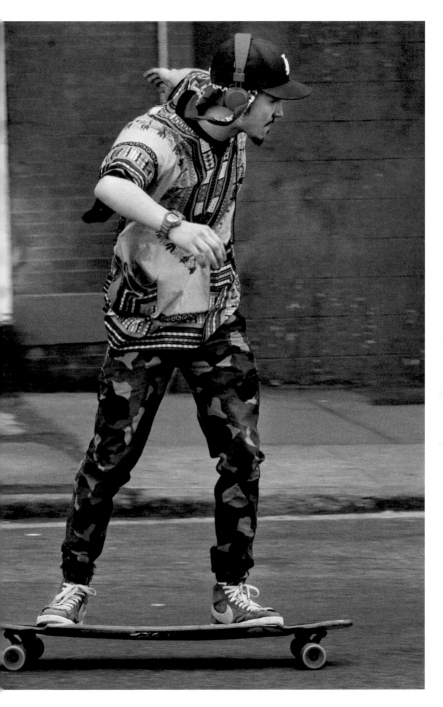

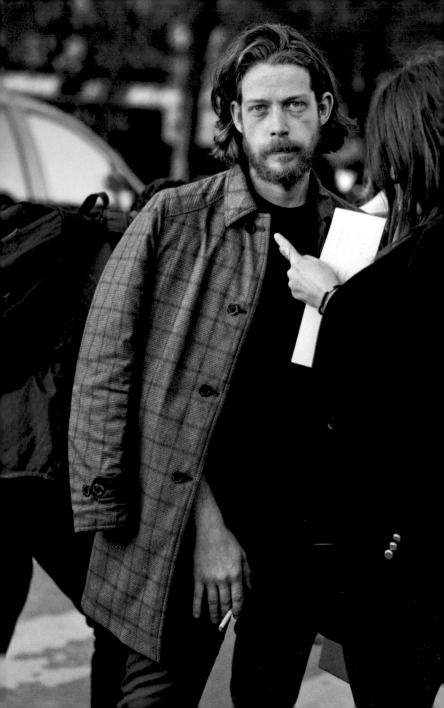

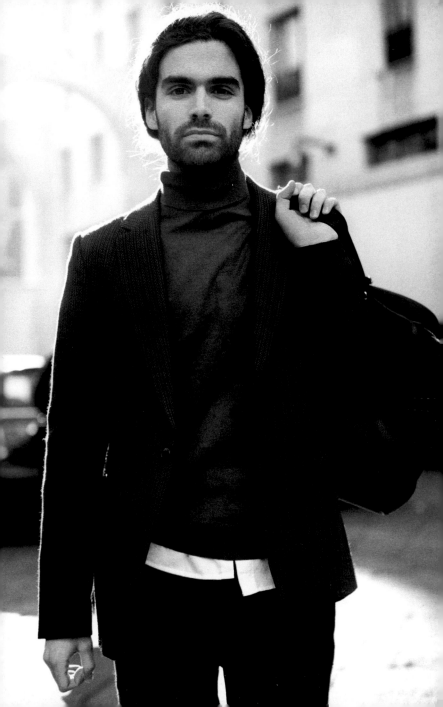

CAROLINE

———

I don't know how Caroline Issa didn't make it into my first two books. She's easily one of the most beautiful women I know and she has clearly established herself as a style icon for our times.

The problem is that Caroline is so damn charming and so damn funny that I often forget to shoot her. She's one of those people that I enjoy so much as a friend, I take for granted how striking and how cool she really is once we get talking. And, amazingly, she is unaware of her own beauty, so she's not expecting me to shoot her.

But I have finally found a solution. As you'll see in the following images, she is usually looking back over her shoulder. This is because when I first see her, I call out, she turns (hopefully smiles when she sees me) and I get the shot right away. Then, with my work done, we can focus on our main agenda… fashion gossip.

———

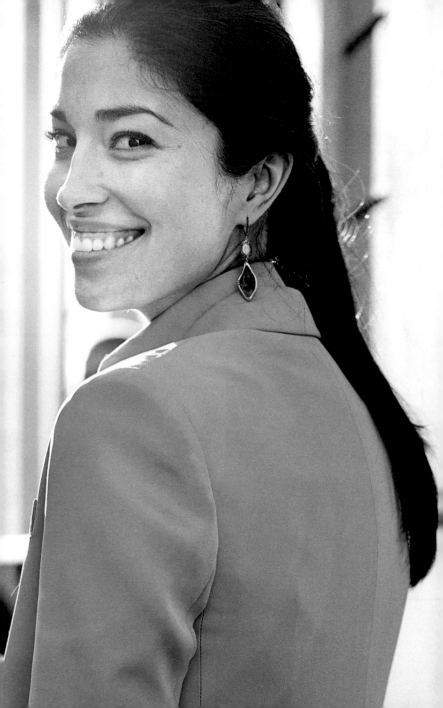

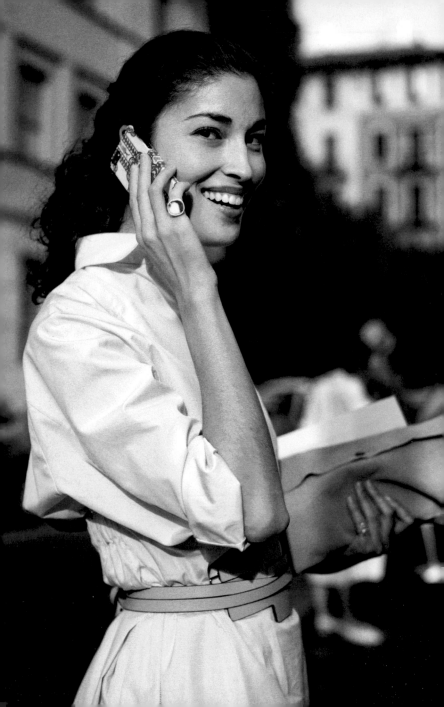

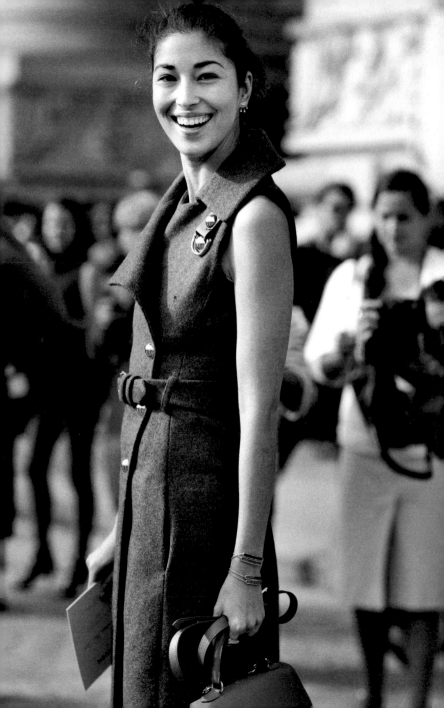

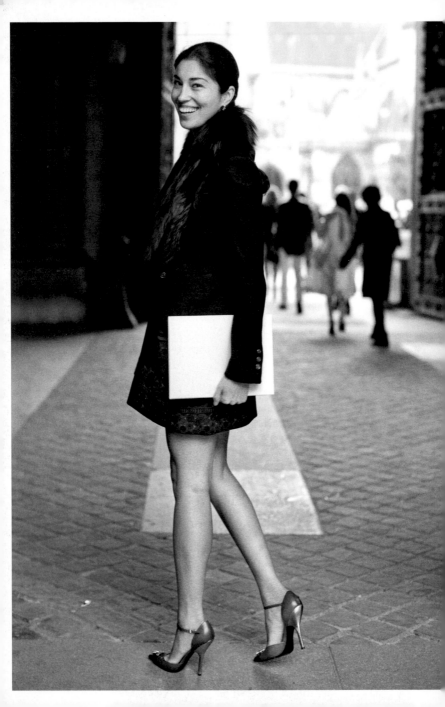

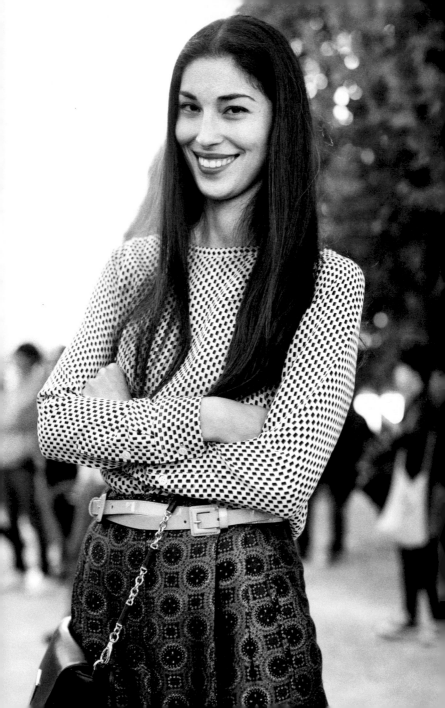

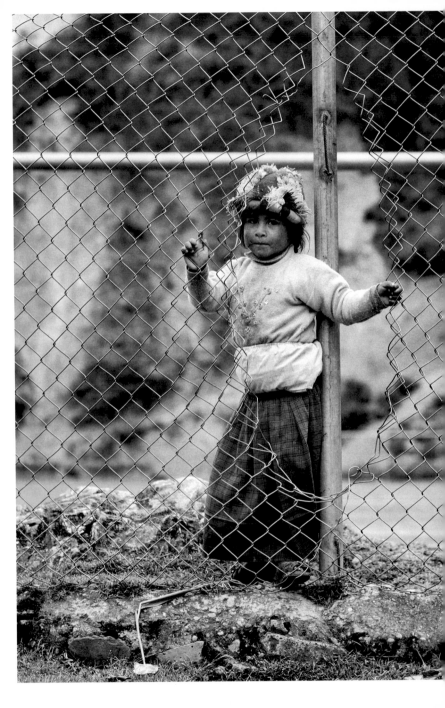

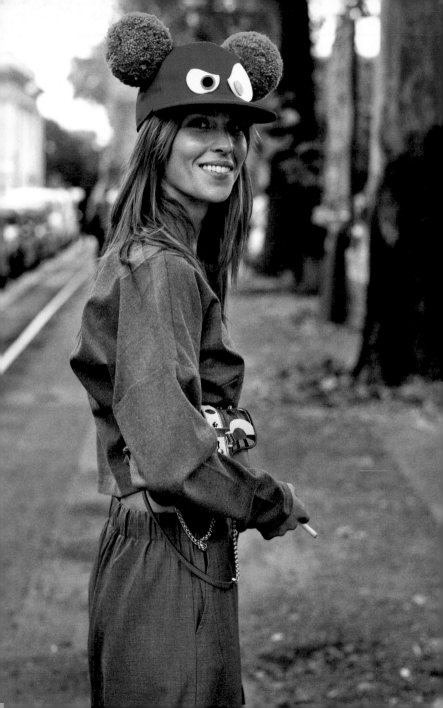

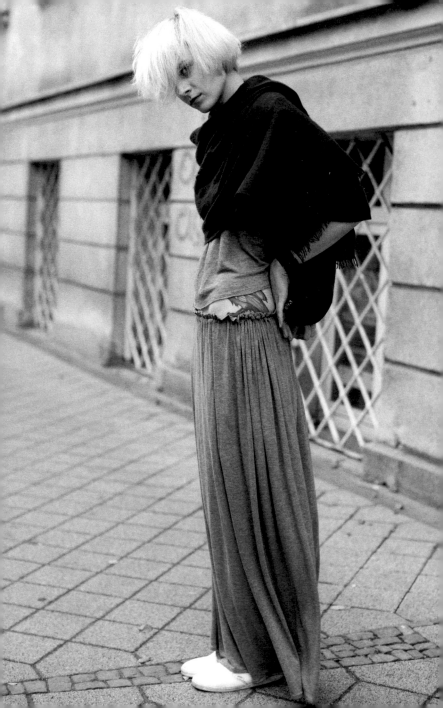

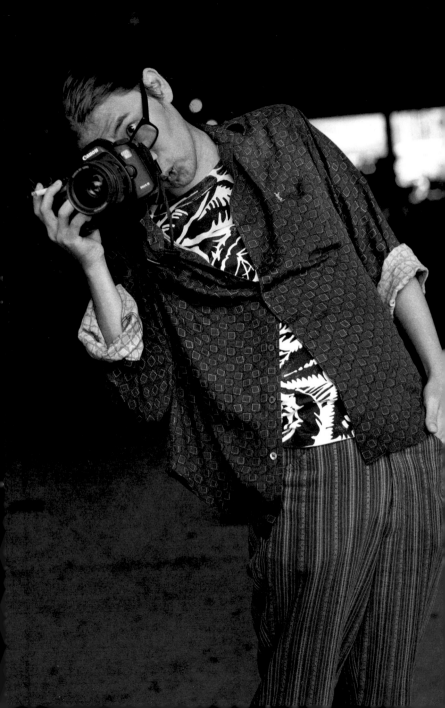

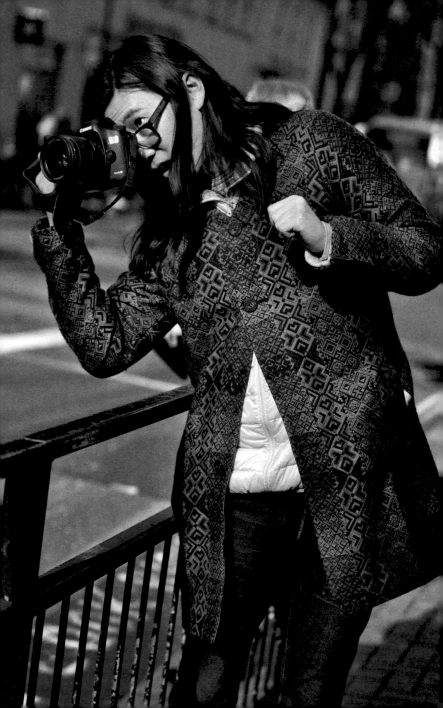

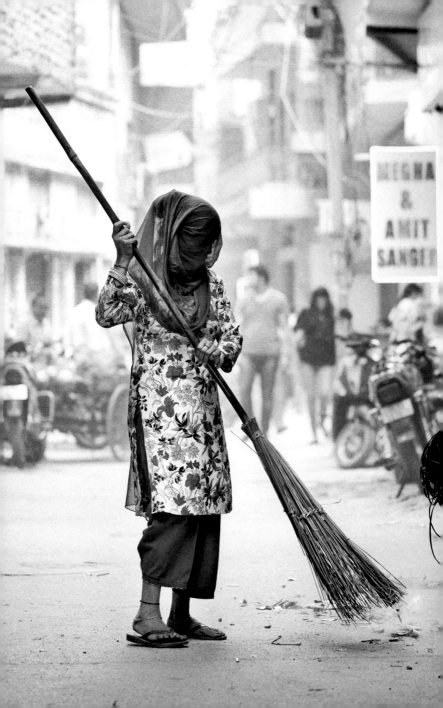

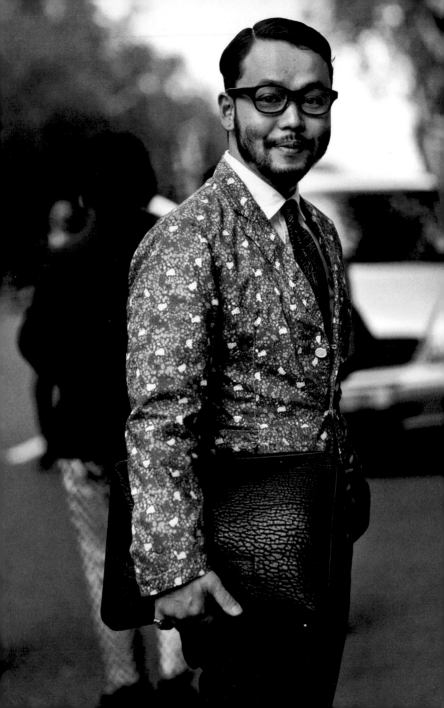

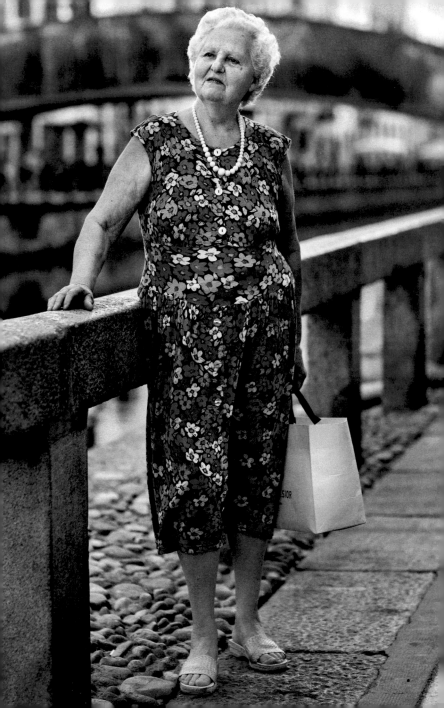

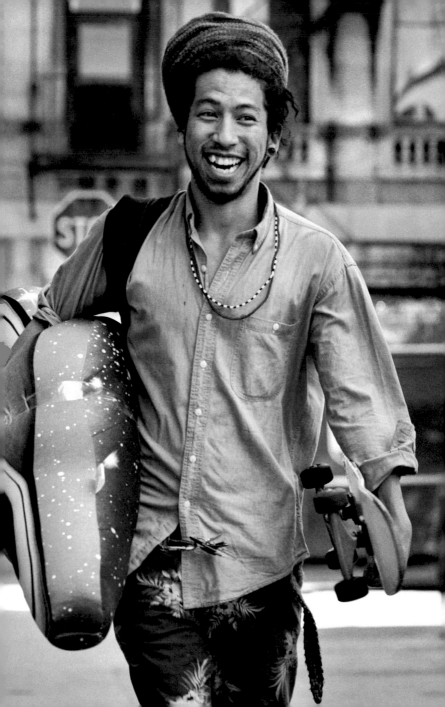

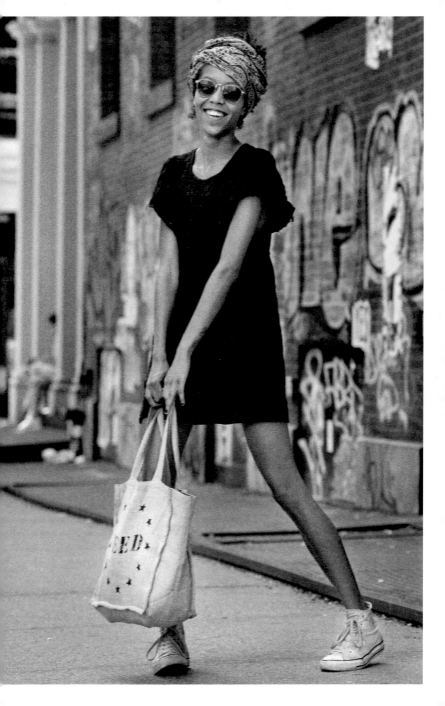

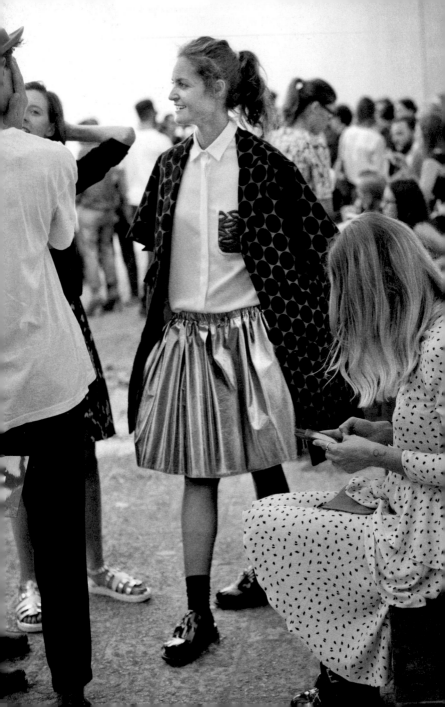

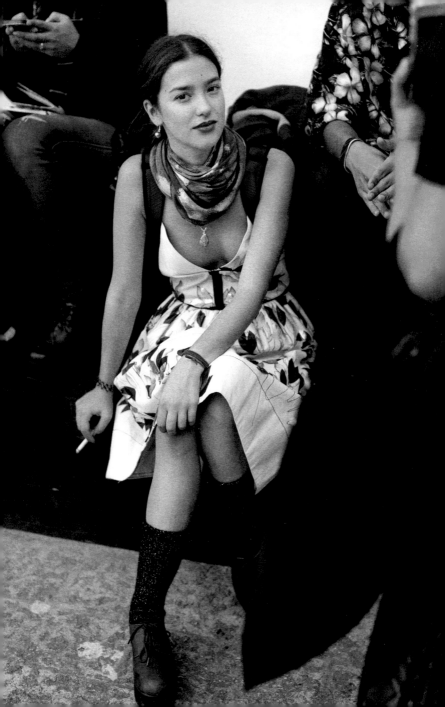

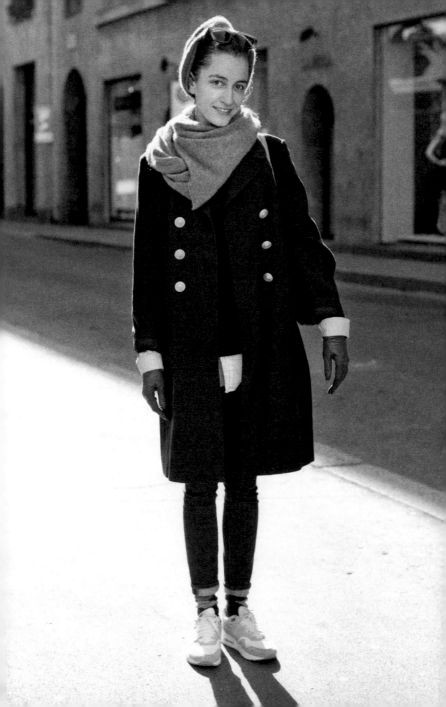

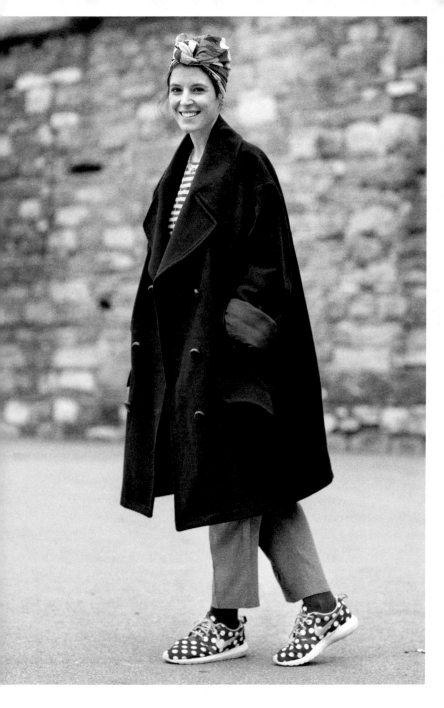

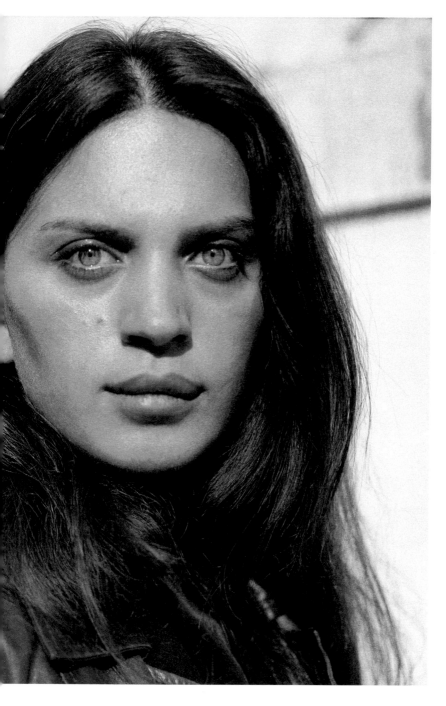

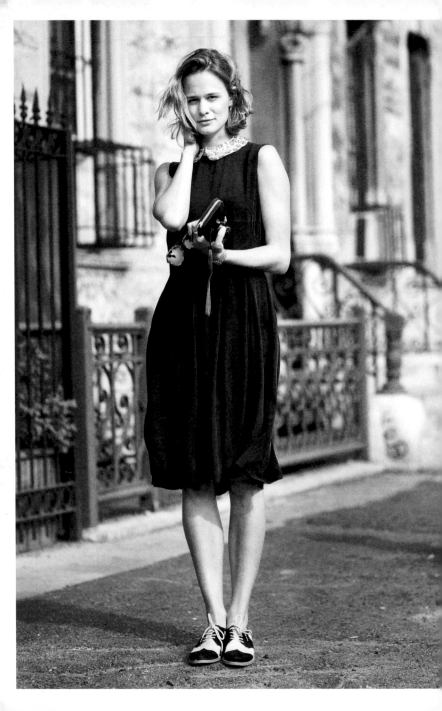

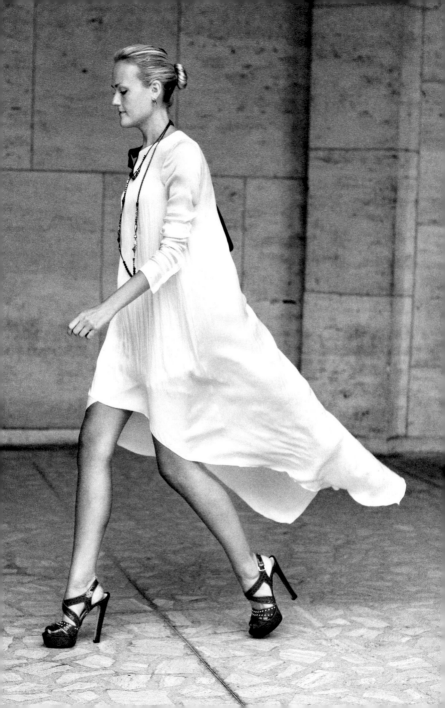

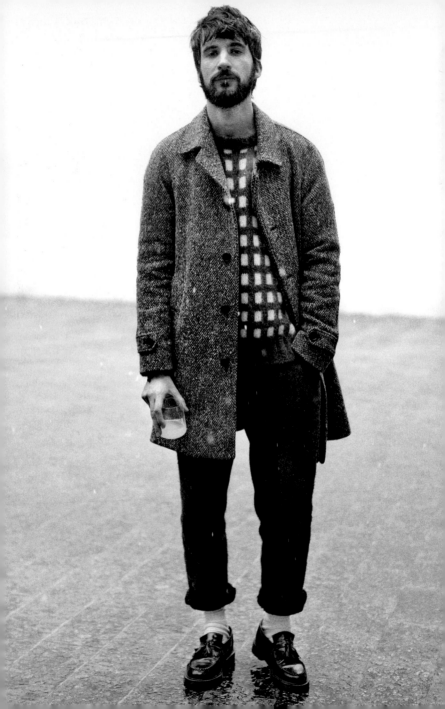

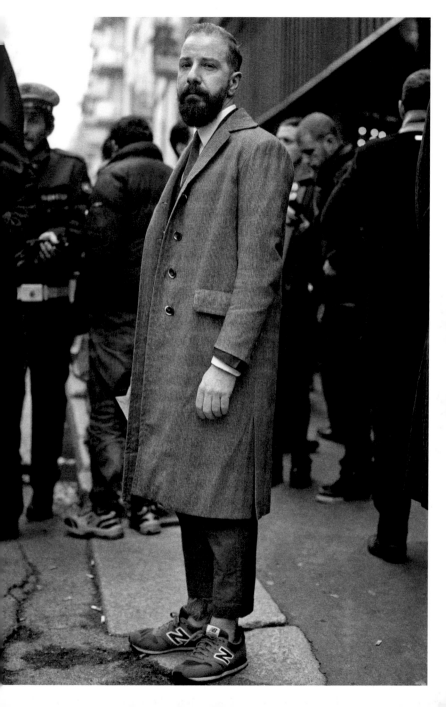

BEPPE

Beppe Modenese is my fashion godfather.

Maybe I don't understand Italian very well, but doesn't 'mode' translate as fashion? So wouldn't Modenese be 'of fashion' in the way that Milanese is 'of Milan'? I might be totally wrong, but that's the story I'm choosing to believe.

He's the one gentleman I just love to watch working the room during Milan fashion week. He's the ultimate, elegant diplomat. I don't know if he has developed this manoeuvre on purpose but I've noticed that when he moves from place to place he looks quite serious and maybe a bit troubled by a situation. But when he sees someone he knows, his face lights up with the biggest smile. This of course makes the person he's just met feel great, like they've brought Beppe the sun itself. Like I said, I don't know if it's something he's purposely developed over the years but it's something I will have to start trying when I hit 60.

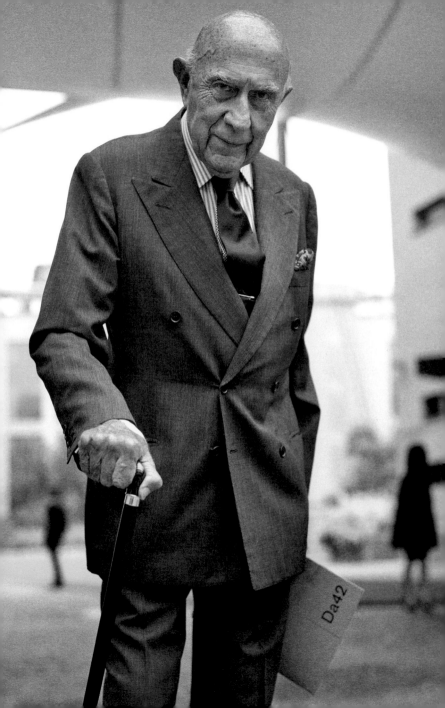

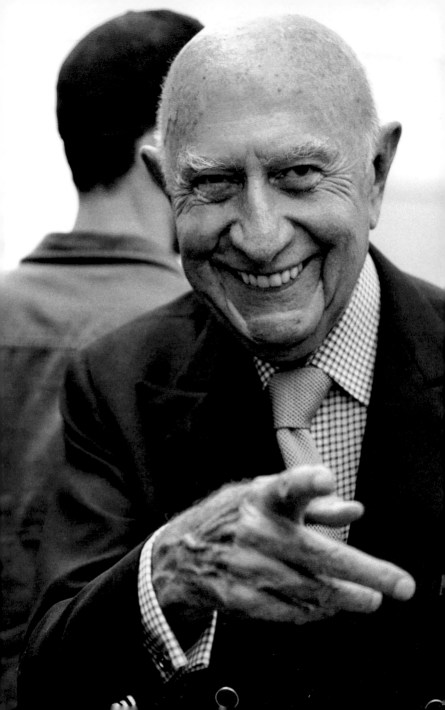

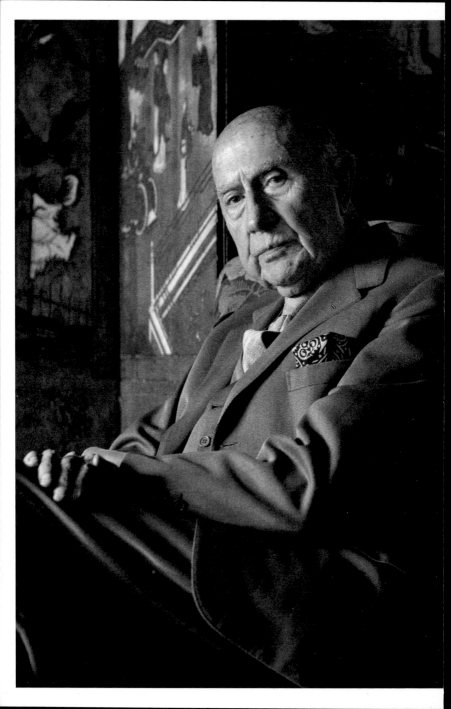

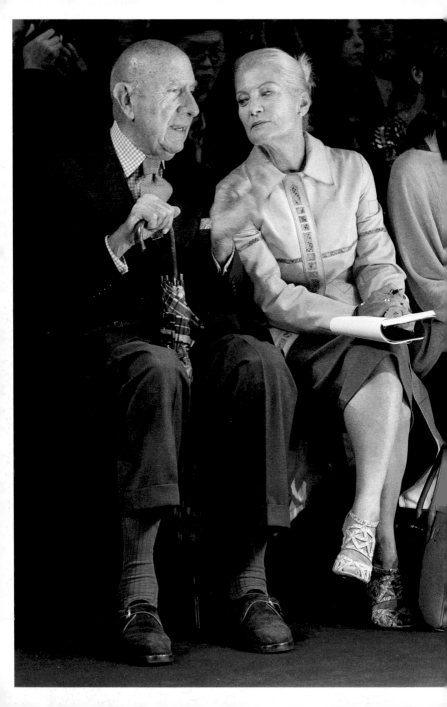

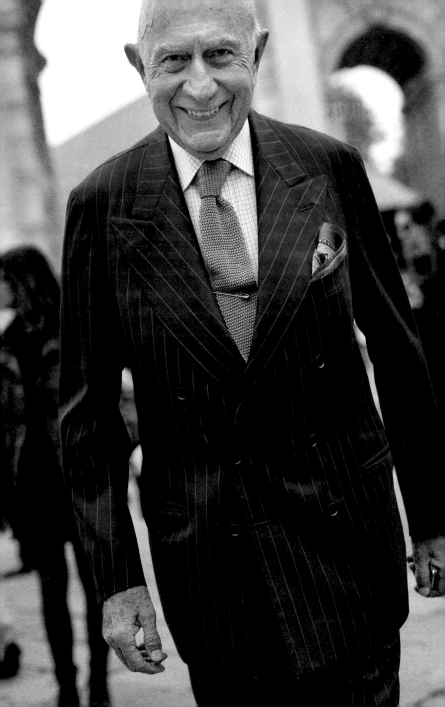

COSTANZA

While we're on the topic of fashion fairy-tales, if I had to choose a fashion fairy godmother, it would have to be Costanza Pascolato. She is incredibly chic, graceful and a very tactful person. What makes her so cool is how tuned in she is to the world around her, not only in terms of fashion but also art, culture and technology. When I started going to the shows in Milan ten years ago, she was the first person to recognize me. She was following my work long before anyone else was.

She has an innate curiosity about the world, which is surprisingly the most common trait shared by stylish people, and this is why she is Brazil's most beloved style icon.

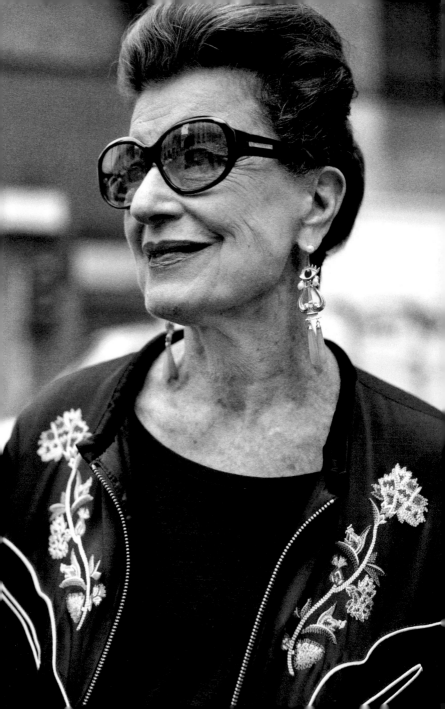

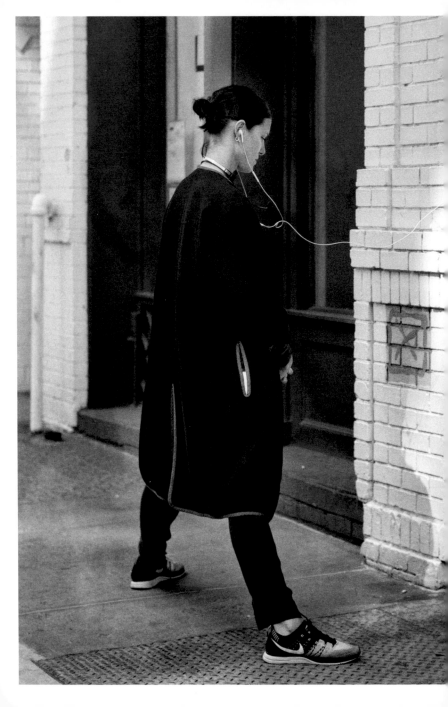

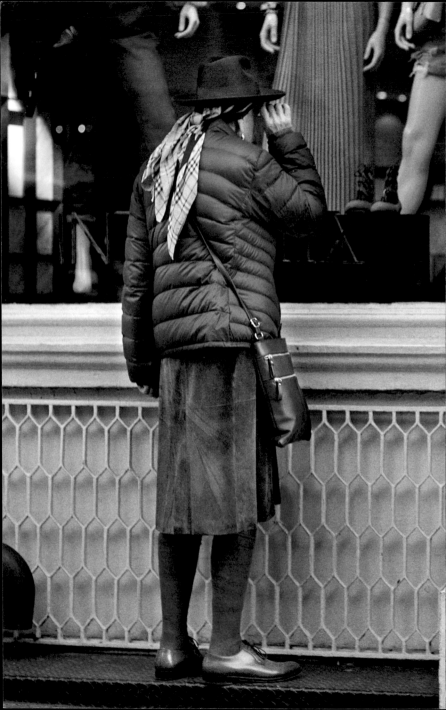

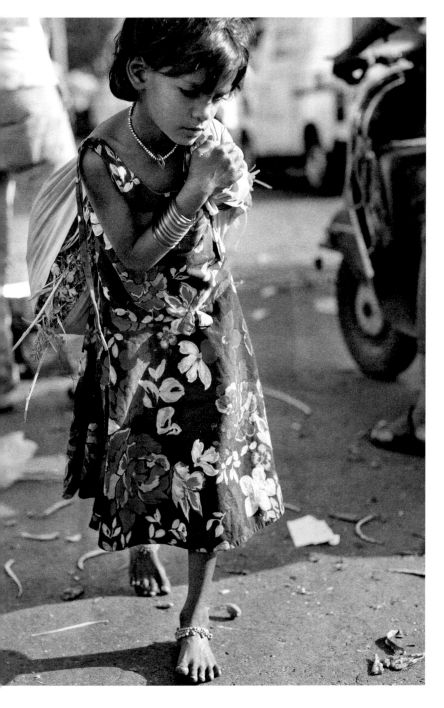

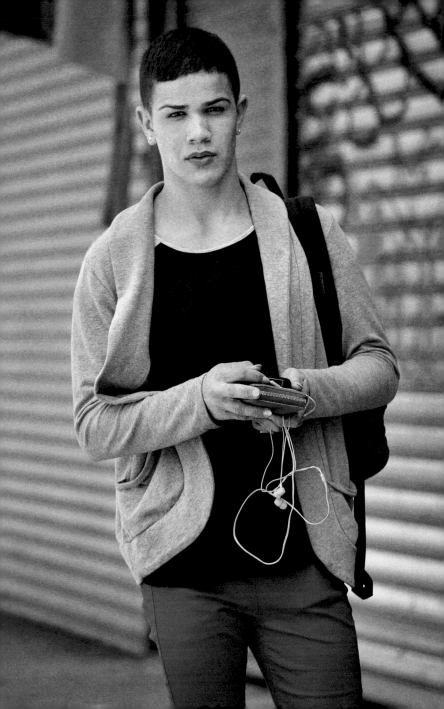

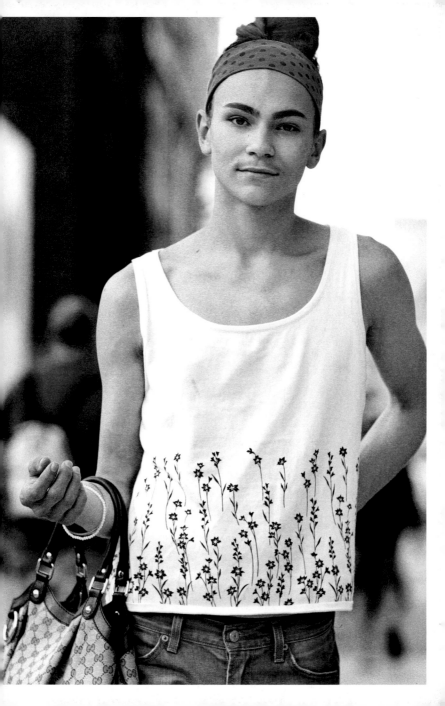

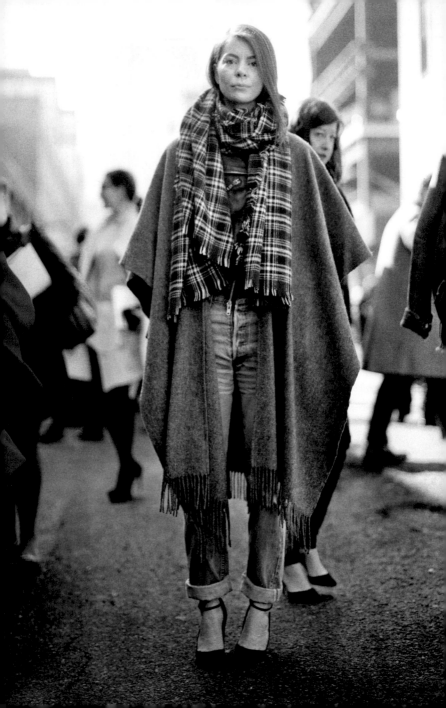

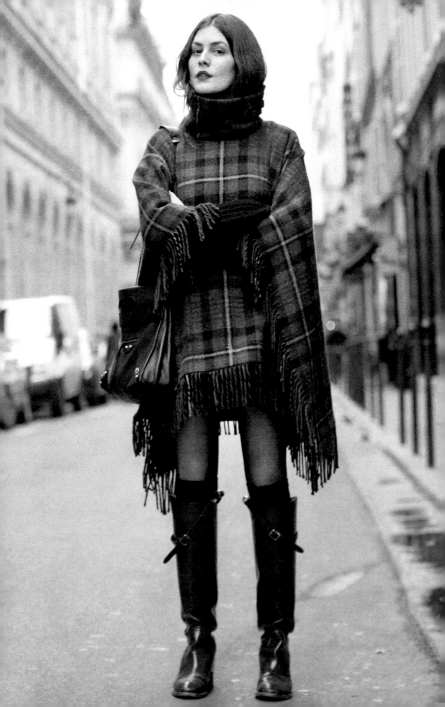

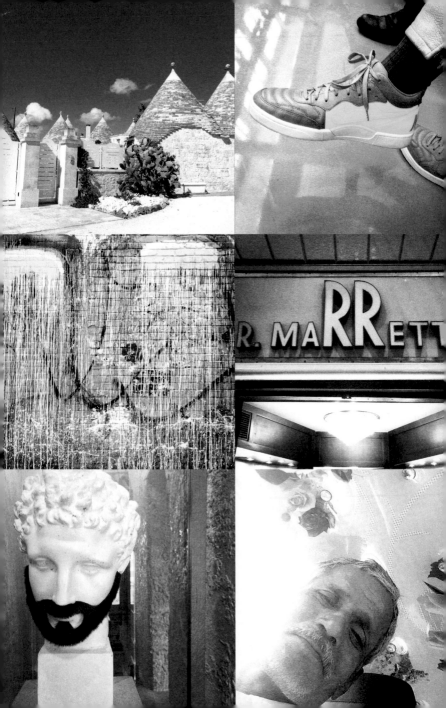

ARMANI CAFFE

On every finger at least one ring, but often three stacked tightly before the first knuckle. The brim of her hat gives way under the weight of a faux bouquet of flowers. Enough bracelets and necklaces to stock a small boutique.

It's nine-fifteen in the morning. She's easily seventy-five years old, sitting at a small table right next to the busy bar of the Armani Caffe, coyly watching the beautiful people rush by but also unmistakably allowing herself to be seen.

Of course I wanted to take her picture but I had one problem: no camera. I sprinted upstairs to grab it, thinking about the story of Brassaï and his Cafe Woman, one of my all-time favourite photos. Brassaï met a be-jewelled, be-dazzling lady late one night in a dive Paris brasserie. He created a small set of images and, although he searched for her, he never found her again after that first meeting. I didn't want this to happen to me.

I approached and explained that I wanted to take a photo of her. She seemed embarrassed but very pleased and adopted what I soon learned was her photo face, chin down, and eyes staring off to the middle distance.

I now know that she can be found in the same spot every morning. Whenever I'm in Milan I stop by the Armani Caffe for an espresso and a little inspiration, thanks to her.

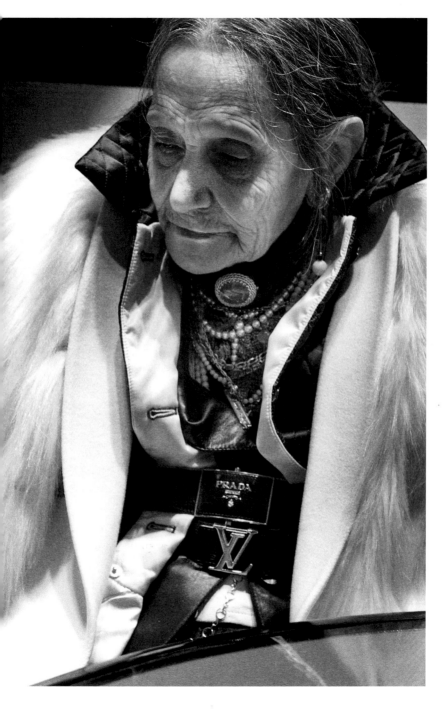

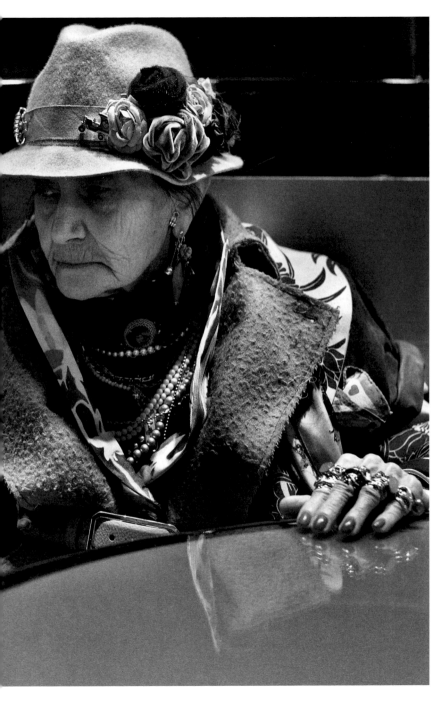

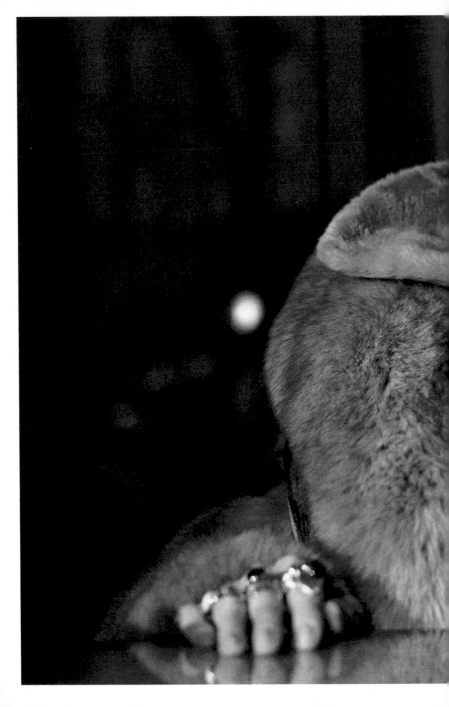

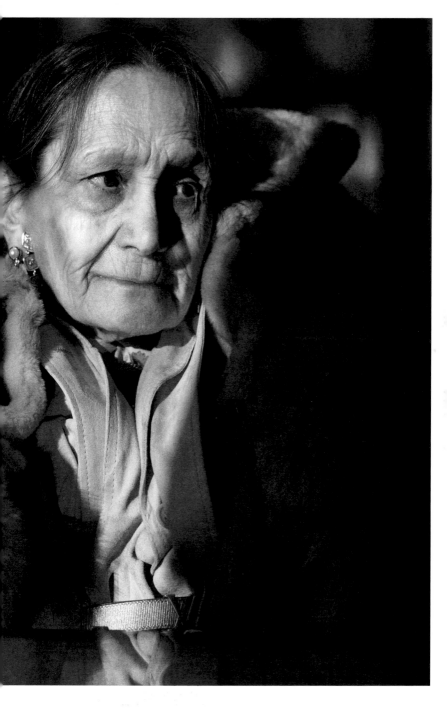

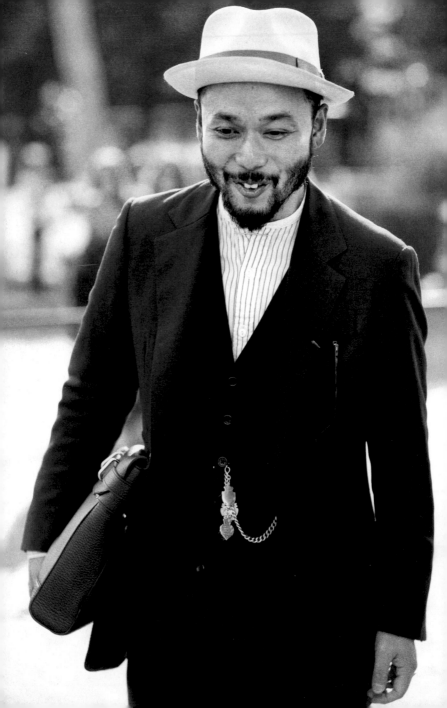

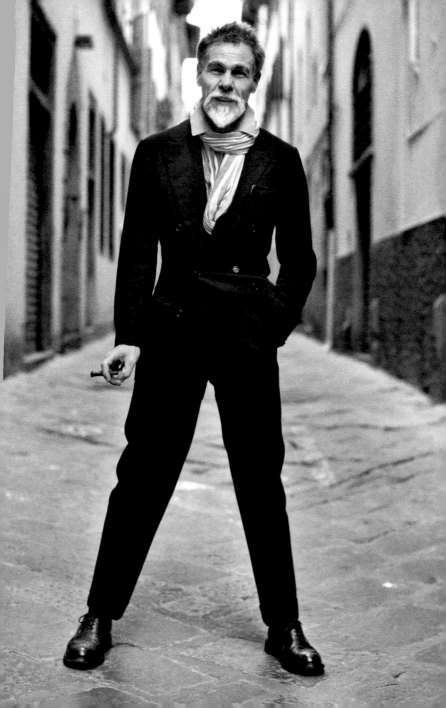

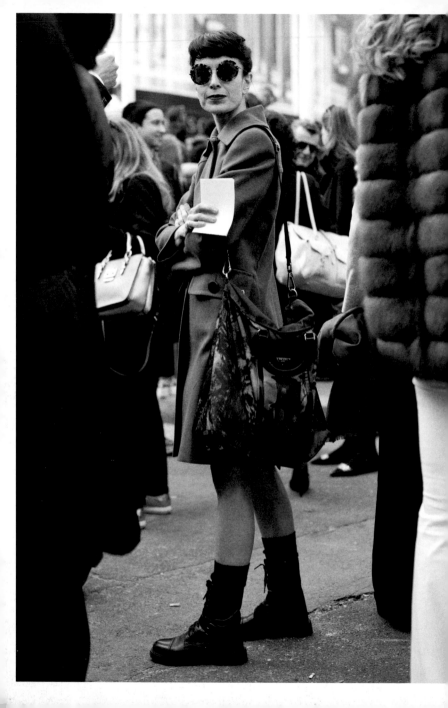

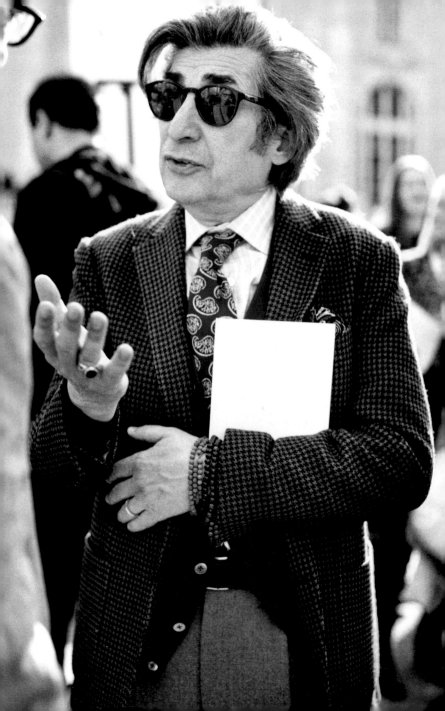

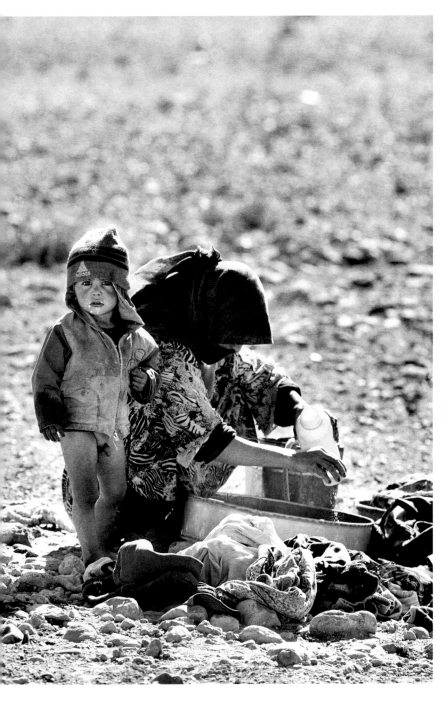

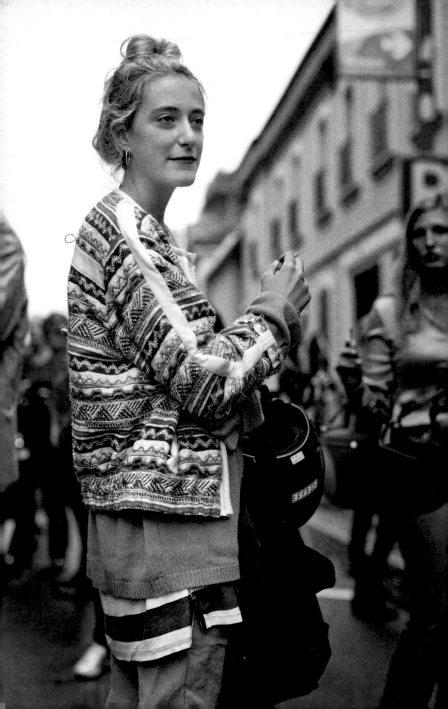

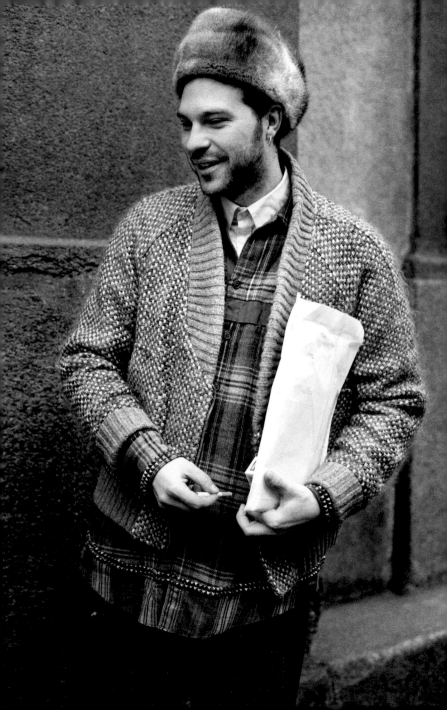

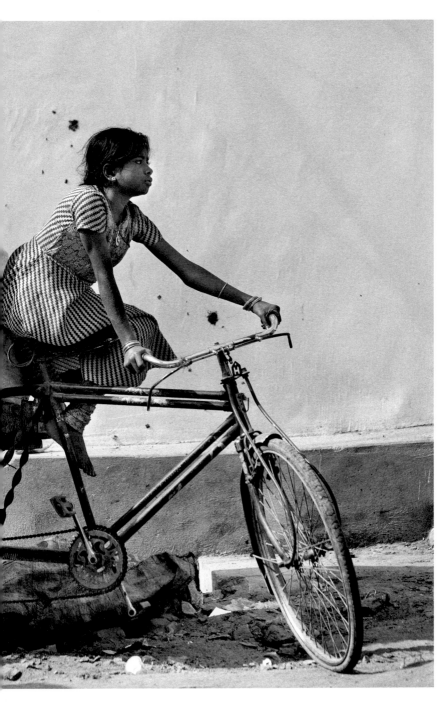

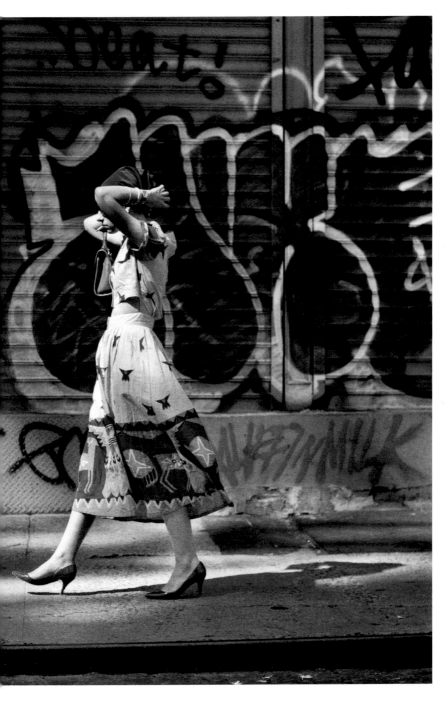

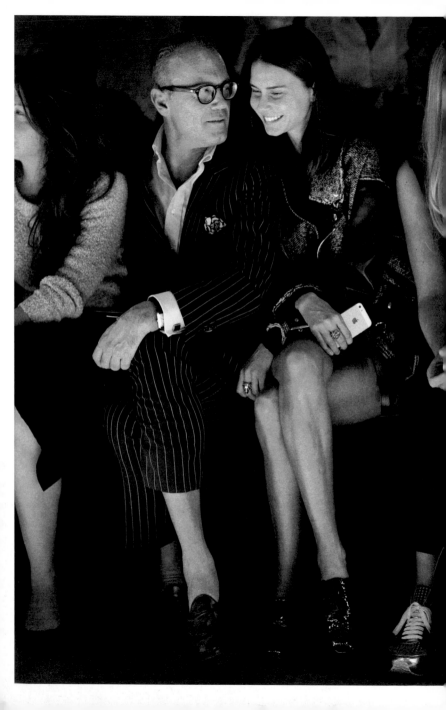

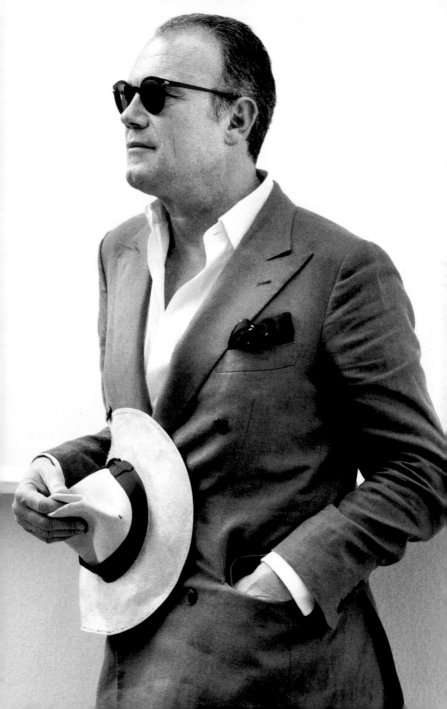

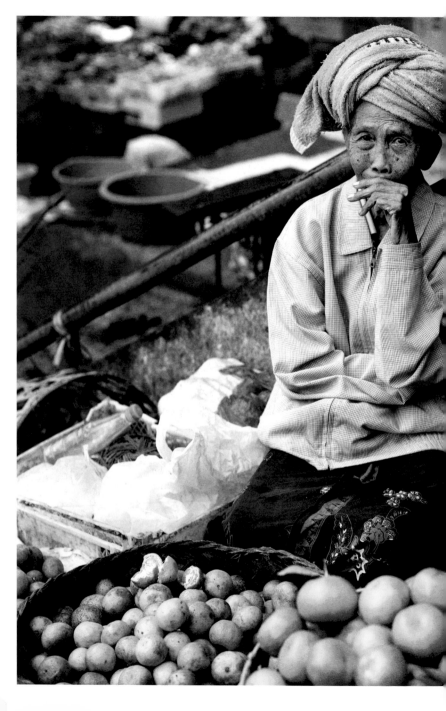

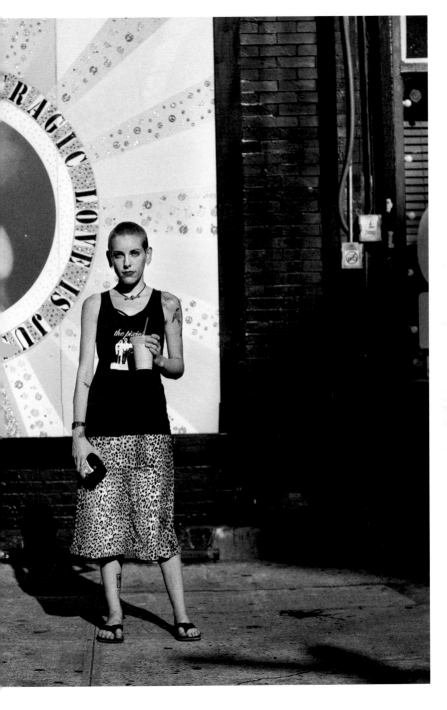

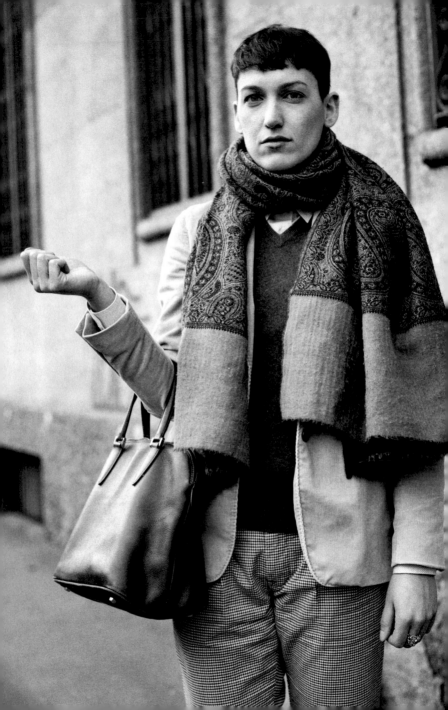

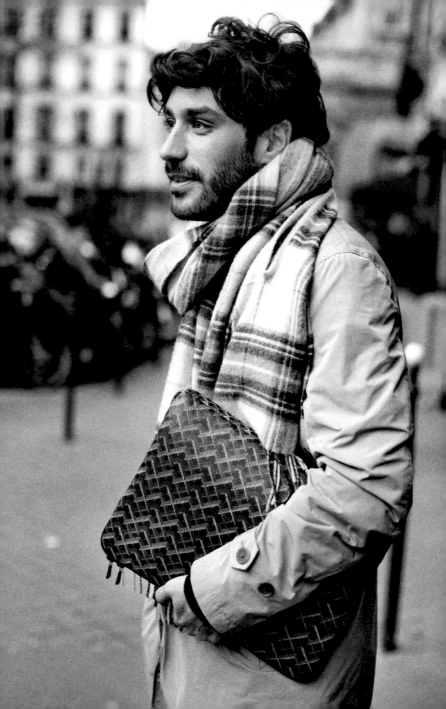

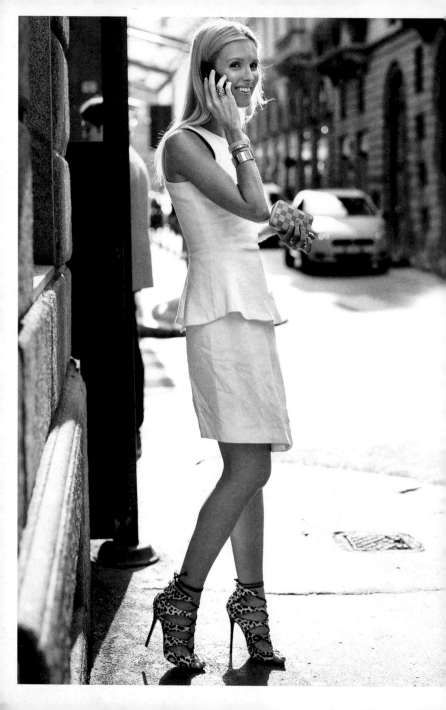

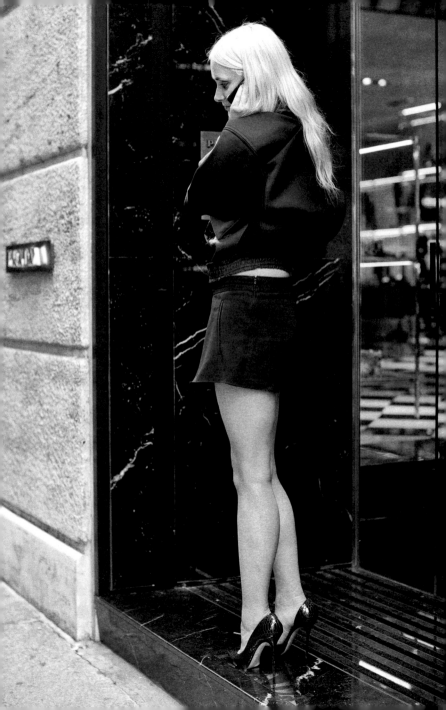

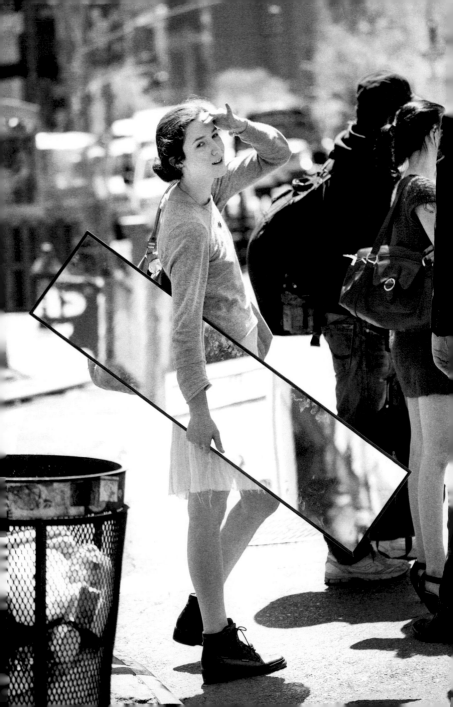

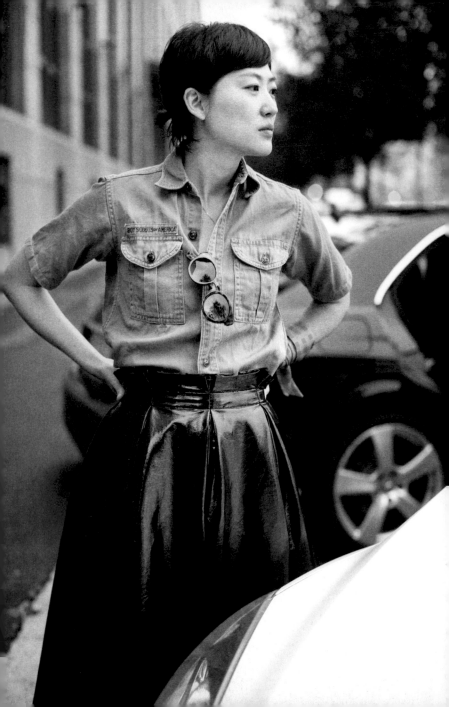

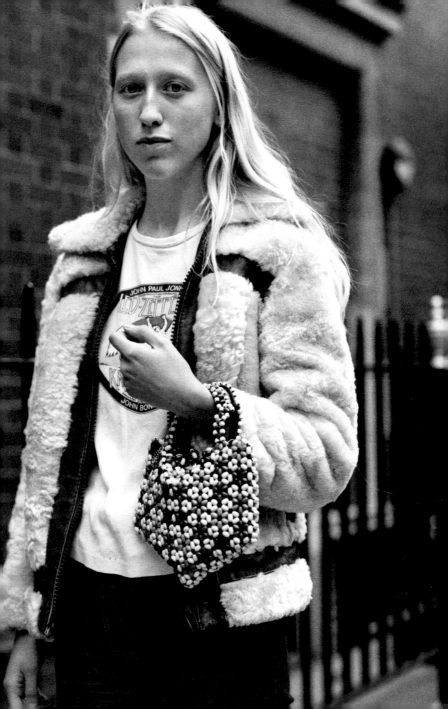

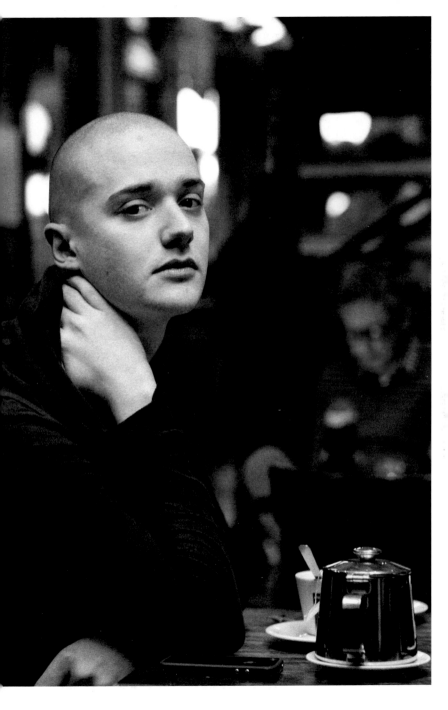

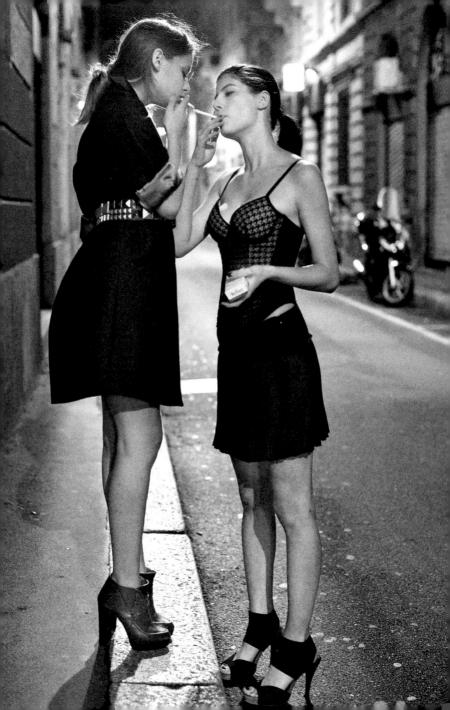

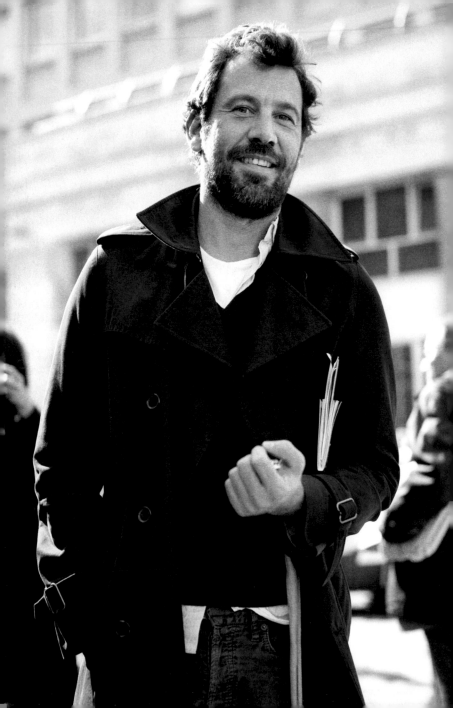

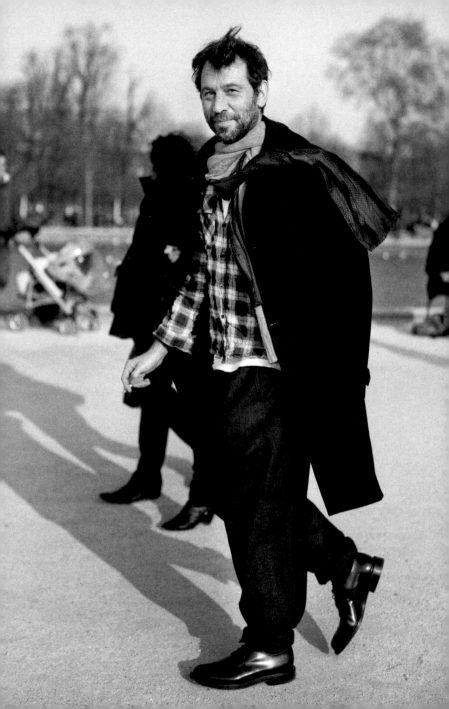

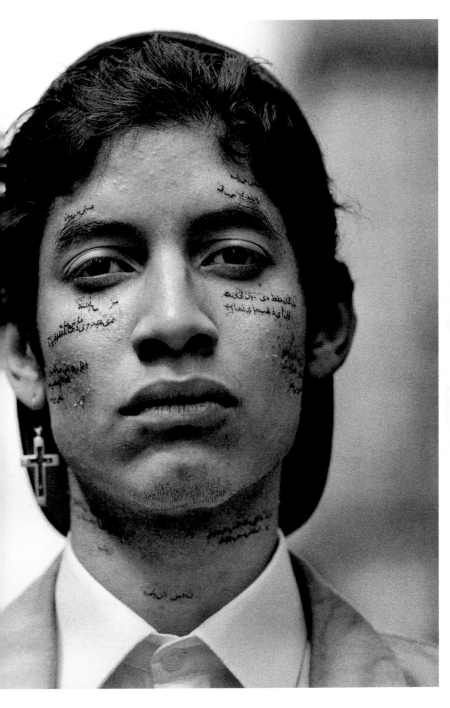

—

ON THE STREET...
MONTAUK,
NEW YORK

—

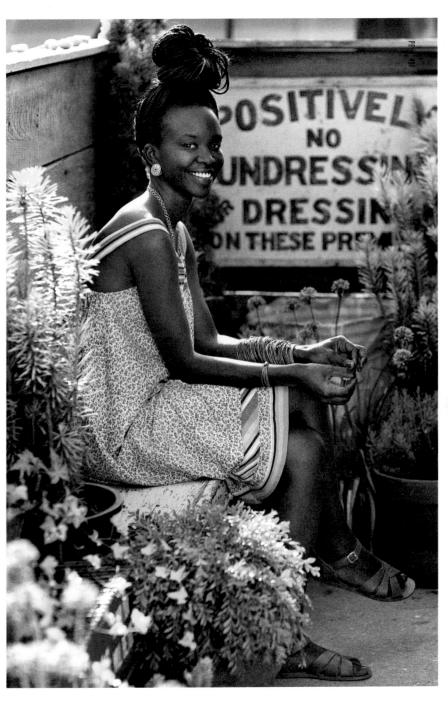

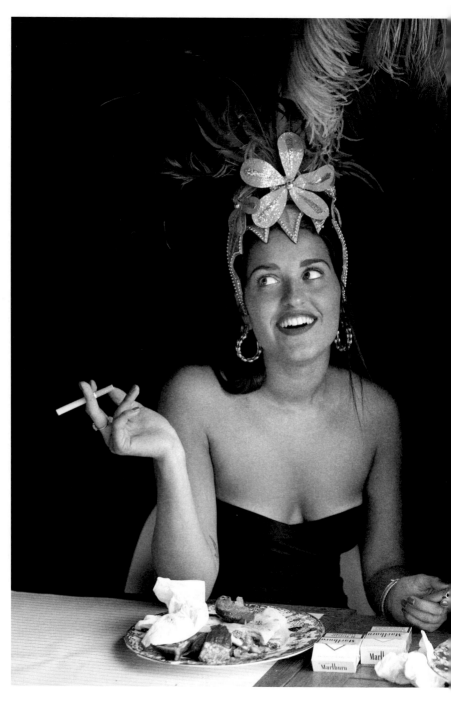

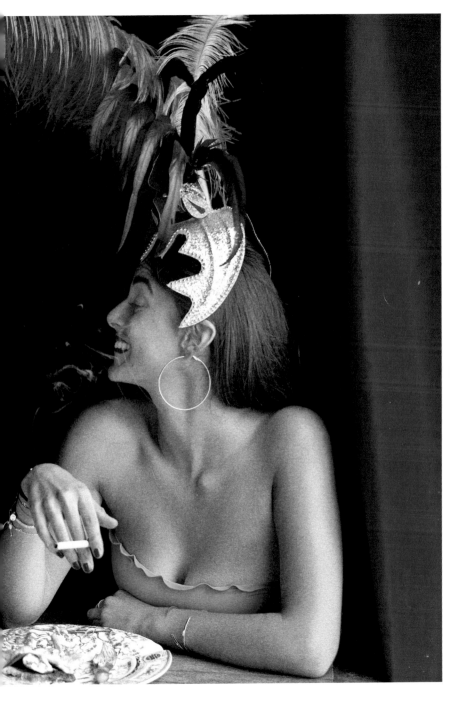

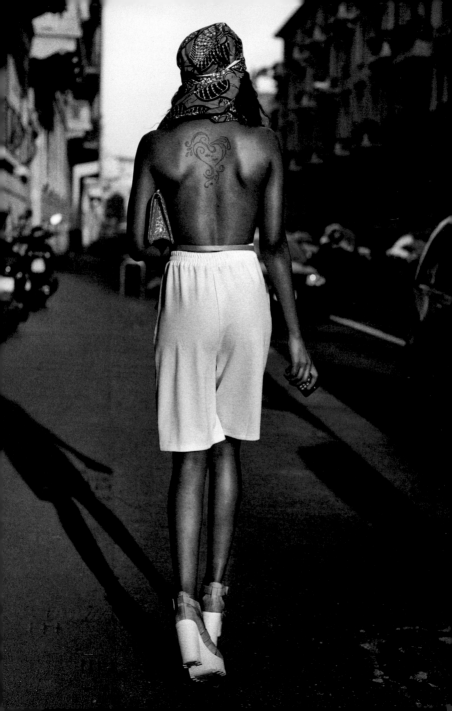

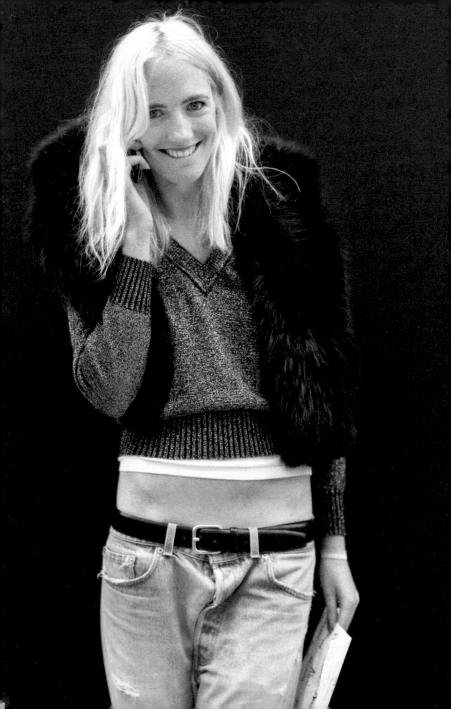

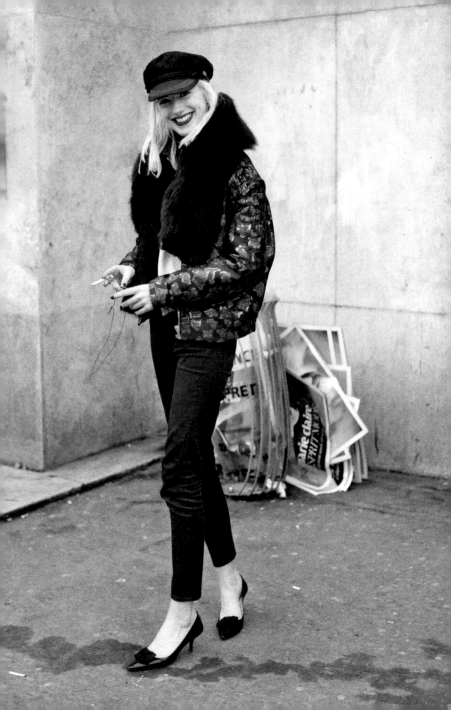

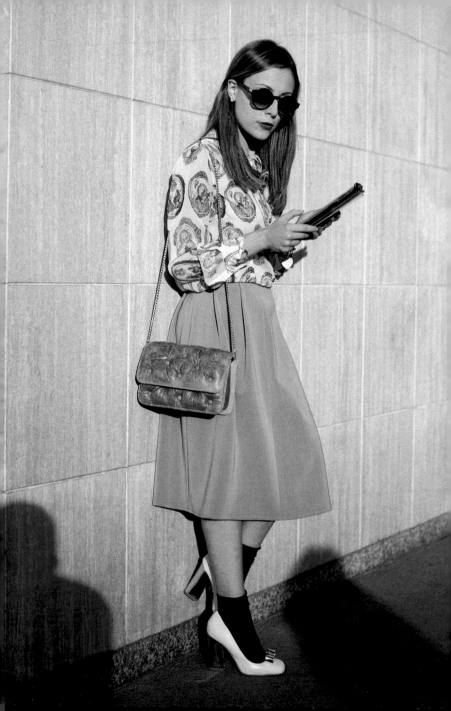

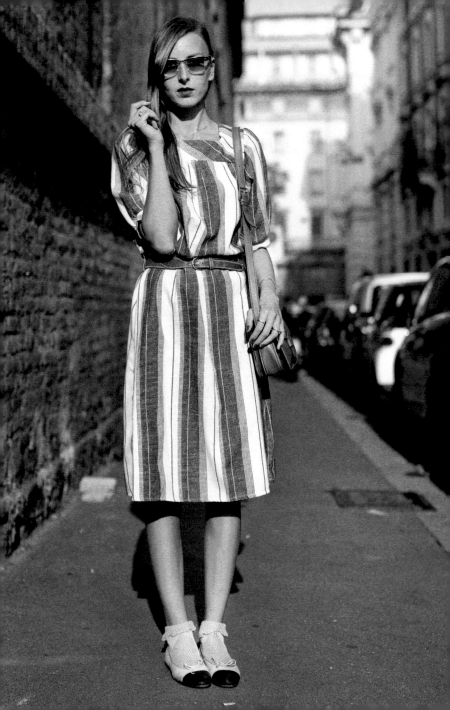

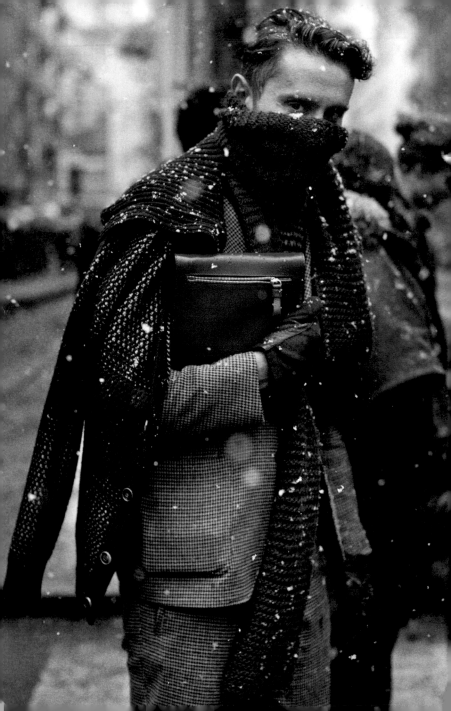

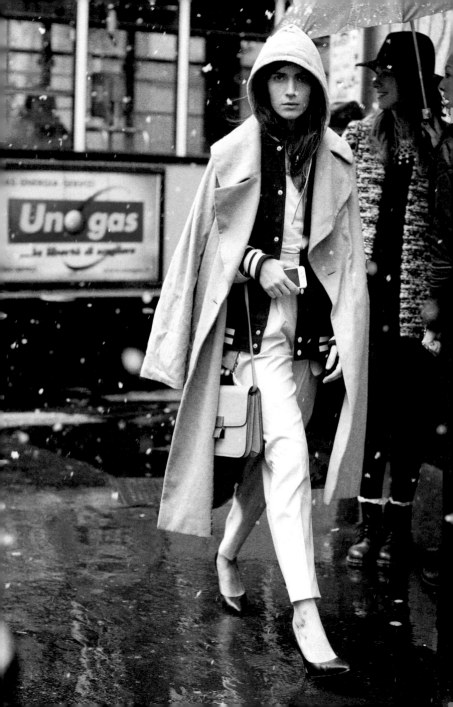

—

ON THE STREET…
SEVENTH AVE.,
NEW YORK

—

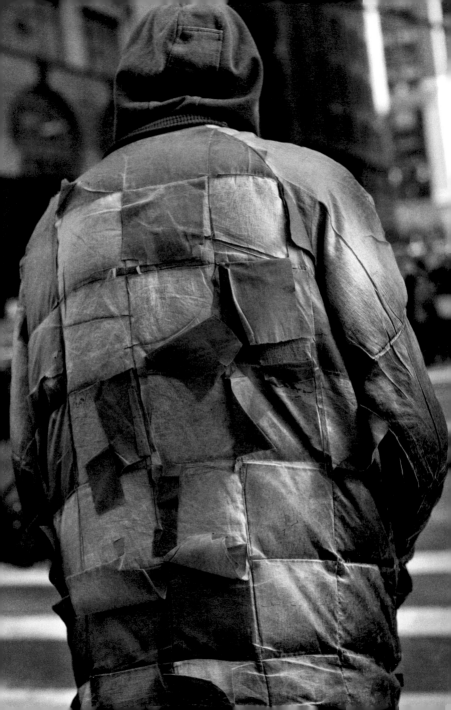

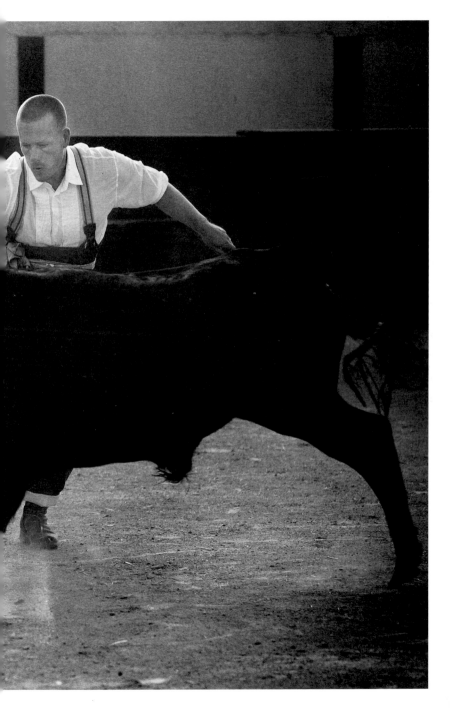

I would like to thank these people for their help and support…

Joan and Earl Schuman
Isabel and Claudia Schuman
Tracy Schuman and Lyn Simuns
Jenny Walton
David Allen
Wes Del Val
Caroline Issa and Masoud Golsorkhi
Alessandro Squarzi
Giampaolo Alliata
Domenico Gianfrate
James Danziger
Tommy Ton
Dirk Standen
Tyler Thoreson
Adam Rapoport
Michael Hainey
Nick Sullivan
Helen Conford
Cecilia Stein
Valentina Tagliamacco and Luxottica Group
Fotocare

Photographs of me in this book by my first best assistant Camila Falquez.

INDEX

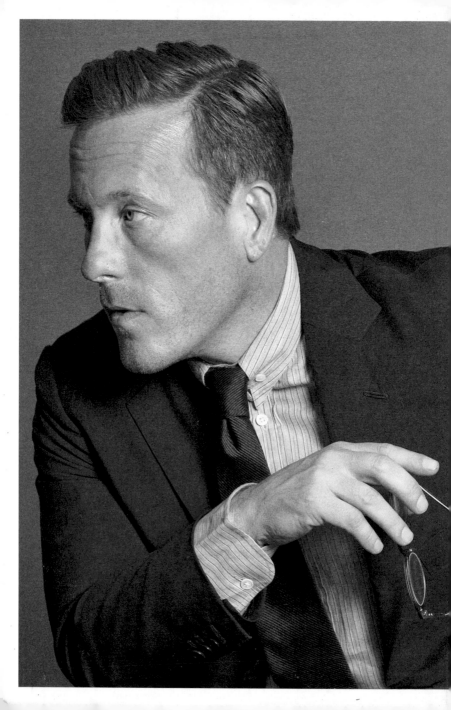